C000117964

Hawkers, Beggars
and Quacks

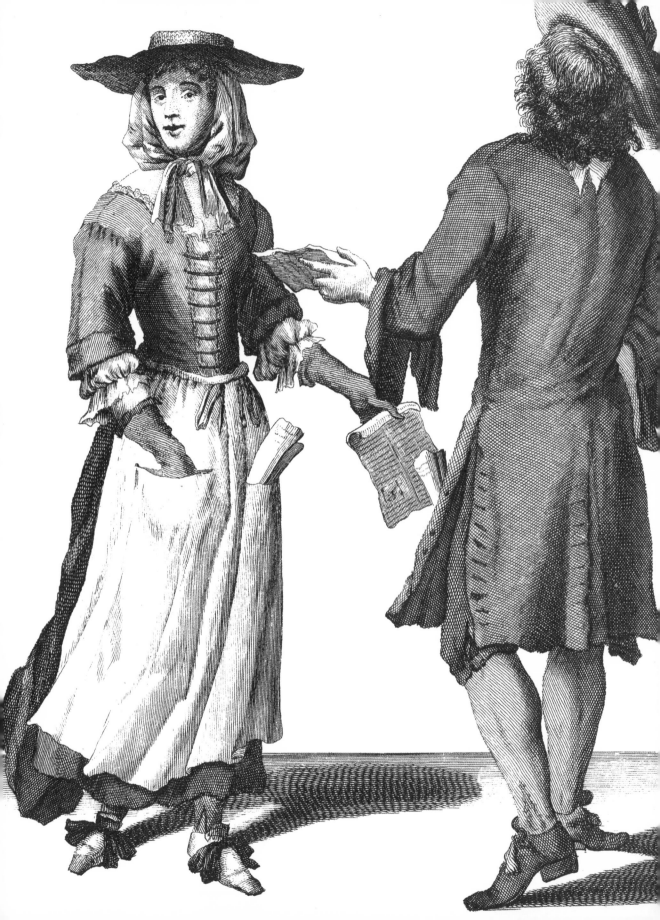

Hawkers, Beggars and Quacks

Portraits from the Cries of London

Sean Shesgreen

BODLEIAN
LIBRARY
PUBLISHING

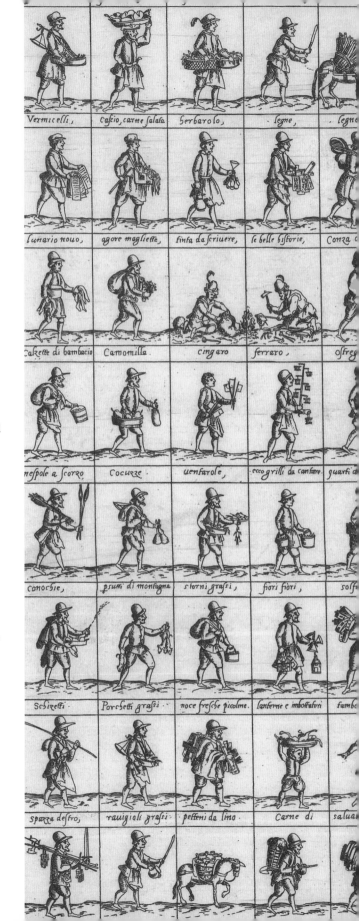

First published in 2021 by the Bodleian Library
Broad Street, Oxford OX1 3BG
www.bodleianshop.co.uk

ISBN: 978 1 85124 551 2

Cover design by Dot Little at the Bodleian Library
Designed and typeset by Caroline and Roger Hillier,
The Old Chapel Graphic Design,
www.theoldchapellivinghoe.com, in Caslon
Printed and bound through South Sea Global
Services Limited on 120gsm Ivoprint Ivory paper

MIX
Paper from
responsible sources
FSC® C122901
www.fsc.org

British Library Catalogue in Publishing Data
A CIP record of this publication is available from
the British Library

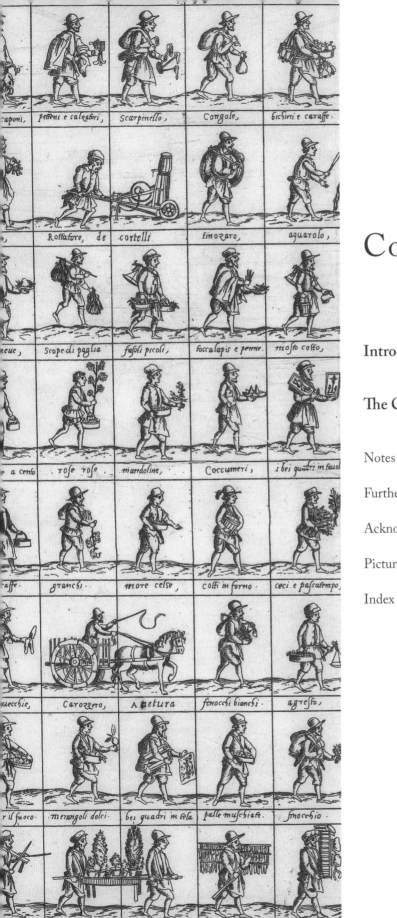

caponi, petteni e calzatori, Scarpinello, Congole, bichieri e caraffe,

Roffatore, de cortelli, finozaro, aquarolo,

eue, Scope di paglia faſoli picoli, foccalapis e penne. moſto cotto,

e a cento roſe roſe, mandoline, Coccumeri, i bei quadri in fuſol

affe. granchi, more celſe, coſſi in forno, ceci e paſſatempo,

uecchie, Carozzero, A petura fenocchi bianchi, agreſto,

ril fuoco, merangoli dolci, bei quadri in tela, palle muſchiate, finocchio,

Contents

THE
LONDON
CRIES
&
PUBLIC
EDIFICES
FROM SKETCHES
ON THE
SPOT

BY LUKE LIMNER ESQ.

PRINTED AT THE LITHO PRESS, OF LEIGHTON, & TAYLOR, 19, LAMB'S CONDUIT STREET

Introduction

The only artist known to have depicted himself in the act of sketching images of hawkers is John Leighton, who in the frontispiece to his *London Cries and Public Edifices from Sketches on the Spot* (*c*.1847) shows himself drawing a small coal man (fig. 1). Leighton, despite his claim to offer 'sketches on the spot', pictures himself in his cosy atelier, the time-honoured locus of creativity, surrounded by artistic properties and aids to stimulate or curb his invention. Most notable among this lumber evoking art's theatricality are thirteen hawkers, tiny fairy folk, wending their way on to his drawing table to take their turns posing. Who are these diminutive hawkers clambering about him? Led by the small coal man who appears to be giving the artist directions, disciplining his hand and guiding his eye, they are figments of his imagination, remote from the living, breathing street vendors of the period. In this respect Leighton's iconography shows that his sketches, like those of other artists featured in his book, cannot be viewed as more or less transparent likenesses of real people from the visible world of Victorian London.

When draughtsmen create images of hawkers, they do not produce literal reflections of historical figures, as the aphorism about 'holding a mirror up to nature', with its implication of quasi-objectivity, once proposed. In a long and intricate process with many steps and agents, artists and others strip real people of their particularities, transforming individuals into art's coinage: representatives, stereotypes and myths. In recasting historical human beings as ciphers and clichés (a nineteenth-century French term for a plate from which images are run off), they use the taxonomic tools of their discipline, the conventions that shape their compositions, their age-old traditions, up-to-date stylistic fashions that change over time. Even more important are the designs of other artists, antecedents or contemporaries with whom they are in dialogue or competition. Even when designers loudly proclaim that their work is

1. The only depiction of an artist in the act of creating a set of Cries, this image raises questions about the circumstances of their aesthetic production. 'Luke Limner' [pseudonym, John Leighton], *London Cries and Public Edifices*, *c*.1847, frontispiece.

'drawne after the Life', 'done from Life' or 'after Nature', they compromise absolute fidelity to visual appearances, engaging in simplifying, ordering, systematizing and metamorphosing whereby they aestheticize reality and transform or distort it. The radical nature of this transformation is caught by Paul Sandby when, in a sketch for his own *Cries of London*, he draws a picture of a surrogate 'artist'. He presents this artist/hawker as a counterfeiter, whom he uses to allegorize the vendor's recasting as a form of alchemy. But the alchemy he proposes to depict is a reverse kind. Using his trickster, who falsely promises to turn people's copper money into silver, Sandby indicts artists like Marcellus Laroon and his followers who turned their copperplates into the 'silver' or cash by drawing sham, romanticized characters to popularize and sell their Cries. Artists are not the only active agents in this transformation: audiences, engravers, editors and most of all publishers, the financial engines of art, also play shaping roles, however hidden. They select, suppress, sequence, pair, contrast and order graphic imagery as it makes its way from the sketcher's pen to the engraver's burin, to the printer's press, to the publisher's bookshop.

Though marginal people in art are hardly literal mirrors of historical reality, images of hawkers, commonly called Cries, enjoy special value as historical documents whose immediacy, vividness and empirical slant give them the ability to inform, move and propagandize viewers. They belong to that genre of social art that takes as its métier money, class, status, hierarchy, wealth and poverty. Cries are imaginative and mythic images; they are also memorial and commemorative, committed to offering vibrant, powerful or seductive transcriptions of the lives of have-nots. Their role in history is particularly important because they promise to tell us of people about whom we know little. Such people, though they have left a scant record, are among the most numerous and essential of our ancestors and, contrary to the prejudices of their contemporaries, among the most diligent.

The documentary information available about this inaccessible and fugitive underbelly, especially its women, comes from statistical and legal sources. The first of these is both scant and bloodless while the second is adversarial, viewing hawkers and marginal people as pests, nuisances, idle good-for-nothings, even criminals. By contrast, images of hawkers in art possess discernibility, concreteness and particularity. One of the paradoxes of art's alchemy is that while it strips people of individuality it clothes them in humanity as words cannot. Owing to the primacy of the eye,

images of the outcast have a directness and a palpability not enjoyed by literary descriptions. Focusing on everyday life and material culture, visual depictions of hawkers can be powerful complements and correctives to statistics and legal records, especially in the specificity and copiousness of their description. They can chart ties between buyers and sellers; detail what people bought, ate and drank; report what these things cost; describe the occupational injuries they suffered; show the rigours of their labours; and recount what they wore.

Take, for example, the question of hawkers' costumes in Marcellus Laroon's *Cryes of the City of London Drawne after the Life*. Born in The Hague, Laroon (1653–1702) emigrated to England where he worked as a draughtsman and a painter. Today he is chiefly renowned for his likenesses of street vendors in his *Cryes*, the drawings of which were engraved by the publisher Pierce Tempest in many different editions, beginning in 1687. As a painter, Laroon was employed by the fashionable seventeenth-century portraitist Sir Godfrey Kneller to reproduce the sumptuous costumes of sitters. Working as Kneller's chief costume painter, Laroon earned renown in his own day as 'an exact draftsman … chiefly famous for drapery, wherein he exceeded most of his co[n]temporaries.'[1] When he turned to Cries, Laroon banked on his expertise in costume painting, creating sketches of over eighty hawkers dressed in outfits that are varied, complex and minutely realized. Consequently, he created a suite that was an encyclopedia of the dress of the lower orders in seventeenth-century England, though he did not resort to metonymy, shrinking hawkers to their costume. When the book's publisher, Pierce Tempest, came to advertise his suite of engravings in the *Term Catalogues* (Hillary and Michaelmas Terms 1688), this astute marketer retitled it 'The Crys and Habits of *London*', adding 'Habits' to stress its status as a document in costume and fashion, drawn with exact attention to detail. He repeated that emphasis a second time in describing his suite of images as offering a 'great Variety of Actions and Dresses'.

Laroon's *Cryes* demonstrates that some images yield different kinds of evidence or information and in different degrees. In contrast, Francis Wheatley's saccharine Cries reveal that even sanitized, antiseptic images can offer evidence against the artist's intent, about the grim realities of street selling in eighteenth-century London. His romanticized primrose seller (fig. 2) and her two angelic children from his *Itinerant Trades of London* (1793) are catechisms to demonstrate how street vendors should

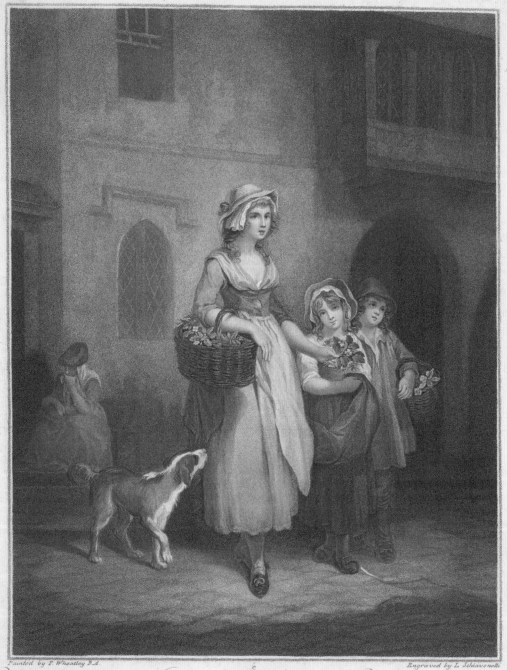

Painted by F. Wheatley R.A. Engraved by L. Schiavonetti

Two bunches a penny primroses, two bunches a penny *A un sou mes deux poignées de primeveres, a un sou*

first plate of the Cries of London London Pub.ᵈ as the Act Directs July 1ˢᵗ by Colnaghi and Cᵒ Nᵒ 132 Pall Mall *premiere planche des Cris de Londres.*
1793

comport themselves with their betters. What they fail to tell us about hawkers is compensated for by what they reveal concerning elites' expectations about marginal people, offering insight into mentalities, ideologies and attitudes.

In 'Primroses', these three characters conform to stereotypes: they are idealized figures imagined by the elites they served. Highlighted and eye-catching, they make it easy to overlook a female figure behind them, who is solitary and passive, sitting on the ground, her face half-buried in her hand. In contrast to the image's titular figures, she has no children to accompany her, no basket to bear, nothing to sell. A figure of anonymity and isolation, she evokes more vividly, and at a deeper level of experience than words plumb, the misery of the street vendor who is unemployed, alone and destitute. Such images, regardless of their purpose and current functions, offer powerful evidence about history's others even when they do not intend to.

The debut of street vendors: social and economic background

[Though a friend volunteered] to shew me the Princes of the Blood ... yet I refus'd the Civility, and told him, that I took more pleasure to see honest John Sharp of Hackney, in his White Frock, crying Turneps, ho! four bunches a penny, than Sir Charles Cottrel, making room for an Embassadour.

Samuel Sorbière (1615–1670)
French physician, man of letters, philosopher

By the year 1700, London, Paris, Rome, Bologna and many other European metropolises were hosting a new, colourful and, to some, menacing tribe of people who had not populated these cities before 1300. A subset of those migrating to cities at the end of the Middle Ages, these idiosyncratic and ephemeral folk were called by various names, the multitude of appellations testifying to their dramatic presence: 'criers', 'hagglers', 'hawkers', 'hucksters', 'pedlars', 'itinerant vendors', 'coal porters', 'chapmen', 'wanderers', 'costermongers', and, more venomously, 'Caterpilars of the Common wealth'.[2] In France, they were called *les petits métiers*, or 'little trades', sometimes *les vils métiers*. Unlike pedlars carrying packs who provisioned themselves in cities but sold their wares

2. Wheatley's *Itinerant Trades of London*, based on paintings and done in colour, was the most popular set of prints ever published in England. It remains a favourite to this day, though its critical fortunes have declined. Francis Wheatley, 'Two Bunches a Penny Primroses', 1793.

in the countryside, tramping from door to door, the new sort of people reversed this age-old practice, 'crying', that is, shouting out the names, virtues or prices of what they hawked in urban streets. Operating legally and illegally outside powerful guilds, they purchased their goods from individual producers and at the great urban markets in city thoroughfares and commercial centres, the most important places where fresh foods could be bought and sold before 1800.[3] Such markets were often specialized, as in London. For example, if the hawkers sold fruits and vegetables, they flocked to London's Covent Garden and its environs. If they were 'lewd and wicked women called fishwives, which swarm about in all parts of this city', they favoured Billingsgate, London's notorious seafood market, founded in the fifteenth century, after which its name became a synonym for the erotic and profane language attributed to the fishmongers who worked there.[4]

These ambulant merchants sold their goods to a new class of consumers, themselves also new city dwellers living cheek by jowl in a density that made it possible for hawkers to exhaust their daily stocks of goods. And, while pedlars carrying packs dealt in hard goods, peripatetic urban hawkers traded chiefly in perishables that could be transported only over short distances and that vendors sold to housewives, scullery maids, servants of the rich and the urban poor. City pedlars advertised their presence by appearing on customers' doorsteps, uttering loud, raucous shouts. Antoine Truquet, in 1545, recorded 'one hundred and seven cries which were uttered every day in Paris'.[5] Drawing the attention of householders and their servants, street vendors sometimes inspired the ire of their casual hearers instead. Jonathan Swift, living in London and writing home to his friend Stella in Dublin, complained of such a crier beneath his window: '[Here's] a restless dog crying cabbages and savoys, plagues me every morning about this time; he is now at it. I wish his largest cabbage was sticking in his throat.'[6]

Not every Londoner would have greeted hawkers with Swift's dyspepsia: street vendors acted as suppliers of daily meat and drink to a broad spectrum of city dwellers. Hawkers must also have played indispensable and beneficent roles in the personal lives of their customers, rich and poor. Known by their faces, their cries and their goods, they surely filled special orders like chestnuts at Christmas and located hard-to-find medicinal items like saffron, while they extended credit to their customers, though they were also energetic debt collectors, as

William Hogarth's *The Distrest Poet* shows. They certainly ran errands for householders and their servants, delivering personal messages, love letters or gifts on St Valentine's Day, which was celebrated with much ado in the seventeenth century. Hawkers must have been welcome sights to people confined to their homes, the aged and the sick, not just for the comestibles they sold but also for the brief sociability they offered with their produce. They must also have proffered news, rumours and gossip with their turnips and herbs.

Beyond provisioning, they delivered essential services to cities, many of which were unacknowledged. Rat catchers did more to stem the spread of the Black Plague than doctors. Sweeps extinguished fires in flues, sometimes at the cost of their lives. Mercuries (as messengers were commonly called) promoted literacy. They managed the vast distribution of England's newspapers, books, pamphlets and broadsheets, for which they were regularly whipped, jailed or committed to the workhouse for up to a year and a day.[7] Inspired by their sharp sense of enterprise, they created a novel and largely undocumented system of making the daily press broadly available. They created a lending-library system of newspaper distribution whereby the popular classes and the poor could rent one or more of England's news sheets, either by the day for a halfpenny, or by the week for a trifle more, returning the paper or papers at the end of the rental period.[8]

Where did this class of people and those they served come from and what social or economic changes gave rise to their appearance in cities across Europe? The decline of feudalism and the dawn of early modern Europe's new urban economy created a migration that not even the ravages of the Black Death could stem. The thirst for these vendors and their services was unquenchable; no urban centre's population in Europe was self-sustaining until the late eighteenth century. From 1200 to 1650, Rome's population grew from about 35,000 to 98,000, London's from 25,000 to 350,000 and Paris's from 110,000 to 400,000.[9] These people, displaced by the scarcity of land in the country following its increasing enclosure from the sixteenth century onwards, were drawn to the big cities by the promise of cash wages, which was related to the growth of coinage.

At the lower end of the economic scale, these street sellers included a floating population, some with special skills but most without, who gravitated to markets to buy, resell and transport fruits, vegetables and more, which they hauled through cities on foot and cried from door to

door. Theirs were conveniences or indispensable services when these involved sweeping chimneys and sharpening knives or toting water, milk or coal down to cellars or up to attics and garrets. And they offered an irresistible expediency when streets were crowded, stinking, filthy, even chaotic and dangerous. Their offices were welcome when they provided entertainments such as juggling, ballad singing (p. 104), dancing on ropes (pp. 204 and 208) or fiddling (p. 126).

Some of these itinerants journeyed from nearby suburbs into the great cities to hawk two types of goods: foodstuffs grown in the gardens encircling every large European city where men gardened and their wives marketed. From West Ham, Alice Wilson and her maid rode on a horse five miles to London, where they sold their peascods in the spring.[10] Likewise makers of hard goods, artisans and small manufacturers dwelling in the same collar suburbs journeyed themselves or dispatched their servants and even their children to hawk goods in high demand by city dwellers: brooms, kitchen utensils, glassware, flint with tinderboxes and the like. Others came to the big cities to provide the services that urban populations demanded: cleaning the streets; playing their musical instruments in squares, piazzas and street corners; and selling sex. A few offered knick-knacks that were little more than an excuse for begging, such as children selling laces.

Renting or lodging in London's rookeries and ghettos, street sellers were chiefly city dwellers and day traders who outnumbered the formal employment opportunities that were available to them. Their common stock was perishables which needed little capital and were easy to store, could not be transported over lengthy distances and kept no longer than a day or two.

Typically, street sellers were poor women. In London's overcrowded labour market, hawking, a makeshift business, was one of the few jobs open to unskilled women. They could easily enter such jobs and easily exit them. Objects of bitter hostility in the sixteenth century and later, they were blamed for increasing prices by the offences of engrossing, forestalling and regrating, or selling outside market times and places. Such women, especially when they were single or had otherwise evaded men's control, were also viewed as sinks of lewdness. Women, a mayoral proclamation of 1590 alleged, were 'not only of lewde and wicked life and behavior themselves but procurers and drawers of others also servauntes and such like to sundry wicked accions, the nomber of which people are of late yeres soe wonderfully encreased'.[11]

Living in urban slums, these women caught the eye of Donald Lupton. In his *London and the Countrey Carbonadoed* (1632), he called them 'Crying, Wandring, and Travailing Creatures [who] carry their shops on their heads, and their Store-house is ordinarily *Bilingsgate* or the *Bridgefoote*, and their habitation *Turnagain-lane*'. Lupton, a sharp and expressive observer of London life, offered this account of their way of doing business:

> they set up every morning their Trade afresh. They are easily set up and furnish't, get something, and spend it Jovially and merrily: Five shillings a Basket, and a good cry, is a large stocke for one of them. They are merriest when all their Ware is gone: in the morning they delight to have their shop ful, at Even they desire to have it empty: their Shoppe's but little, some two yards compasse, yet it holds all sorts of Fish, or Hearbs, or Roots, Strawberries, Apples, or Plums, Cowcumbers, and such like ware: Nay, it is not destitute some times of Nutts, and Orenges, and Lemmons.[12]

Hawkers, then, belonged to the bottom rungs of those migrating to cities, and indeed they were commonly referred to in England as the 'lower orders' and in France as *le bas peuple*. But that statement must be qualified because certain hawkers were moderately prosperous, to judge by their dress, that they owned equipment or animals and the kinds of customers they interacted with. Men who owned horses, mules and hunting dogs were of a so-called better sort. So too were those who owned equipment like wheelbarrows or knife-grinding contraptions; grinders did well if they served butchers or slaughterers rather than housewives. Finally, street traders following skilled trades and specialized callings did well; in this category were coopers, wine sellers, bricklayers and certain old clothes dealers, whose elegant dress may be a courtesy they practised to cultivate their customers. Men and women occupying the high end of the old clothes trade engaged in barter; the man trading in 'Old Cloaks, Suits and Coats' (p. 140), which he seeks to buy, not sell, offers swords in exchange for cast-off vestments, which were a valuable commodity. Fancy rapiers, symbols of gentility, were more likely than small money to snare customers like upper servants and domestics with aspirations. Traders were a far cry from rag-and-bone merchants, a trade associated with impoverished Jews at the very bottom

of the old clothes trade, a people then socially despised and viewed as emblems of nihilism due to anti-Semitism.

The vast majority of street hawkers were, however, the poorest of the poor, especially women vendors who engaged in casual, temporary and seasonal labour. In Annibale Carracci's (1560–1609) landmark *Trades of Bologna*, one of the earliest and most important Cries in Europe, eighteen hawkers go in bare feet, a sign of extreme want, as in the case of his street cleaner (fig. 3). Most of Marcellus Laroon's seventy-four hawkers in his *Cryes of the City of London Drawne after the Life* dress in outfits that are patched, torn, tattered or frayed, notably the attire of those who followed trades that were stinking, mean and dirty: coal sellers, mackerel vendors, eel hawkers, rag pickers and dustmen. This troop also included sellers of meat for cats and dogs, a fetid stew of tripe, offal and meat residues often sold by women.

More disfavoured still were street denizens who fell not just to the social bottom but entirely outside the pale of respectable society. Under the cover of hawking, they practised thieving, prostitution or gambling. Such petty rogues included barrow men who were gamblers, flower girls selling sex, poor women fencing stolen clothes, ballad sellers and singers who drew crowds for their accomplices to rob, prostitutes and their madams disguised as elegant ladies, and tricksters like the Squire of Alsatia. The latter's strategy was to gull country folk into gambling or women into marriage. Typically, he would throw a five-shilling piece on the ground and pretend to find it just as a peasant leaving market happened along. He would then entice his new 'friend' to share in the money they have 'found' and retire to a nearby tavern. Alcohol would then appear, followed by cards and dice.

Most hawkers were costermongers, that is, they sold fruits and vegetables and also edibles including prepared foods like sausages, baked apples, hot eel pies and even luxuries such as saffron, fortified wines and oranges. Those who sold fruits and vegetables rarely specialized in a single product. Of course they changed what they sold with the passage of the seasons. John Gay, in his *Trivia, or, the Art of Walking the Streets of London* (1716), imagines how vendors' customers followed the changing times by listening to hawkers' shouts. Gay's calendar of vendors' cries, identifying the fruits and vegetables they sold, offers a romantic narrative of the year from spring to Christmas, casting hawkers as pastoral figures such as those in the Labours of the Months from books of hours:

3. Carracci's 'Street Cleaner' is a print from one of the artist's seventy-five drawings (most now lost), said to have been created in his hours of leisure. This and others show the toll taken on the bodies of hawkers by manual labour. Annibale Carracci, 'Street Cleaner', from an edition of *Trades of Bologna*, published in 1740.

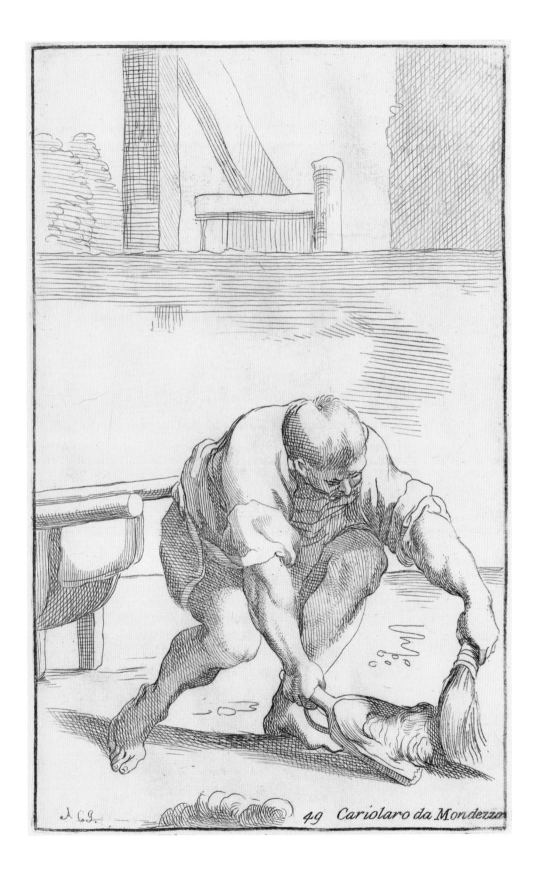

A.C.g. 49 Cariolaro da Mondezza

Successive Crys the Season's Change declare,
And mark the Monthly Progress of the Year.
Hark, how the Streets with treble Voices ring,
To sell the bounteous Product of the Spring!
Sweet-smelling Flow'rs, and Elders early Bud,
With Nettle's tender Shoots, to cleanse the Blood:
And when *June's* Thunder cools the sultry Skies,
Ev'n *Sundays* are prophan'd by Mackrell Cries.

Wallnuts the *Fruit'rer's* Hand, in Autumn, stain,
Blue Plumbs, and juicy Pears augment his Gain;
Next Oranges the longing Boys entice,
To trust their Copper-Fortunes to the Dice.

When Rosemary, and Bays, the Poet's Crown,
Are bawl'd, in frequent Cries, through all the Town,
Then judge the Festival of *Christmas* near,
Christmas, the joyous Period of the Year.[13]

From the viewpoint of hawkers, the realities of street vending differed from the bucolic picture Gay paints. In the sixteenth and seventeenth centuries casual street labourers earned a hand-to-mouth living. They took what tasks presented themselves, however unrelated: fishwives and vegetable vendors were midwives to the poor, and everybody scavenged.[14] Full-time labour at a single task was uncommon before and during the seventeenth century. In contrast to Gay's cheerful annual calendar, here is Lupton's tale of how hawkers' routines shifted from one day to the next, based on what they sold:

They change every day almost, for Shee that was this day for Fish, may bee to morrow for Fruit; next day for Hearbs, another for Roots: so that you must heare them cry before you know what they are furnisht withall, when they have done their Faire, they meet in mirth, singing, dancing, and in the middle as a *Parenthesis*, they use scolding, but they doe use to take and put up words, and end not till either their money or wit, or credit bee cleane spent out. Well, when in an evening they are not merry in an drinking-house, it is suspected they have had bad returne, or else have payd some old score, or else they are banke-rupts: they are creatures soone up, and soone downe.[15]

Lupton ignores here the challenges of market work – its unpredictable supplies and demands; the uncertain quality of its foodstuffs; its heavy lifting and toting; and the harshness of London weather and of city life – all of which made heavy demands on the poorest of poor women. In addition he goes so far as to confirm fishwives' reputation as tosspots (drunkards) and streetwalkers: 'If they drinke out their whole Stocke, it's but pawning a Petticoate in *Long-lane* or themselves in *Turnebull-streete* [notorious for prostitutes] for to set up againe.'[16]

What are Cries? The first ensembles of Cries

The word 'Cries', sometimes spelled archaically as 'Cryes', first referred to the shouts hawkers used to sell their wares. But in the late 1500s in England, it also came to allude to a genre of popular images showing more or less realistic and striking likenesses of the lower orders, with brief texts or captions joined to them naming what street hawkers sold or recording their shouts. This genre of serial images was the first in art to take as its exclusive subject the urban outcast, marginal and disfavoured. (From the early fifteenth century, when the *Très Riches Heures du Duc de Berry* (1413–16) appeared, peasants were a popular topic in illuminations, paintings and prints.) In this study, Cries, spelled with a capital C, alludes to these suites of images sometimes called 'Costumes' or 'Costumes of the Lower Orders'. Thomas Busby called his images *Costume of the Lower Orders of London. Painted and Engraved from Nature* (1820) because of their minute attention to depicting naturalistically the bizarre, striking or curious clothing that hawkers wore. In other images, the focus is on the picturesque, odd or technologically complex things that were sold or used.

The earliest known Cries of any nation is a suite of Cries of Paris. Some have no legends, but fifteen bear French captions rendered in black letter emblazoned across each design, which gives them a literary and aural tone. This prototypical ensemble of picturesque figures inaugurated a tradition of Parisian Cries that unfolded across four centuries, spreading to different European cities, continually renewed in complex forms and constituting, with the Cries of London, an *oeuvre* that is the most numerous, varied and dazzling of any Cries in the genre.

This set is preserved in the Bibliothèque de l'Arsenal, Paris. Dated to *c.*1500 and executed by an anonymous hand, the images depict single,

isolated figures. These sell glassware, flint and tinder, leeks, hot cakes and warm pies, herring, beautiful ABCs and *belles heures*, wafers, turnips, faggots, brooms, mussels, good milk, old shoes and almanacks. Other figures include a tinker, a sweep, a knife grinder and a man offering to perform filthy tasks.

Executed in a bold style, the woodcuts employ an expressiveness akin to that of popular northern European images. Their style, which has a heraldic character, is more Dutch or German than French. All are hand coloured with precision and skill. The chimney sweep's face, arms and hands are tinted black to highlight the effects of his sooty calling. Hawkers' limbs, and especially clothes, are drawn with care and detail; the hats of every figure, carefully particularized, differ from one another in style and colour. None of the hawkers is enclosed in a frame, which might serve as an artistic reference; without this, the naturalism of the images is intensified. All the hawkers pose in theatrical postures or stride vigorously across tiny rural landscapes decorated with plants and flowers. These tiny landscapes report that the traders are journeying from the countryside to Paris to sell their wares; this view is corroborated by the fact that their stock is ample, suggesting that they have not yet begun their day's labours. The objects they carry – flint and tinder boxes, brooms (fig. 4), books and

4. Anonymous, 'Brooms', *Cris de Paris*. This print and others from a Cries of Paris suite possibly date from *c*.1500, but some experts think they were made later. The series was not well known before the twenty-first century and so does not have any successors.

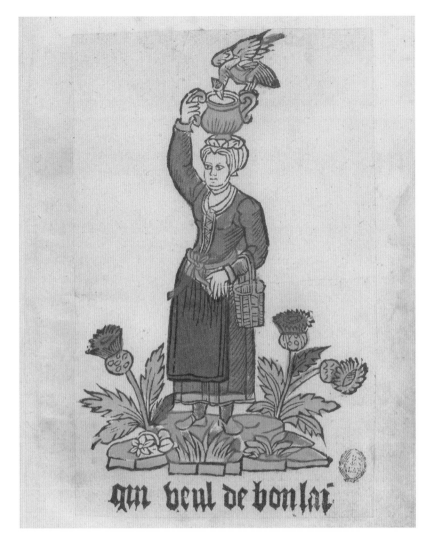

qui veul de bon lai

5. This print depicts a country woman selling milk to city dwellers. The crow on her milk pail suggests an emblematic meaning, now lost. Anonymous, 'Milkmaid', *Cris de Paris*, c.1500.

glassware – also argue that they are bound for Paris. These goods represent the artisanal objects manufactured in early proto-industrial districts, while their perishables evoke the foods from gardens just outside the city walls.

The milkmaid (fig. 5), who wears a blue apron and blue stockings with a laced bodice, is the most fashionable and striking of the eighteen hawkers. She is also the most puzzling. She carries a basket on her left arm (is she also a butter-woman, a cheesemonger or perhaps an egg vendor?), and she balances her milk pail on her head, impervious to the crow perching on her vessel. The elaborate and complex motif of the crow stealing her milk, akin to an emblem, suggests that this image has an allegorical, proverbial or moral aspect. Is she a variant of Aesop's fabled 'silly milkmaid', whose daydreaming causes her to spill her beverage?

The early development of Cries: Cologne, Rome, Paris and London

Many years after the publication of the first Cries of Paris, images of hawkers trickled into popular art. In 1589 Franz Hogenberg etched and engraved the 'Cries of Cologne' (fig. 6), which he titled, signed and dated, making him the first artist to canonize and historicize the genre. By adding his name to his sheet, he bestowed on the theme the prestige of his own personal identity and his professional standing as an engraver of international renown. His two strips feature thirty-six figures in rows with a couplet beneath each figure. Standing or striding across a common and generic landscape, these thumbnail figures (fifteen of whom are women bearing astonishing burdens on their heads) sell apples, broadsheets, hats, fowl, chairs and so on.

Around 1590 an anonymous draughtsman published a broadsheet of London Cries, which bears no title but which I shall name 'The Bellman of London' (fig. 7) after its large central figure showing the watch along with his dog, pike, lantern and bell. With its thirty-seven tiny, gesticulating figures and its affinities in form and content with the Cologne image, this sheet may have come from a Hogenberg workshop established in England (Franz was probably in England for a short time in the 1560s, and his brother Remigius worked in London, certainly from the 1570s until his death in 1588). These two sheets and their several variants show that, by the late sixteenth century, Cries had been established as a category of programmatic art, a popular genre composed of secular topics or themes fluctuating from one artist to another. The chief examples of programmatic art, composed of multiple images adding up to a series, are the Seasons, the Temperaments, the Ages of Man and Four Times of the Day, all existing in thousands of different iterations.

Between the late sixteenth and the early seventeenth centuries, when Rome became the hub of Italy's renewed dominance in the visual arts, the trickle of Cries became a steady stream that expanded and varied. Of the six sets of broadside Cries of Rome appearing around the year 1600, one deserves comment, not for its aesthetic merit, but because it is a plagiarism of Ambrosius Brambilla's *Portraits of Those who Sell and Work in Rome* (fig. 8), an encyclopedia of Roman street sellers in 1582. Bearing the same title as Brambilla's sheet, this anonymous image demonstrates that a cut-throat market existed for Cries in Italy, even when it offered recycled

iconography. More importantly, it demonstrates that Cries had entered into a mode of self-propagation, a landmark development. In the creation of any programmatic theme in art, the first step in the process of bringing into being a history and a tradition is slavish imitation, leading to the second: inventive, complex and original creations.

Such invention and creativity was the achievement of three Continental artists of repute, whose remarkable images established Cries as a cardinal theme in the history of fine printmaking: Annibale Carracci in Italy; Abraham Bosse in France; and Marcellus Laroon in England, who had emigrated from Holland to settle in London around the time of Charles II's Restoration, which was accompanied by the false promise of revived artistic patronage. Annibale Carracci's (1560–1609) *Trades of Bologna*, first cut by Simon Guillain, was published in 1646 as eighty etchings after pen drawings (c.1580–90), mostly now lost. Carracci, one of the most gifted artists of his time, disliked formally posed portraits, favouring instead casual likenesses of anonymous individuals, such as in the portrait of his street cleaner (fig. 3). The figure's face is obscured as he stoops to pick up the filth on the pavement; the same stoop produces the contorted pose of his body. This intricate attitude suggests that Carracci drew this figure and others like it to hone his technical skills and master the art of depicting the human form, shown in action and half-naked even as it reflects the artist's observation of daily work in its physical and social milieus.

Abraham Bosse (1604–1676), one of seventeenth-century France's most celebrated etchers, created ('in et fc') twelve plates of the 'Cries of Paris', published mid-century (c.1640–50). In contrast to Carracci's informal poses, which border on the undignified, Bosse's rat-catcher (fig. 9) dresses as a gentleman and adopts a prideful stance, though he himself is a maimed figure, with a wooden box of poison. He is draped in rats, some dead and some living; the lively vermin suggest that he is as likely to infest as to rid a locality. The text, in contrasting his hyperbolic past to his degraded present, suggests that the figure may be a satire of the Spanish gentleman's vanity: 'A nobleman who made the entire earth tremble in war, due to a misfortune of battle, now cries death to rats.' Though the 'gentleman's' ruff is old and out of fashion and his trousers are torn, he affects a certain elegance or pretension, which is accentuated by his great sword. The artist's naturalism and precision pay special attention to the figure's dress (Bosse's father was a tailor).

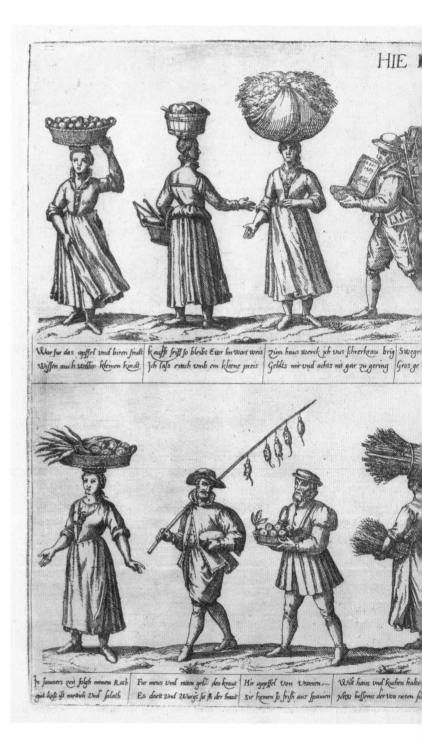

right and overleaf
6. This influential image inspired Cries in large single sheets showing hawkers from cities across Europe, including Rome and London. Franz Hogenberg, 'Cries of Cologne', 1589.

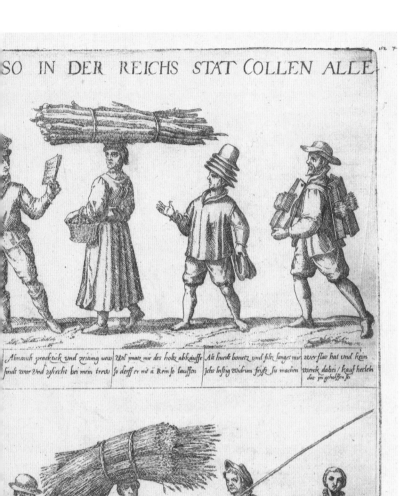

Almanah practick vnd zeitung new | Vnd iman mir des holz abkauffe | Alt huedt bonetz vnd filz langet mir | wer flas hat vnd kein
sindt war Vnd zsrecht bei mein trew | so derff er mit a Rein so lauffen | ichs lustig Widrum fryss zu machen | werck dabei / kauf heelen
| | | das jm geholffen sei

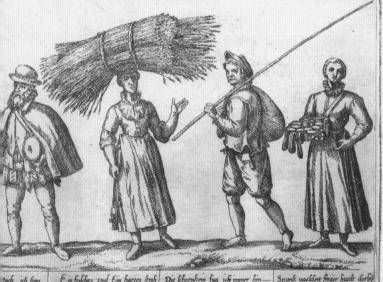

Juch vb han | Ein frisches vnd Ein hartes stroh | Die schornstein fug ich immer hin | Spanß waeldem finger huedt darby
schreiben kan | Es dient Jm beth vnd ander stuw | Vnd gern de Winters vorbors bin | Vnd noch mehr ander kremerey

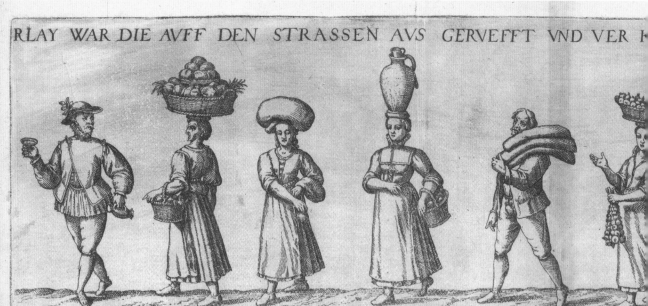

Ein frischen Wein von guter art | Gelt Cappes vnd morre sie sindt frisch | Gut weissen mehl thuts mir versuche | Ein kuhle milch von guter art wer | So bring ich vns den silber sant | Kaufft vll
Den sindt jr vf dem altemart | Vnd kumme Euch wol vf den disch | Jn weissem brei vnd pannekuchn | wer sie begert der gelde ein qwart | haus maegden wol bekant | zu vil ding

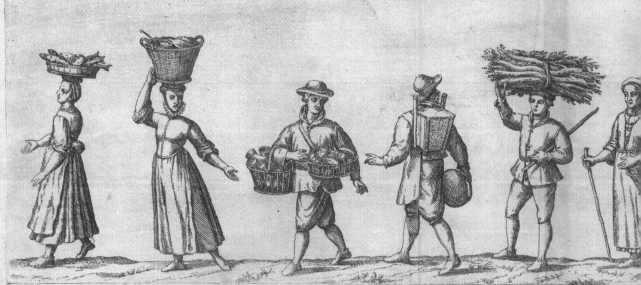

Gut Rein fisch Vnd auch bocknig hab | Ein dicke milch vnd dar zu suess | Ich seh gern das man in den zechen | Geschuh vnd nder zu klippe klappe | Hie kum ich juger bawersman stoltz | Den b
wer erbegert der geld mirs ab | Kaufft sr rs ist ein got gemuss | Vil romer vnd glaser thu zerbrechen | Vnd such mir alte kessel zu lappen | Vnd bring vns güt Wreckholder holtz | jm su

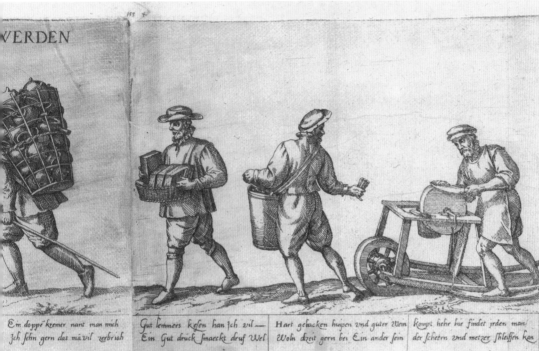

Em doppr kremer nant man mich
Jch sehn gern das mã vil zerbriah

Gut lemmers kesen han jch vil
Ein Gut druck smaeckt druf Wel

Hart gebacken huspen vnd guter Wein
Woln dreit gern bei Ein ander sein

komst hehr hie findet jeden man
der scheten vnd metzer schleiffen kan

...cht So bring jk hie Wellstowr enthauwen
Sehr gewieglich stuel fur meod vns frauwe

Wer alt schin hat vnd brucht sie nit
Verkaufft mirs Jch Weis Rath damit

Sucht jmantz Wein Vnd beir krannen
grosen Vnd kleinen Gut kauf sol Er dar an gerack

Allerhant schlusselbaudt vnd ketten
kan jch EWch Vmb Ein klein beyseten

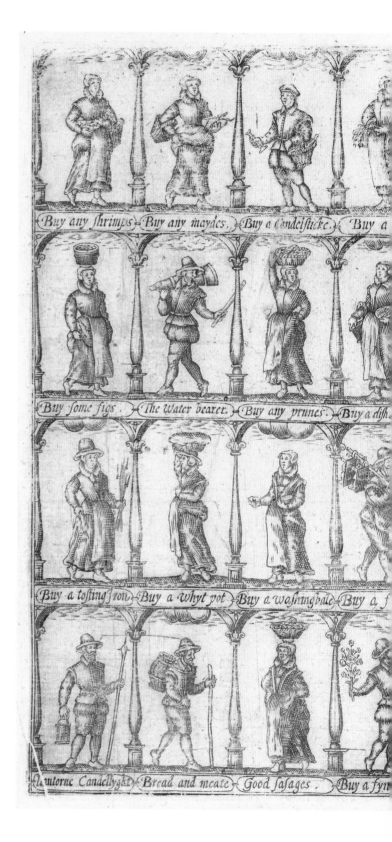

Buy any shrimps • Buy any maydes. • Buy a Candelsticke • Buy a

Buy some figs • The Water bearer. • Buy any prunes • Buy a dish.

Buy a tosting Iron • Buy a whyt pot • Buy a washingbale • Buy a f

Lantorne Candellyght • Bread and meate • Good Sasages. • Buy a fyn

7. One of the earliest London Cries, this sheet testifies to the vitality of domestic and foreign trade in England's capital at the end of the 1500s. Anonymous, 'The Bellman of London'.

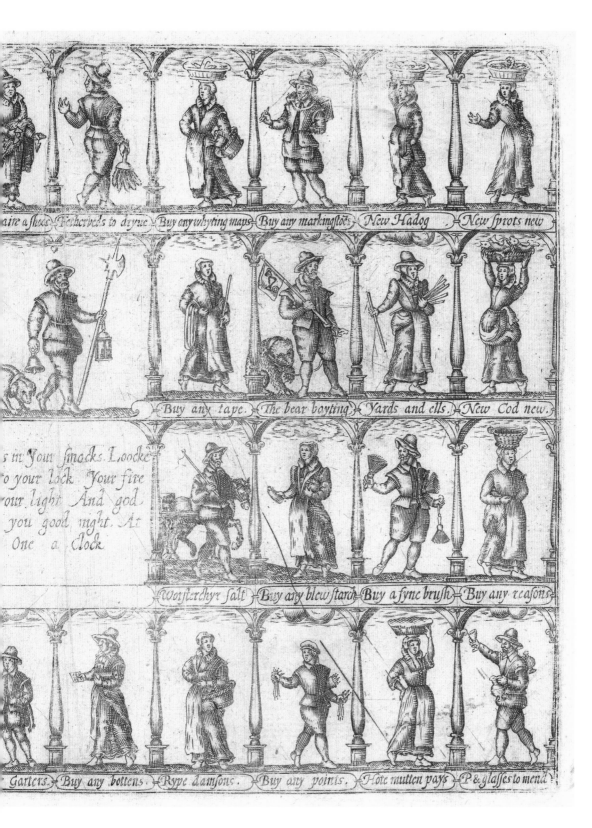

aire a shoes · Fisherbeds to dryue · Buy any whyting maps · Buy any markingstocks · New Hadog · New sprots new

· Buy any tape. · The bear boyting · Yards and ells. · New Cod new.

s in Your smocks Loocke
o your lock Your fire
our light And god
you good night. At
One a Clock

Worsterchyr salt · Buy any blew starch · Buy a fyne brush · Buy any reasons

Garters · Buy any bottens · Rype damsons · Buy any points · Hote mutten pays · P & glasses to mend

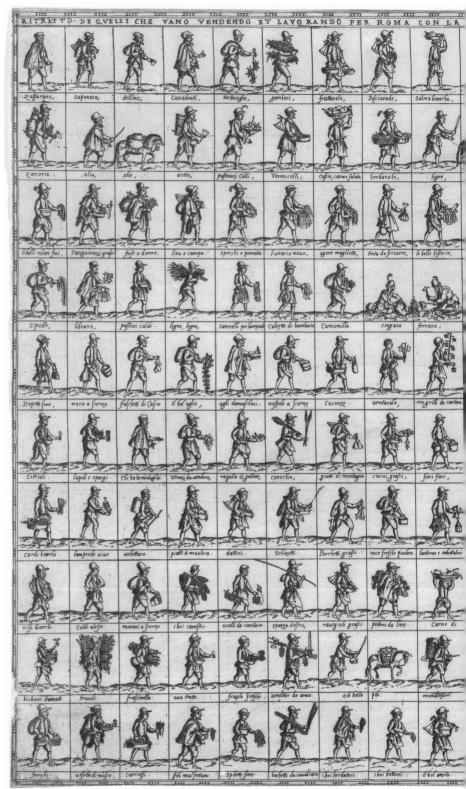

8. Brambilla's immense sheet is an encyclopedia of those who sold and worked in the streets of Rome c.1582, all of whom are men. Ambrosius Brambilla, *Portraits of Those who Sell and Work in Rome*, 1582.

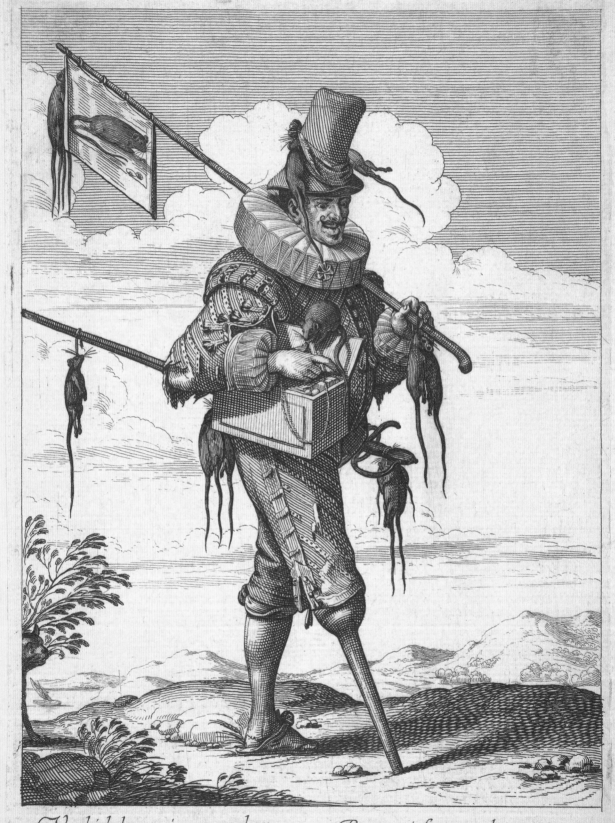

Vn hidalgo qui aux combats Par vn infortune de guerre.

Faisoit trembler toute la terre. Va criant de la mort aux rats.

Bosse in. et fe. le Blond excud auec Priuilege.

Although Marcellus Laroon was a painter, draughtsman and printmaker, his most regular employment in the 1680s when he drew the sketches for his *Cryes of London* was as a drapery painter. But he was also adept at pairing, sequencing, captioning and structuring his own art. These skills served him well when he turned to his *Cryes of London* (1687), though it was his talent as a costume artist that served him best. The care and detail he devoted to the dress of the outcast appears in his 'Four for Six pence Mackrell' (p. 160). The fishwife's bulky, layered clothing suggests that she is wearing all the garments she owns. Her man's coat, which does not button in the front and is too big for her, is tattered, torn and endlessly patched. She has lost her right eye, perhaps in an accident – more likely a fight. But she has preserved her voice with which she utters her cry vigorously. She is not an ambulant hawker because of her age and infirmity; indeed, she stands only with the aid of a stick. Though impoverished, she is not homeless, for the key to her dwelling hangs by her side, just below her purse. The powerful naturalism of Laroon's figures argues against allegorical or moral readings in the case of most images. That said, the mackerel seller evokes emblems of old age and of Lent, when mackerel was most in demand. She carries a single fish at her side, having none of the grace of Bosse's mongers, whose pieman offers pastries to his customers on a plate, exhibiting a class deference and elegance of gesture more common to the dining room than the hurly-burly streets of seventeenth-century Paris.

The proliferation of Cries for European cities

Cries were imagined, by the artists who created them and the audiences who bought them, as an indigenous genre specific not only to different countries but even to different cities. Among other things, they were mementoes of the grand tours and forms of armchair travel aimed at stay-at-home tourists or seekers of the authentic, the nostalgic and especially the picturesque, including picturesque poverty. In its search for the intriguingly foreign, Cries were also regarded as ethnographic: old clothes sellers were Jews; potato vendors were Irish; and rhubarb hawkers were Turks. These assumptions were to some extent plausible: London did not have street vendors of wine, but Paris and Bologna did. London had vendors selling meat (offal) for cats and dogs, hot cross buns and Yorkshire cakes but no Continental city did.

9. This proud 'merchant of dead rats' also carries living vermin and is as likely to infest as cleanse. Abraham Bosse, 'Rat Catcher', c.1650.

London Cries and their buyers from the Renaissance to the Victorian age

From the 240 sets of Cries published between 1580 and 1900, I shall describe, chronicle and illustrate two large categories of works based on their common importance to the tradition of Cries. The first category is composed of broadsheets (or broadsides). Executed by anonymous foreign and domestic craftsmen, they are few in number and vary only slightly one from another. The second category is made up of ensembles produced by artists who signed their work. These are numerous, and exhibit dramatic variations in form and subject matter. Predictably, ensembles and broadsheets were bought by very different groups of people.

Broadsheets

Broadsheet (single-sheet) images are of unique importance in the history of London Cries because they initiated the genre. Among the least expensive of all popular images, the earliest were published in the late sixteenth century and were followed by mid-seventeenth-century pot sheets by Peter Stent, who ran one of the earliest printmaking shops in London. Measuring about 180 mm by 270 mm, these sheets are surprisingly similar in form and content. On them, thirty-seven or so tiny hawkers appear, sequestered within honeycombed niches that evoke, perhaps deliberately, the architecture of the London Royal Exchange. The isolation and order in which they appear in these arcades are at odds with hawkers' behaviour in Lupton's narrative, which depicts their lives as communal and chaotic. Typified by 'The Bellman of London' (fig. 7), these sheets classify, rationalize and map London's shopping scene with its pandemonium and anarchy. They offer a rigidly ordered procession of men and women, young and old, sellers of services such as the bear baiter and hawkers of foodstuffs such as 'Worsterchyr' salt.

Since mapping and classification are the first steps in social regulation, the sheets control, symbolically, London's masterless men and women, a class of people that was especially feared when London's population grew so suddenly. But the sheets are also revelations of the mass consumption that turned London into a gallimaufry 'where men like Ants / Toyle to prevent imaginary wants'.[17] An unpublished and undated poem in the

Madden Collection of ballads at Cambridge University Library, titled 'The Cries of London' and probably sung by its sellers, offers a useful literary analogue to these early broadsides:

> Here's cucumbers, Spinage, and French beans
> Come buy my nice Sallery.
> Here's parsnips and fine leeks.
> Come buy my potatoes, ho!
> Come buy my plumbs and fine ripe plumbs.
> A groat a pound ripe filberts, ho!

Unremarkable today, these literary and visual catalogues provoked a desire for the goods on sale by exploring 'with a Traveller's Eye, all the Remarkable Things of this Mighty City', with 'more New Countries, and surprizing Singularities, than in all the Universe besides'.[18]

Broadsheet Cries flourished from the late sixteenth century to the late seventeenth century. Some twelve rare sheets have survived from this epoch, but the incomplete state of some and the mutilated condition of others suggest that most did not survive the hard use they met. Unlike printed ballads such as the Madden example, which cost a halfpenny or a penny, these illustrated sheets went for sixpence, two thirds of a day's wages for a labourer in the building trades. Such labourers, if they could read, were more likely to buy a printed broadside for a copper, promising 'all the Newes in England, of Murders, Flouds, Witches, Fires, Tempests, and what not'.[19]

Lawyers, clerics, professional people like doctors, well-off householders and bureaucrats such as Samuel Pepys bought the first Cries, and so too did Pepys's French counterpart, Nicolas Boucot, whose collection included multiple Cris de Paris in sheets. Robert Walton, an early London printseller, stocked Cries which he sold with maps and allegories of the seasons, the senses and the elements. In an advertisement entitled 'The names of several Maps and Prints, that are Printed, Coloured, and sold by the said Robert Walton', he recommended these prints 'as a most commodious ornament for every man's house, and therefore you may either have it in paper coloured or not, or else on cloth'.[20] Alehouse keepers and coffee shop proprietors also bought such sheets, using the images to draw customers to London's 'penny universities'. John Gay recounts that, in the eateries and public houses along London's Arundel

Street, there 'Now hangs the Bell-man's Song, and pasted here, / The colour'd Prints of *Overton* appear'.[21]

The very first Cries, despite their novelty, were simple, repetitive, difficult to decipher and lacking in aesthetic allure. They did however acquire greater complexity and appeal as their production increased, which 'The Manner of Crying Things in London' (c.1640) shows (fig. 10). This depicts sixteen designs on each of two tall sheets, only one of which has survived intact. It was still selling a hundred years later when, in 1759, William Herbert offered an entirely recut version at the sign of the Golden Globe under the piazzas on London Bridge. Alternating men and women, it evokes with vividness and precision the street hawkers of Stuart London, especially with respect to poses, costumes and faces. Every face is carefully differentiated, while hawkers' goods such as the onion seller's and the screen seller's are depicted in arresting geometries. The cheese and cream seller is a figure of eye-opening elegance: her kerchief is fringed in decorative lace and her turned-up cuffs are ornamented with matching borders.

When broadside Cries debuted, the English print market was not divided into elite and popular; different social classes, to wit, elites and at least the broad urban middle classes, patronized the few printsellers active in London. Or perhaps they bought them from the ateliers of their engravers, which they had to seek out – but this is speculation. Neither 'The Bellman of London' (fig. 7) nor 'The Common Cryes of London' (fig. 11), a rival sheet engraved by a less practised English hand, bore publication lines indicating where the sheets could be bought. A subsequent state of the latter retitled 'Parte of the Criers of London', the first example of the genre in England to bear the canonical title 'Cryes', announced that it was 'Printed and Sold by I Overton at the white Horse over against St. pulkers by newgat'.[22] Overton's clients included connoisseurs, but they constituted a small share of the market for Cries. Less prosperous customers bought most of these sheets, which explains why so few have survived.

Broadside Cries declined dramatically towards the end of the seventeenth century, and in the eighteenth century they virtually vanished. During the nineteenth century, however, a small number reappeared (of which I have recorded eight in all), a few of which were political. One of the most noteworthy is William Heath's 'Public Characters', a miscellany of people from London's streets (fig. 12). Aggregating street celebrities and hawkers such as the old clothes vendor

10. The title of these two sheets comes from a handwritten inscription on an early copy; the sheets pay special attention to hawkers' tools of trade and what they vend. Anonymous, 'The Manner of Crying Things in London', first printed c.1640.

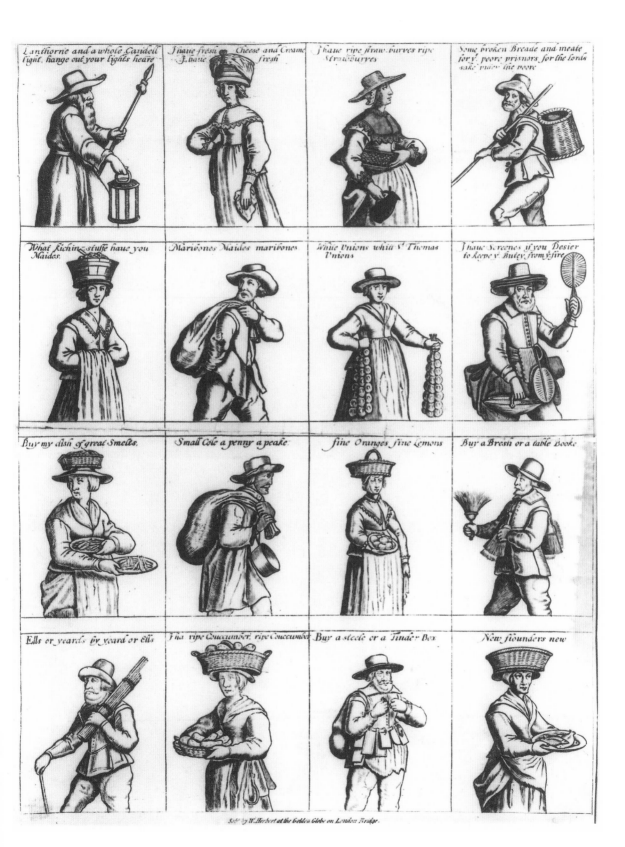

Lanthorne and a whole Candell light, hange out your lights heare

I haue fresh Cheese and Creame I haue fresh

I haue ripe straw.burues ripe Strawburues

Some broken Breade and meate for y.e poore prisners, for the lords sake rmew the poore

What fichin stuffe haue you Maides.

Mariwones Maides mariwones

White Vnions whit S.t Thomas Vnions

I haue Screenes if you Desier to keepe y.e Butey from y.e fire

Buy my dish of great Smelts.

Small Cole a penny a peake.

fine Oranges fine Lemons

Buy a Bresh or a table Booke

Ells or yeards by yeard or ells

I ha ripe Coucumber. ripe Coucumber

Buy a steele or a Tinder Box

New flounders new

Sold by W. Herbert at the Golden Globe on London Bridge.

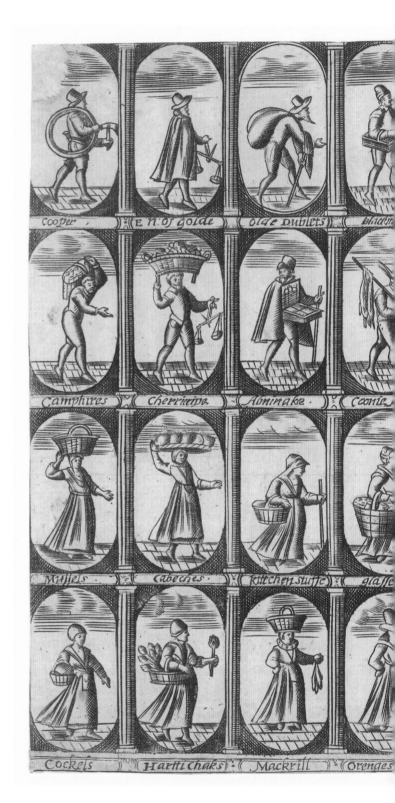

11. Two different states of this sheet exist: one shows rat-catchers in the large central panel and the other a figure crying 'Buy a new Book'. Anonymous, 'The Common Cryes of London', c.1660.

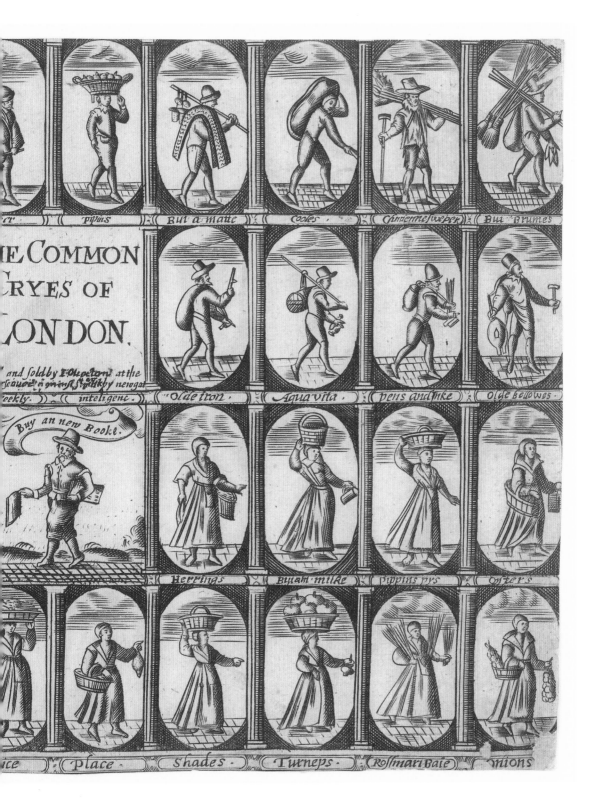

12. Detail from an early version of London's diverse population
from England's disunited kingdom. The image suggests that
hawkers commonly came from places other than London.
William Heath, 'Public Characters', 1827.

and various street musicians, the full print also features a giant, a dwarf, a Scot and an African. Its tone is one of good-humoured (and early) satire on the topic of England's disunited kingdom.

Suites of Cries

After the Restoration of Charles II, when prints from the Continent began to flood into England, and dealers such as Arthur Tooker offered 'Italian, German, and the Low Countery Prints' ... 'useful for Gentlemen, Artists, and Gentlewomen, and School-mistresses', broadside images seemed coarse and mechanical to collectors and cognoscenti.[23] Having lost their appeal to the broad middle classes and literati, they came to be regarded as they are today by connoisseurs such as Richard Godfrey, whose *Printmaking in Britain* relegates them to 'the crude woodcut purchased from a street-hawker's basket'. In his view these images are 'best passed over in discreet silence' – a form of social snobbery and condescension that is misapplied to the serious study of popular and mass images like Cries but that still thrives among connoisseurial art historians.[24]

 With the advent of dealers like Tooker, John Overton and Pierce Tempest, a new class of buyers and collectors entered the print market. These *virtuosi* or *amateurs* were men (women bought chiefly children's Cries) and wealthy bibliophiles seeking images that were more naturalistic and aesthetically complex than earlier sheets. Their requirements were catered for by a second coterie of immigrant artists who created innovative Cries in ensembles employing a style of draughtsmanship based on direct observation, which Henry Peacham described as 'cut to the life, a thing practised but of late yeares'.[25]

 These suites contain as few as four images or as many as a hundred. They are the original designs of artists who were not lowly engravers, though these craftsmen may have engraved the copperplates based on such originals, but rather were artists who were renowned nationally or internationally. These Cries show the formal training of their creators who exhibit, in their work, the traditions and practices of artists who had preceded them. Their most dramatic innovation is their enlarged scale, which expresses the new importance of their subject matter while responding to what William Ivins calls 'the informational pressure' on prints, that is, the escalating imperative to cram more information into the

same space.[26] Pot sheets previously allotted to thirty-seven hawkers now feature a single vendor.

The first such suite of London Cries to appear was *The Cryes of the City of London Drawne after the Life*, published in 1687 by the bookseller Pierce Tempest, who laid out about £200 for the copper alone, not including the cost of engraving and paper. No copy of this first edition survives and no record of how many plates it contained exists. However, the many different editions and transformations the book went through are known in rough outline if not in granular detail. The ensemble grew from a volume of forty plates in 1688 to seventy-four plates in 1689. It passed into the hands of Henry Overton in about 1711, then to Robert Sayer who issued a newly refurbished edition in 1760. Finally, R.H. Laurie bought the plates and issued the last edition from the original coppers in 1821.

One of the very earliest copies, now in the Senate House Library (University of London), tells us something about the new suite's audience. That copy was the gift of the volume's chief engraver, John Savage, who presented it to John Mill with this elaborate inscription: 'To John Mill Esq In acknowledgement of those many Favours received from your Father & Grandfath. this Book is Humbly Presented by Your most humble Servant & Kinsman John Savage'. But this gift copy is not a common version of Laroon's *Cryes*.[27] Four of the prints are artist's proofs pulled off and bound into this presentation copy, giving it a special cachet. The second title page appears in an early state, before 'Cum Privilegio' had been added. 'Oliver C: Porter' is in a state before diagonal hatching over the vertical shading on his coat. And 'Frater Mendicans' is in a state showing the title as 'The Spanish Fryar' and before 'MLaroon delin:' and 'PTempest ex:' were cut to compose the publication line. The presence of these states indicates that there was a thirst for rare and unique impressions that offer an insight into art's processes among sophisticated print collectors as early as 1687.

Just as the first broadsides were bought by several different classes, so too Laroon's *Cryes* was purchased by different groups of buyers, three of which can be identified. A note in the Sterling Library's volume records that John Mill was 'the eldest son of the 3rd Baronet of that name, whom he succeeded as the 4th Baronet in 1697'. Mill represents aristocrats and gentry, one of three different classes patronizing *The Cryes of the City of London*. Among this class is the 1st duke of Marlborough who acquired forty-nine of Laroon's original drawings the artist had passed on to his

son Marcellus. The latter became a soldier and served under the command of the duke of Marlborough, to whom he likely sold his father's drawings. They were preserved in an album with the misleading title 'SCRAP BOOK' stamped on its spine, which lay in Blenheim Palace's Long Library until 1981 when it was discovered by Sotheby's during a routine evaluation. The drawings were correctly attributed to Laroon by Dr Celina Fox.

A second class of buyers is surprisingly homogeneous: they cultivated politics and the arts; were intellectuals, bibliophiles and writers; had university educations (two went to Cambridge) except for Defoe; and were deeply tied to London. Samuel Pepys, Narcissus Luttrell, Joseph Addison, Daniel Defoe and Zacharias Conrad von Uffenbach all owned copies of the *Cryes*. (Von Uffenbach also represents another large category of buyers: men on the Grand Tour.) All were wealthy; in Defoe's sevenfold division of social prosperity, they belonged to 'the Rich who live very plentifully'. Based on their keen interest in London, all paid half a guinea for Laroon's prints because they enjoyed their subject matter, as reflected in the way Pepys interacted with the book, carefully recording the names of certain hawkers in his copy.

A third class of buyers purchased Laroon's *Cryes* not for their subject matter but for their form. To promote his own *Cryes* Tempest advertised them in the *London Gazette*, where he described his ensemble as 'fit for the Ingenious and Lovers of Art'. Who were these 'Ingenious and Lovers of Art' solicited by Tempest in the *Gazette*? Just as Annibale Carracci's *Trades of Bologna* had been bought by artists viewing them not as low-life subjects but as life studies appealing to draughtsmen, so too Laroon's *Cryes* was purchased by both amateur and professional artists acquiring them as academic figures and aides-memoires to assist them in copying the human figure in its various poses. Carracci's and Laroon's Cries acted as primers and manuals guiding the aesthetic education of young people aspiring to become painters, amateur or professional. But they were also pedagogical instruments shaping the taste of patrons. And finally they were prompt books for virtuosi who wished to acquire a connoisseur's dexterity as amateur artists like the Count de Caylus, a talented printmaker, who, with Etienne Fessard, etched Bouchardon's *Cries of Paris*.[28] One person who had purchased Laroon's *Cryes* for that purpose preserved the fruits of his labours. Ebenezer Taylor honed his skills as a draughtsman by laboriously copying sixty-two of Laroon's images in pen and ink onto sheets he bound together into a volume which he signed with his own name. His

images are preserved in the Deering Rare Book Room at Northwestern University, Evanston, Illinois.

Laroon's audience was also attracted by his style of drawing, combining naturalism with a subtle romantic aestheticism. It is illustrated in his 'Merry new Song' (p. 104), which is representative of his style in its treatment of the two ballad sellers' dress and the personal tie linking them. The business of selling ballads was neither a respectable nor a lucrative trade. Such hawkers were believed to augment their income by drawing large audiences for thieving confederates to rob. And their income from ballads going for a halfpenny or a penny was never great. Samuel Curwen, an American sitting out his country's revolution in England, met

> a man [in Bath] whose haggard looks, and tattered garment denoted [a] variety of wretchedness, having a long squalid grisly beard, his face dirty and wrinkled, his hair through which, in appearance, a comb had not passed for many years, his garment of every possible colour and shade, each piece of the bigness of ones palm tackt together by thread of a different colour and in stretches ½ as long as ones thumb, the length of this partly coloured garment scarce down to his knees.

The fellow, whose name was Selby, earned 'a wretched livelihood by begging and selling ballads'.[29]

Unlike Selby, Laroon's songsters are prosperous, from the evidence of their dress. The man wears a fashionable coat with side- and back-buttoned vents and falling cuffs called hound's ears. The woman sports a lace kerchief, fringed sleeves and elegant, full-length gloves. Her shoes have large fashionable bows. The couple sing and dance, interlacing their hands expressively in a theatricalization that is remote from street selling. They exude financial ease and conjugal harmony.

About 1760, Robert Sayer, who had acquired the copperplates of Laroon's *Cryes*, proposed to reissue them serially in six parts 'with additions & Improvements' by Simon François Ravenet. This project would have represented a triple outrage to the chauvinistic Paul Sandby, then an aspiring Englishman making his way in London's fractious art market. First, Sayer was reissuing a set of images created by a foreign artist (Laroon) who, in Sandby's view, knew little about English life and who had romanticized hawkers shamelessly in order to sell prints. Second, the

Rare. Mackarel Three a Groat
Or Four for Sixpence

Maquereaux, Maquereaux Monsieur
Madame en voulez vous des Maquereaux

newly proposed volume offered 'additions & Improvements' by another foreigner who, again in Sandby's view, was every bit as ignorant of English life and a more shameless romanticizer than Laroon. Finally, these new French designs were to be engraved by a third foreigner, the Parisian Louis Peter Boitard. Not a single Englishman was involved.

To challenge Sayer's scheme, with its French cast, Sandby undertook to create his own ambitious set of English Cries with their own unique innovations shaped by his astringent English empiricism. That Sandby also meant to target Laroon's originals is apparent from the fact that in 'Four for sixpence Mackerel' (fig. 13) he copied in part the price of the fish sold by Laroon's monger (p. 160). Sandby's path to creating his rival Cries is instructive. In the wake of Scotland's 1745 rebellion, Sandby was hired and trained as a surveyor by the Military Drawing Department of Ordnance which assigned him to map the north and west Highlands for the purposes of subjugation and pacification. There he also mapped Scotland's natives, particularly their marginal types and street hawkers. Returning to London in 1752, he turned to the capital's 'primitives', drawing about a hundred hawkers' likenesses. These he planned to etch himself and to sell serially, following Sayer's marketing strategy.

The bleak tone and content of Sandby's watercolours may be gleaned from his 'Last Dying Speech' (fig. 14), his riposte to Laroon's 'Merry new Song' (p. 104). Sandby's first innovation is his use of colour, which gives his image a quite unprecedented vividness and gritty realism. Equally innovative is the link between the man and woman ballad sellers. For, while Laroon's songsters sing and dance together in harmony, Sandby's duo work apart, doubling the size of their audiences. This selling strategy reveals the marketing shrewdness of seasoned, real-life ballad hawkers. Instead of dancing, Sandby's woman plants both feet on the ground and bawls aloud, using her hand to amplify and direct her voice.

But the difference between the two women's clothing is even more dramatic than their postures. Sandby's ballad seller wears the remains of a coat or cloak on her back. Her bodice is a wrap tied with a string, and her skirt and apron are tattered, rotting rags. Her left shoe is tied with a twig, and her stockings are wrinkled and filthy. She reeks on the page. But Sandby's most significant innovation is his setting: unlike Laroon, who depicts his hawkers floating in white space, Sandby delineates the spot where the two sellers vend their ballads. With true-to-life shrewdness, this Hogarthian couple operate where the call for their last dying speech is

13. Sandby's fishwife is a satire on rival artists' anodyne depictions of earlier fishwives and an attack on the aggressive practices of contemporary hawkers. Paul Sandby, 'Rare Mackerel, three a groat or four for sixpence', 1760.

loudest – at a public execution, where they work with brisk indifference to the literal death of their author.

Sandby etched a selection of his watercolours, publishing them as *Twelve London Cries done from the Life by P. Sandby*, and using on his title page the same figure as Sayer: a street performer operating a peep show. Though 'Last Dying Speech' was not among the subjects, those he did etch also offer a darker view of hawkers than that of any artist of London Cries before him, depicting them as criminals, rogues, scoundrels, even murderers. Selling for three shillings the set, they were bought by the upper middle classes (Sir Joseph Banks, Maria Walpole and her uncle Horace all owned copies). However, their grim mood meant that they did not sell widely or well, and Sandby abandoned the plan to serialize his inventive, vigorous watercolours.

The lesson of Sandby's pungent failures was not lost on Francis Wheatley, and the naturalism versus romanticism debate that Sandby argued with Laroon and his French 'improvers' was reprised by Wheatley and Thomas Rowlandson. A landscape, portrait and figure painter of popularity, Francis Wheatley (1747–1801) was nonetheless chronically short of money and even pawned his diploma for twenty-two pounds in 1797. He lost his house and its contents to his creditors in 1793 when his 'habits of expense became too unbounded for his means', prompting him to turn to Cries.[30] Between 1792 and 1795 he exhibited his *Itinerant Trades of London*, fourteen small oils, at the Royal Academy.[31] The appearance of Cries on the walls of the Royal Academy, a remarkable apotheosis for a popular theme, indicates the genre's rise in status from ephemeral broadsides tacked upon tavern walls to oil paintings hung in England's premier exhibition space. The paintings were sold to Colnaghi, the dealer and print publisher, who had them engraved in the fashionable and decorative stipple technique and often printed in colour. These remained popular, and expensive, until the crash of the late 1920s. They bore English and French titles and sold for fifteen shillings coloured and seven and sixpence plain.

Wheatley's images, promoted as 'advances on the "old" subject of the Cries of London' and sometimes disdained as furniture pictures, are not a reply to Sandby's mordant images, though they certainly are antithetical. By 'advances' Colnaghi argues that Wheatley's Cries introduces itinerant tradesmen in the midst of small groups of buyers, representing them as 'subservient to humourous incident'. More specifically, Wheatley's signal

14. 'Last Dying Speech' shows two shrewd ballad sellers hawking their wares where they were most in demand: at their putative author's execution. It also exposes the romanticism of Laroon's 'A Merry new Song' (see p. 104). Paul Sandby, 'Last Dying Speech', c.1759.

innovation is that he includes a loose collection of hawkers' customers and bystanders in his designs, representing London as a city in which rich buyers and poor sellers mingle harmoniously. His ballad seller hawking a romantic 'New Love Song' (fig. 15) stands in pointed contrast to Sandby's 'Last Dying Speech', in which hangings occur in the background. The former features a well-dressed lady and her beautiful child, a boy, benevolently feeding a dog. Nearby are three customers to whom the hawker curtsies deferentially. She herself is dressed in a style of modest prosperity, wearing a bonnet with a ribbon, a shawl with a hood and a long white dress in fine repair. The painter Edward Edwards, Wheatley's contemporary, remarked that in *Itinerant Trades* 'the women are dressed with great smartness, but little propriety, better suited to the fantastic taste of an Italian opera stage than to the streets of London'.[32] The ballad seller is moderately prosperous in contrast to her poor customers; the fellow buying her ballads has a large rip in his greatcoat. Smaller than her in stature (size in relation to others indicating social standing), he and his companion are also her inferiors, as indicated by their clumsy poses and improper stare (at her bosom?). Their countrified awkwardness and her social poise reverse the usual pattern in Cries in which prosperous, elegant customers condescend to penniless clients. Of Wheatley's thirteen hawkers, nine are elegant women, and the four remaining male hawkers are overshadowed by their voluptuous female customers, who are highlighted and foregrounded. The role of this bevy of sentimentalized women, in the penumbra of the French Revolution, was to assure rich buyers that London was a centre of picturesque and harmonious commerce entirely devoid of dangerous types, where different classes, sexes and ages came together in peaceful commerce.

The demand for Wheatley's prints, when they first appeared, was so enormous that it wore out the copperplates, which Colnaghi promptly recut. His was not only the most successful suite of hawkers ever published but 'perhaps the most enduringly popular of all English prints', according to Stephen Calloway's *English Prints for the Collector*.[33] His set of Cries remains so today. However, Wheatley enjoyed popular but not critical success. The art journalist John Williams, under the pseudonym 'Anthony Pasquin', echoed Edward Edwards in writing about the painter's women:

Whenever Mr. Wheatley presents us with a rural Nymph whom he wishes to be peculiarly impressive, he decorates her head with

15. Wheatley's Cries owed their popularity to how they intensified the genre's idealization and romanticism. Wheatley's hawkers show profound deference to their 'betters', and are shaped by the tastes of wealthy clients reacting to the French Revolution. Francis Wheatley, 'New Love Song', *c.*1796.

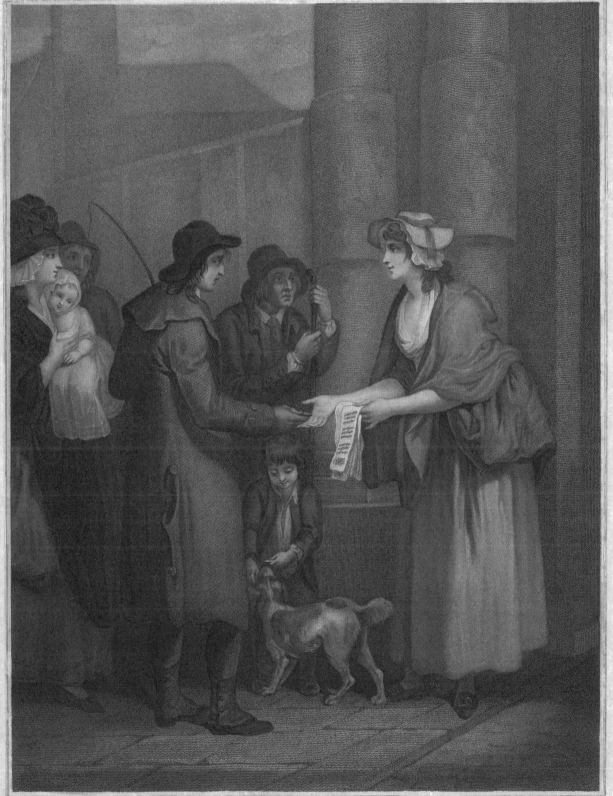

Painted by F. Wheatley R.A. Engrav'd by A. Cardon.

A New Love Song only ha'penny a piece.

CRIES
of
LONDON.
Plate 11.

Chanson nouvelles deux sols le livret.

a profusion of party coloured ribbands, like a maniac in Coventry, which play in the breeze, offensive to thought and propriety. As this is not the character of our village Daphnes, why make them so prodigiously fine at the expence of truth?[34]

The satirist Thomas Rowlandson (1757–1827) took the same view of Wheatley's figures but expressed his opinion in images rather than words. In 1799 he drew eight *London Cries*, from which Rudolph Ackermann issued etchings with aquatint (by Henri Merke) at his gallery in the Strand.

What Rowlandson's figures hawk – filth such as brick dust, vermin such as rats, and cast-offs such as moth-eaten clothes – proclaim his closeness to Sandby and his distance from Wheatley, whose itinerants sell primroses, scarlet strawberries, sweet China oranges and the like. Rowlandson's lyrical-seeming images even have a perversely erotic mood: 'Water Cresses' (fig. 16) depicts a grotesque octogenarian debauchee entering a brothel, watched by two lovely young prostitutes. 'All a growing, a growing, here's flowers for your gardens' shows a leering predator's sexual interest in a sheltered girl from a genteel family. Rowlandson's *Cries*, as 'Water Cresses' shows, are suffused with erotic tension, often between mismatched men and women: old and young, rich and poor, exploiter and exploited.

While Rowlandson's eight images are acerbic and Wheatley's poetic, the former's 'Last dying speech & Confession' (fig. 17) strikes directly at the latter's fancy picture with a similar title. Like Sandby's, Rowlandson's principal figure amplifies her shout against London's pandemonium with her hand, but there all similarities end. Obese, ugly and past her prime, the satirist's itinerant opens her cavernous mouth to bawl her cry as she hawks the speech of a malefactor hanged that morning. The grace of Laroon's two balladeers contrasts with the ungainly posture and maladroit expression of Rowlandson's figure. Her clothes document her destitution; her cloak, dress and apron are eaten away and the upper of her right shoe is rotted to expose her toes. Secondary figures in Rowlandson expand and intensify the themes of his principal characters. The dog that is a mere sentimental decoration in Wheatley's print here howls at the hawker, drowning out her cry and perhaps causing her distress. Behind her, the beautiful mother and child are a foil to her hideous appearance and troubled state, as reflected in her wide-eyed look. Rowlandson's chief innovation in his *Cries* is that he often adds sub-narratives to the main plot. Posters stuck to the wall tell of forgery, which likely characterizes the

16. The title of this image is misleading, as its chief subject is the visit of an aged profligate to a brothel, whose inhabitants observe the street scene at their door, where a hawker embarrasses the women's customer into a purchase only to be rid of her and her importuning child. Thomas Rowlandson, 'Water Cresses', 1799.

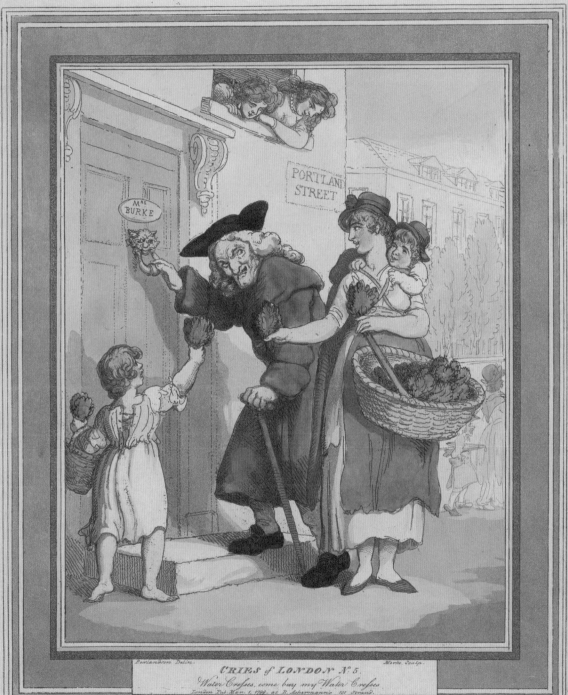

CRIES of LONDON N.º 5.
Water Cresses, come buy my Water Cresses
London Pub. Mar. 1, 1799, at R. Ackermann's 101 Strand.

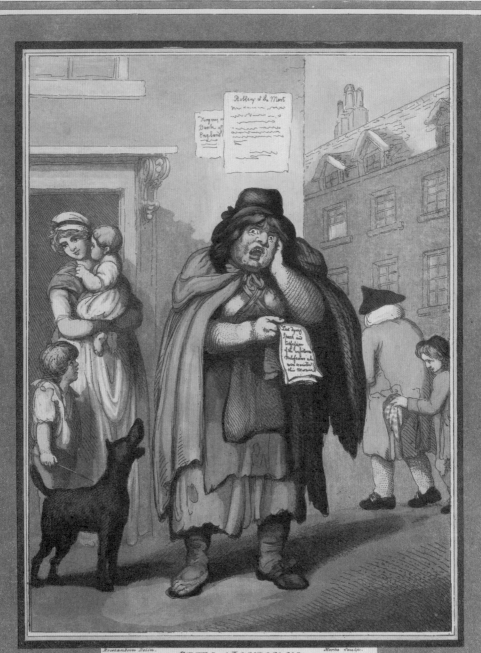

Rowlandson Delin. Merke Sculp.

CRIES of LONDON Nº 3.

Last dying speech & Confession.

London Pub. Feb 20. 1799, at R Ackermann's Gallery 101 Strand.

hawker's ballad, while the news of theft comments on her execution ballad and the boy pilfering the handkerchief of an old man. Is the child the hawker's accomplice?

The period from Laroon's suite in 1687 to Rowlandson's in 1799 was the golden age of London Cries in both form and subject. The most inventive, complex and imaginative designs in the genre appeared during this epoch, the high points being Laroon's *Cryes* and especially Sandby's watercolours; the latter are masterpieces of the genre that have not yet been systematically documented, published or studied. As a group, all these Cries add up to a vital dialogue (or artistic brawl) between foreign and domestic artists about the essential nature of the so-called lower orders. Were hawkers saints or sinners? Were they benevolent street denizens, as Laroon and Wheatley alleged, or crooks, drunks and sexual predators, as Sandby and Rowlandson argued? In cultivating the genre, artists in the nineteenth century created an explosion of Cries that went in many different directions, broadening the theme's reach in several new respects. As greengrocers replaced costermongers and London's population diversified with immigrants, colonists and tourists, artists moved away from hawkers to embrace street characters, city celebrities and denizens. Or they drew eccentrics or characters who had come to London from places as far afield as the New World. John T. Smith's portrait of Joseph Johnson (fig. 18) illustrates a number of these changes in one figure. Johnson is not a hawker but a beggar, holding out his hat in supplication. His eccentricity is shown by his bearing a replica of the ship *The Nelson* on his head, which seems to bob when he nods. He appears to have come from Jamaica. His biography records that he served with the merchant marines until his wounds caused him to be discharged; in this respect he is one of the maimed who haunted London at the end of the Napoleonic Wars.

Word and image in London Cries

Cries, and particularly London Cries, are unique in one important respect: without exception, they unite verbal and visual elements to create unified works of art. In marrying picture and text, they join elements that are often locked in competition and difficult to reconcile or harmonize, not least in that both vie for space and pre-eminence. Across the history of

17. In separate Cries, Sandby (fig. 14) and Rowlandson both attacked Laroon's lyrical 'Merry new Song'. Here Rowlandson plays on the contrast between the beautiful young mother and the grotesque hawkers with the larcenous child. Thomas Rowlandson, 'Last dying speech & Confession', 1799.

Cries, this marriage began in the first broadsheets, where images assumed a dominant role while texts appeared to play cameo parts. That balance of power shifted in the course of the late eighteenth century and later, when texts ultimately predominated over and cannibalized images, effecting a metamorphosis that contributed to the demise of the genre.

In early broadsides, where they are so tiny that they can be difficult to read, the words sit above or below the images they explicate, and serve simple, declaratory functions, giving a voice to vendors. Documentary in mood, the legends in 'Parte of the Criers of London' (c.1660s) are the simplest and least complicated, consisting of a single word or two and drawing attention to the vendors' merchandise, chiefly foodstuffs. Most of these comestibles are sold by women marching energetically to the right: their provisions are 'HarttiChaks', 'Mackrill', 'Cherrieripe', 'Orenges Lemens' and more. The captions of 'The Bellman of London', by contrast, are short, hortatory sentences ('Buy a purs'): they name vendors' goods or services ('Fetherbeds to dryue'), and often they tout the virtues of sellers' goods as incentives to shop ('Buy a fyne Bowpot'). This hortatory aspect reaches its zenith in a rudimentary advertisement in *The Common Cryes* where the hawker in the centre panel urges viewers to 'Buy an new Booke', and conveniently provides the name and address of the bookseller and of the broadside itself; he is 'J[ohn] Overton', his sign is the White Horse, and his location is 'by Newgate'. In these early sheets, the texts name decencies and luxuries (like 'an new Booke' and the sheet of Cries) but not many necessities. And they highlight 'bellycheer', focusing on prized fruits to eat or snack on, such as figs, strawberries and pippins. Many foodstuffs are imports, for example, lemons, oranges and raisins, which the traveller Fynes Moryson reported were devoured 'in all places, and with all persons in *England*' so that 'the very Greekes that sell them, wonder what we doe with such great quantities thereof, and know not how we should spend them, except we use them for dy[e]ing, or to feede Hogges'. The sober-minded Moryson, alarmed by new practices such as snacking, complained that 'other Nations esteeme us gluttons', and devoutly prayed: 'God deliver mee from meates, that invite to eate beyond hunger.'[35]

All these early legends are terse and cryptic – what exactly does the man crying 'Fetherbeds to dryue' do? Judging by their non-standard spellings (e.g. 'dryue'), the captions are semi-literate commonplaces. While images address the eye, legends address the head. However, they are not as peripheral as their subordinate placement might suggest.

18. Smith's portraits featured not characters but living, breathing people, many of whom would have been known to contemporary Londoners. Smith names them and describes their lives and callings, especially when these are regarded as bizarre, sensational or picturesque. John T. Smith, 'Joseph Johnson', *Cries of London* (19th century).

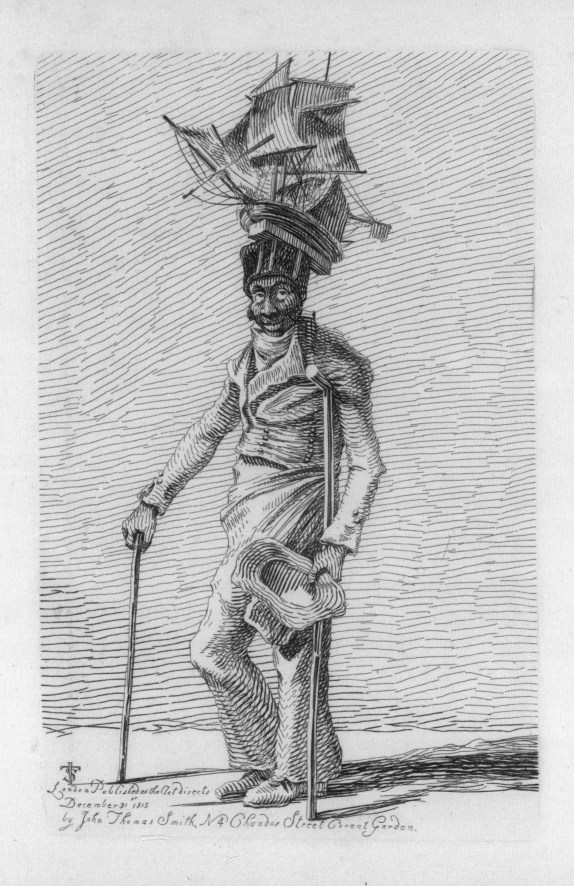

London Published as the Act directs
December 31.st 1815
by John Thomas Smith, N.º 4 Chandos Street Covent Garden.

Though prosaic and spare, they are the force that brings the sheets to life, vivifying them by their systematic annotations. They provide essential interpretations of the images, and compensate for the shortcomings of the sheets' designs and imagery, which lack the aesthetic complexity and sophistication of so-called fine prints such as the etchings of Wenceslaus Hollar, a near contemporary. Without these tiny texts as keys, the hawkers are mere notations, and busy, repetitive notations at that. The texts allow viewers to differentiate the otherwise similar, puzzling hawkers, who, when known, conjure up seventeenth-century London as a horn of plenty bringing treasures and treats to the capital from all over England and even Europe.

Marcellus Laroon's subscripts resemble the banal captions of the first broadsides, whose conventions they follow. Most are terse and factual, not articulations but ejaculations shaped by the shrill, rapid force of the moment.[36] They transcribe hawkers' shouts, momentary utterances otherwise evanescent and lost: 'Old Shooes for Some Broomes'; 'Old Satten Old Taffety or Velvet'; 'Pretty maids, Pretty pins, Pretty women'; 'Crab, Crab any Crab'. Some of these, such as the pin seller's 'Pretty maids', use repetition to evoke an incantatory sense of song or chant which reminds us that certain hawkers sang rather than uttered their cries, which is confirmed by the Grand Tourist from Germany, von Uffenbach. A few offer enticing words, 'pretty', 'ripe' and 'merry'; 'fine' is the most popular allurement. Others provide specific information about the economics of hawking, suggesting that the portraits were indeed 'drawn from the life': 'Lilly white Vinegar 3 pence a quart'; 'Six pence a pound fair Cherryes'; '4 Paire for a Shilling Holland Socks'.

Despite the conventionality of their captions, Laroon's prints introduced two singular innovations to the genre. They record legends in French and Italian as well as English. This innovation was undoubtedly the brainchild of Pierce Tempest, an astute businessman. His intent may have been to give his prints a cosmopolitan patina that would appeal to the snobbery of English collectors. It is unlikely that the publisher imagined selling his prints on the Continent, where there was not much demand for English engravings before 1800. Might he have intended his *Cryes* to appeal to well-to-do foreigners visiting London on the lookout for souvenirs of their visit? Cries made perfect keepsakes for such tourists: they were light and portable. Some (but not Laroon's) could be bought as single broadsheets and were comparatively cheap to those taking the

Grand Tour. As Ingrid Rowland points out, prints could serve as treasured memories for tourists long after the trips had ended and, arranged into albums or displayed on closet walls, to dazzle people back home. Furthermore self-appointed tour guides like Tall John of Rome often colluded with printsellers to direct tourists to spots where these images could be bought.[37]

Such customers are typified by the rich bibliophile von Uffenbach (1683–1734), who visited London and kept a diary of his doings there. Shopping in the capital in 1710, he entered a print shop where he bought Laroon's ensemble, commenting specifically on its captions:

> After this we went to a print dealer's and bought the 'Cryes of London' in seventy-four sheets for half a guinea. In these engravings all those persons who hawk cheap wares, crying them in the streets, are represented from life with the words that they cry. They are similar to the 'Cris de Paris'. One can also obtain them with notes, for the curious tones that they call or sing can be freakishly imitated on the violin. They had no copies left of this last variety with the notes.[38]

Alas, no copy of this Cries with notes survives, if it ever existed, though a Mr Shurer is recorded as mimicking the London Cries in a concert of music at the theatre in Richmond on 23 September 1749.

Tempest's second innovation is his introduction of title pages, separate sheets devoted to images and texts giving invaluable information about the complex circumstances under which these had been produced. No previous London Cries makes use of a title page, and whenever any self-referential information appears in earlier prints, it is scant indeed and is commonly relegated to a peripheral space outside of the design proper. It commonly appears at the bottom of the sheet, and collectors such as Pepys would cut it off and throw it away. Today this scarce information is highly prized because it provides scholars with vital details about a design's origins, including the dates, names, addresses and roles of the publishers, artists and engravers who created it.

In the case of the *Cryes*, these title pages give the full name of the suite of images and describes the methodology used in their creation, 'Drawne after the Life', repeated in French and then in Italian. Legal information appears in Latin, identifying 'P Tempest' as the person who published the

THE CRYES
of the City of
LONDON
Drawne after the Life.

Les Cris
de la Ville de
Londres
Desfignez apres la Nature.

L'Arti Comuni
che vanno p
Londra
Fatte dal Naturale

P. Tempest excudit.

Cum Privilegio

M. Lauron delin: Printed and Sold by **Henry Overton** at the White Horse without Newgate **LONDON** P. Tempest exc:

37

images ('excudit'); this word means that he was the book's publisher (then called bookseller), its money man. Below Tempest's name, the Latin 'Cum Privilegio' appears. This phrase was intended to scare off pirates but was powerless. No protection existed for engravers of original or reproductive designs in England before the so-called Hogarth Act of 5 June 1735. Outside the framed title pages 'MLauron delin:' appears to the left, designating the artist who drew ('delin[eavit]'), that is, created the original designs. That artist's name, 'MLauron', as he signs himself, is today anglicized as 'Laroon'. To the right 'P Tempest exc[udit]' repeats the name of the publisher. The person portrayed in 'A Nonconformist Minister' (see p. 222) is said to be a likeness of Tempest.

Nowhere on the title pages is the name of the engraver who executed the seventy-four plates recorded. He would have been paid by the hour by printsellers like Stent and Walton, earning a pittance of twelve pence per sixty minutes, clocked by candle or hourglass. His lowly status as a copper scratcher placed him beneath mention, despite the arduous and enduring nature of his labours.[39] It is by his engravings and not the artist's drawings that the *Cryes* survived and is known today. Not until 'The merry Fidler' (see p. 126) did the engraver identify himself with these words and initials: 'I Savage sculp.ᵗ A:O et S:R:', that is, J[ohn] Savage engraver to the University of Oxford (*Academiae Oxoniensis*) and the Royal Society (*Societatis Regalis*). Neither was an official position but there are plates signed by Savage in the *Philosophical Transactions of the Royal Society* from 1683.[40]

Curiously Laroon drew two title pages for this suite of images, the first showing a man resting beside a crate of crockery (see p. 80) and the second, originally plate 37 (fig. 19), showing a woman resting on a hillock, carrying a small basket. Is she an egg seller or a cheesemonger? Perhaps, at some stage, the woman was intended to introduce the suite's twenty-nine female hawkers and the man to usher in the forty-two male vendors? One of the book's plates shows two children, a boy and girl, and two feature couples. Just as the title page's texts are innovative, so too are their designs. Both show vendors resting, a radical departure from the convention that required hawkers to appear to be labouring diligently. Either they rush to the right or left or they energetically brandish their goods in the air, a posture designed to elevate these suspect populations and to distinguish them from vagabonds or the undeserving poor.

19. Laroon's second title page for his *Cryes of the City of London*.

Satirical legends in Cries

The transformative power that legends hold over images appears in twin prints and a watercolour Cries from mid-eighteenth-century London. The first print is a conventional design painted by a Continental artist of repute which survives today as an engraving. The second is the same design transformed into a satirical/erotic print by its caption, the work of a minor London engraver, George Child, of whom little is known beyond his address in Long Acre, against Mercers Street.

In 1730 Jacob Amigoni, an Italian painter celebrated for his Venetian rococo style, moved to England where he worked until 1739. There he painted portraits, decorative cycles and soft-core erotic subjects in oil, as exemplified by *Juno Receiving the Head of Argos* (1730). Before leaving England to return to Naples, his place of birth, he painted a set of London Cries, the first to be executed in oil. The lead image of this Cries is 'Golden Pippins', showing a modest young woman selling apples from a barrow. It was etched by the German Joseph Wagner, who came to London at the incitement of Amigoni, as had Canaletto and the Italian castrato Farinelli (stage name Carlo Broschi), both of whom had temporarily immigrated on the strength of the painter's tales about the munificent sums of money English patrons showered on Continental impresarios. All three, to advance each other's professional interests, formed a clique, whose success made them envied and loathed by English competitors who caballed against them.

Around 1740, a twin to Amigoni's 'Golden Pippins' (fig. 20) appeared, attributed to the artist ('Amiconi Pinx.') and copied by an Englishman, 'G: Child Sculp'. The work of the anti-Italian faction, I believe, this pirated design differs from the Italian's in that it is reversed (indicating it was copied from the original) and that it bears an elaborate caption of over a hundred words that speak to the viewer in two different voices. The first voice, the print's brief title of six words, 'M'st ye ha' some Golden Pippins', is the pippin hawker's cry, which, in its ungrammaticality and colloquial abridgments ('M'st ye ha''), is meant to evoke the London dialect of Nelly the coster. It is worth noting the difference in tone between Nelly's brusque, aggressive greeting calling out 'M'st ye ha'' and the sly but polite, and more practised address of Sandby's streetwalker who inquires with seductive indirection and deference, 'Will your Honour?'

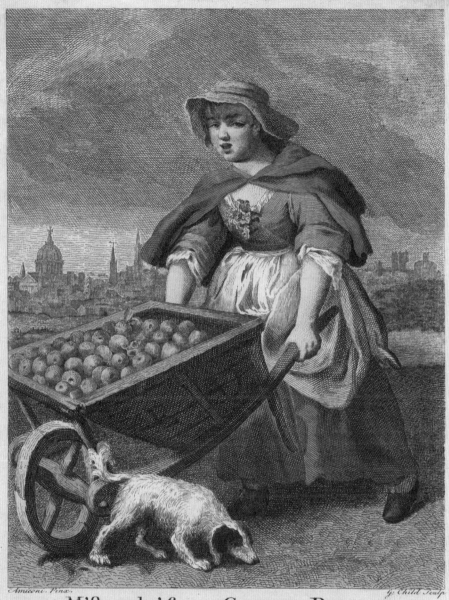

Amiconi Pinx. G. Child Sculp.

M'st ye ha' some GOLDEN PIPPINS.

The Season o'er for Oysters,– Nell,	The Barrow, that She rowls along,
On Southwark Side can Pippins Sell;	Conspicuous shews her Back is Strong;
With Flow'rs bedecks her Lilly Breast,	Her trilling Voice, we'll think we hear,
In Hopes at Night, to have it prest;	Tells you the Soundness of her Ware;
Nature has gave her White and Red,	The artful Face beneath Straw Hatt,
Shou'd Pippins fail,–to get her Bread;	Bespeaks what Nelly wou'd be at –
She'd Education in the Mint,	And proves, by this industrious Feint,
When Whores & Thieves did most live in't.	That, Ev'ry Whore may seem a Saint.

Price 6.ᵈ

Ink Ink come buy my fine Ink
for money that I want to buy me some drink

While the first voice in the legend for 'Golden Pippins' is oral, blunt and slang-like, the second voice is literary and poetic. Composed of sixteen lines in couplets, it is the verse of an omniscient narrator/commentator unmasking the young girl as not what she seems. An oyster wife turned apple seller with the changing season, her real calling is prostitution, exposed by the flowers drawing the eye to her bosom 'in Hopes at Night, to have it prest', while her artful face shows 'that Ev'ry Whore may seem a Saint', as the caption asserts.

Thus does this new legend transform an urban picturesque design into a pornographic image, or worse, an image proposing child pornography. The intent is surely to besmirch the reputation of Jacob Amigoni, whose erotica were not widely known because they were chiefly confined to his oils. Rather mysterious are the letters 'E D' carved on the side of Nelly's barrow, not present in Amigoni's original design. What is this monogram alluding to? Whatever the answer, the print sullies the reputation of the Italian, who did in fact dabble in pornographic imagery; his 'Feeling', from a set of *Five Senses*, sold by William Herbert at the Golden Globe on London Bridge, pictures a half-naked woman gazing at the viewer as she fingers the tip of a phallic arrow with one hand while enticingly caressing the shaft with the other.

Paul Sandby's watercolour 'Ink, ink' (fig. 21) represents a very different kind of satiric image from his extraordinary set of over a hundred designs in pen and wash, attacking Robert Sayer's modernization of Laroon's *Cryes*, which was 'improved' by a French engraver and issued about 1760 with a new title, as *The Cries of London in Six parts, Being a Collection of Seventy two Humourous Prints, drawn from the Life by that Celebrated Artist Laroon, with additions & Improvements by L. P. Boitard.* Sandby himself etched twelve of his watercolours, but 'Ink, ink' was not among them. It shows a hulking, dishevelled man lurching along, steadied by a burly, menacing stick. Carrying a funnel, an ink bottle and other paraphernalia of his trade, he advertises his calling by the quill stuck in his hat. In all respects he seems to be a scruffy variant of Laroon's energetic fellow in 'Fine Writing Inke' (p. 102). But his shout tells a different tale. Transcribed in Sandby's own hand and composed of just seventeen words, it transforms him from a hard-working vendor to a stereotypically shameless drunk hawker, the view of street sellers widely held by Londoners: 'Ink Ink come buy my fine Ink, for money that I want to buy me some drink.' A vagabond, he works only to tipple, the legend asserts;

21. This watercolour was one of a set of twelve that Sandby himself etched and sold. But the set did not retail well, perhaps because of the satiric tone of the images, as illustrated by this legend. Paul Sandby, 'Ink Ink come buy my fine Ink, for money that I want to buy me some drink', 1759.

his shout is as much, or more, a plea for liquor as it is to buy his ink. And yet the frankness of the man's plaintive cry, part confession and part taunt, gives the image a comic turn which also suggests his indifference to public condemnation in response to his blunt confession of his alcoholism.

Celebrities of the street

Early buyers as well as modern collectors and scholars have wondered about the real-life identities of the characters appearing in the individual images of Cries, particularly the designs that are remarkable for their naturalism and representational qualities. Are the figures in such suites fantasies or are they portraits of living people who once walked the streets of Bologna, London and Dublin? In the case of the beggar attended by a boy who pulls him along in a wooden wheelchair (fig. 22), from Hugh Douglas Hamilton's *Cries of Dublin*, the case is simple. The drawing's legend records his given name, 'Hae', and his family name, 'Ball'. But it also records his mock royal title, 'King of the Beggars', even as it shows a fond young woman paying fealty to him in the form of money and reverence, which he receives with regal insouciance.

This historical curiosity is much more complex in Laroon's *Cryes of the City of London*, in which street characters appear not so much as types but more as individuals, each with a distinctive personality and dignity. In this regard, it is striking that Laroon's designs show no formal or iconographic indebtedness to previous images in Continental Cries or indeed to any work in the history of art, with the exception of the artist's vendor of 'Knives, Combs or Inkhornes', whose posture (but not his likeness) bears affinities to Jost Amman's 'Pedlar' in his *Book of Trades* (1568).

How did Laroon generate so many sketches – eighty that we know of – with such a wide variety of callings and poses and so many plausible faces from which John Savage and his fellow engravers cut the *Cryes'* copperplates? Perhaps the key to how he achieved that formidable task is present in the last four words of the book's title, 'Drawne after the Life', a stock phrase of artists common in England after 1600 but not used to describe any London Cries before Tempest employed it to distinguish his designs. The formulaic term means 'drawn or painted from a living model' and commonly refers to likenesses offering detailed and accurate transcriptions as distinct from history and mythological painting. In the

22. Hugh Douglas Hamilton's 'Hae Ball' offers an anecdotal image of the likeness of a celebrated figure from eighteenth-century Dublin. Many of Hamilton's hawkers are indebted to Laroon's. Hugh Douglas Hamilton, 'Hae Ball', from *Cries of Dublin*, 1760.

Hae Ball, King of the Beggars

Cryes the importance of this artistic technique, which Henry Peacham called 'cut to the life, a thing practised but of late yeares', is emphasized by Laroon repeating it in French and again in Italian.[41] But what exactly does all this mean?

Four years after he married, in 1679, Marcellus Laroon established his home, workshop and showrooms at No. 4 Bow Street, Covent Garden, London. From 1656 on, that square was the capital's largest fruit and vegetable market. There, on Tuesdays, Thursdays and Saturdays, Laroon would have rubbed shoulders with and surely patronized the hawkers arriving to buy their strawberries, asparagus, artichokes and the like before they passed his doorstep to fan out into London to sell their produce. The artist may have identified the most striking of the hawkers he had seen and come to know and invited these men and women into his workshop where he could pose them exactly as he wished, at an hour he preferred and for as long as he desired, against a blank background, all for a few pence. Such an invitation would have been welcome to hawkers for whom a penny more or a penny less was consequential.

The Pepys Librarian, Richard Luckett, makes a similar point when, writing of Laroon's settling down in Covent Garden, he calls that square 'as good a venue as can be imagined for observing the subjects of his *Cryes*'.[42] Likewise the sketches depict palpable likenesses of individuals, though the engravings look petrified and stiff. Finally, the legends explicating a good number of his plates testify incontrovertibly that their author (probably the artist, though the sketches have no titles) was interested in individual people, their idiosyncrasies and their likenesses. For that reason he intended his designs as the portraits of real people, contemporary Londoners who had earned a measure of popular fame and whom he identified by name in his captions.

'Oliver C: Porter' (p. 220) is Oliver Cromwell's doorkeeper, whose given name was Daniel, but whose entire name was not spelled out because he was still reviled in the 1680s, when he was confined to Bedlam. There the Plymouth diarist and navy surgeon, James Yonge, paid a penny to look at him in 1678. Other portraits carry captions that point to public figures and celebrities in the entertainment world who were even better known. 'Josephus Clericus Posture Masterius', who appears in two prints (pp. 210 and 212), is Joseph Clark the contortionist, known throughout England and reputed to be the most extraordinary posture master who had ever lived, no doubt by his own telling. The famous Dutch Woman

appears in twin plates (pp. 204 and 208) to show the different kinds of acts she put on: walking on the taut rope and tumbling on the slack. Going by the name of Mrs Saftry, she needed no introduction to Londoners, with whom rope dancing was intensely popular in the late seventeenth century. Pepys called it 'a thing worth seeing and mightily f[o]llowed'.[43]

By reason of her notoriety, Madam Creswell was well known to Londoners, first as a strumpet, when she was reputed to have been a young woman of bewitching charm and beauty. In her old age, she was one of the most famous procuresses in London between the Restoration and the Glorious Revolution. Ordinary street vendors who were distinctive in some small way also appear by name in the *Cryes*, as exemplified by 'Colly Molly Puffe'.

But the most extensive and persuasive evidence that Laroon's portraits of certain vendors were based on living human beings comes from Samuel Pepys, the first Englishman on record to collect Cries. These survive in his library, which is maintained in its original organization and housed in the wooden cases he had commissioned, in Magdalene College (Cambridge), his alma mater. An invaluable account of this collection has been published by Richard Luckett titled *The Cryes of London: The Collection in the Pepys Library at Magdalene College, Cambridge*. Pepys arranged his prints by chapters, two of which bear upon our concerns here. The first of these is 'Chaptr. VIII Cryes. consisting of Several Setts thereof, Antient & Moderne: With The differ(ent) Stiles us'd therein by the Cryers'.[44] Under this rubric Pepys preserved three sets of London Cries published as broadsides and plates from Laroon's *Cryes*.

Pepys identified figures from the *Cryes* as portraits of living Londoners, writing their names beneath their likenesses in this style: 'Merry Andrew– Mr Philipps; Hugh Casey–The Fidler; Kate Smith–The Milk Maid; Mrs Paler–The Dutchwoman' and so on for a total of fifteen prints.[45] Tellingly Pepys did not include these portraits in his collection of Cries; instead he featured them in his section on portraits, with the annotation 'Heads and Figures in Taille-douche & Drawings'. Pepys also identified 'A Nonconformist Minister' as 'Tempest the Printseller as a Presbyterian Parson' but placed him among his collection of clergymen.[46]

In the eighteenth century, the identifications were taken up by James Granger, author of *A Biographical History of England, from Egbert the Great to the Revolution* (1769), which was later expanded. His *Biographical History*, intended to reduce 'our Biography to System, and [as] a Help to

the Knowledge of Portraits', is a precursor to the *Dictionary of National Biography*.[47] It divides people, by reign, into twelve classes, from Class I, 'Kings, Queens, Princes, Princesses, &c. of the Royal Family' down to Class XII, 'Persons of both Sexes, chiefly of the lowest Order of the People, remarkable from only one circumstance in their Lives; namely, such as lived to a great Age, deformed Persons, Convicts, &c'. In response to Pepys's identifications, Granger imported into his *Biographical History* all the people whose names appear in the diarist's copy of the *Cryes*. In doing so he imparts his authority to Pepys's identifications, perpetuating and extending them. 'I have described as many of them in this work, as Mr. Secretary Pepys has taken into his collection. We are beholden to that gentleman for the names of several of the persons, which are written under the portraits.'[48] It is worth mentioning in passing that James Caulfield, working in the same biographical strain as Granger, reported that the antiquarian George Steevens saw a copy of the *Cryes* with manuscript notes describing each character throughout the book, though no such copy is known today.[49]

When Granger had completed his biographical labours, he had second thoughts about including 'the lowest Order of the People'. So he concluded his final volume initially by fretting about his radically democratic innovation:

> I shall conclude this reign [James II's], with observing, that Lord Bacon has somewhere remarked, that biography has been confined within too narrow limits; as if the lives of great personages only deserved the notice of the inquisitive part of mankind. I have, perhaps, in the foregoing strictures, extended the sphere of it too far: I began with monarchs, and have ended with ballad-singers, chimney-sweepers, and beggars.[50]

Granger's acknowledgement of 'Lord Bacon' as the inspiration and authority for his innovative act of acknowledging street people is perhaps too narrow. Many of the individuals depicted in the *Biographical History* come directly from Laroon, who had sketched his likenesses on the basis of the celebrity these men and woman had earned on the streets of London as a result of their skills as songsters, acrobats, dancers, rogues, reprobates and so on. Perhaps Laroon deserves to share credit with Lord Bacon for Granger's daring creation of 'the lowest Order of the People'. This 'lowest

Order' espoused by the biographer in his final words evokes the theme in the Dance of Death of the equality of rich and poor in mortality:

> But they that fill the highest and lowest classes of human life, seem, in many respects, to be more nearly allied than even themselves imagine. A skilful anatomist would find little or no difference, in dissecting the body of a king and that of the meanest of his subjects; and a judicious philosopher would discover a surprising conformity, in discussing the nature and qualities of their minds.[51]

Hawkers' status

The decline and ultimate disappearance of Cries are rooted in four linked developments: social, informational, art historical and technological. Perhaps the changing social attitude to hawkers is fundamental. When street vendors first appeared, they served a broad swath of customers: well-off householders or their servants, the middling sort of people, and their own kind, who were also eking out a life of subsistence. The more prosperous part of their base shrank as the number of grocers and greengrocers grew, when, in the late seventeenth and eighteenth centuries, England became a nation of shopkeepers. The hostility of these retailers resulted in organized assaults like those launched by 'Tradesmen who lately met in Covent-Garden, have[ing] resolved to petition the Parliament the next Sessions, to suppress the Hawkers and Clandestine Traders, whom they apprehend to be the principal Occasion of the Decay of Trade among fair Dealers, and 'tis said, that Petitions of the like Nature are preparing in several of the most considerable Corporations in the Kingdom'.[52]

The decline of hawkers was also hastened by concerns about the cleanliness of hawkers' operations, themselves and their foodstuffs as well as about their honesty. The poor quality of their fruits and vegetables declared by Joseph Addison was intensified by suspicions about the trustworthiness of their weights and measures, as voiced by grocers in hostile advertisements and by artists like William Marshall Craig. Craig reported of cherry sellers: 'These barrow-women undersell the shops by twopence or threepence per pound, but their weights are generally to be questioned; and this is so notorious an objection that they universally add "full weight" to the cry of Cherries.'

71

The Flower Girl.

The nosedive in esteem suffered by hawkers is caught in an anecdote about the fate of a gingerbread seller who squabbled with his customers. In January 1850 a run-of-the-mill dispute broke out between the food vendor and his Stalybridge customers. The vendor, 'a big, good humoured fellow' going by the name of Sheppard, was seen expostulating with a crowd. Suddenly Sheppard was on the ground and under the feet of the mob who formed a ring around him, kicking him with iron-tipped clogs as if he were a stuffed sack. They left him kicked to a pulp according to an eyewitness, 'Lord' George Sanger, himself a costermonger-showman-circus star:

> "Kicked to pulp" is by no means too strong an expression, for that is what literally happened to the poor ginger-bread seller. When the crowd with the kickers suddenly melted away there lay the body – I can see it now – a ghastly, shapeless thing in the clear sunlight, with the white dust of the roadway blotched here and there about it with purple stains. It was one of those things that a man once seeing carries for ever after as a shuddering recollection. … Some little time after the brutal deed had been done one or two constables made a leisurely appearance, looked at the body as though such sights were common to their ordinary day's work, and the corpse was removed.[53]

The scant statistical evidence about licensed hawkers in the eighteenth century records their numerical decline. In the period from 1723 to 1726, the number of licensed hawkers going on foot and by horse stood at 2,321. By 1784–5 that number had declined to 1,290, though the fall-off was not linear and varied from time to time.[54] Obviously the number of unlicensed hawkers was many times larger, but it too is likely to have declined as a result of the rise of shopkeepers and greengrocers. That decline is confirmed by a London Cries, Charles Tilt's *Figures of Fun, or, Comical Pictures and Droll Verses for Little Girls and Boys* selling for one shilling and sixpence, and published in two parts in 1833. Rather than showing costermongers and hot-warden sellers, it pictures instead 'The Green-Grocer' or 'The Flower Girl' (fig. 23) in the manner of Giuseppe Arcimboldo. Showing hawkers as surreal figures composed of the objects they sell, this book is aimed at younger girls and boys, turning hawkers into figures of fun, caprices that are as distant as imaginable from the social world of hawkers.

23. As London Cries became less and less tied to historical street life, their iconography grew ever more fanciful, as Tilt's figures in the manner of Giuseppe Arcimboldo show. Charles Tilt, 'Flower Girl', *Figures of Fun*, 1833.

Calls for new information about hawkers

Images of vendors, when they first appeared, presented imaginative answers to the questions audiences posed about hawkers and their doings. In the mid-nineteenth century hawkers were still an obscure tribe. The Victorian journalist Henry Mayhew, writing in his *London Labour and the London Poor*, referred to them as 'a large body of persons, of whom the public had less knowledge than of the most distant tribes of the earth – the government population returns not even numbering them among the inhabitants of the kingdom'.[55] Answers to questions about vendors – presented with invention, variety and in different styles, genres and hues – captured audiences' curiosity over a long period of time. But ultimately these responses seemed inadequate when old forms of knowledge grew familiar and new mediums raised new and perhaps more exacting questions. When images shrank in size and words increased in importance, as they did in Craig's *Itinerant Traders*, a demand had already emerged for narratives that were scientific, utilitarian, factual and pragmatic. The first, fullest and most dramatic example for this kind of sociological information was published in book form in Mayhew's *London Labour and the London Poor*, which complained that street hawkers 'are so multifarious that the mind is long baffled in its attempts to reduce them to scientific order or classification'.[56] Loudly averse to myth and devoted to fact, these four volumes describe the daily lives of street vendors, give a minute and detailed account of their economic existences and categorize them exhaustively. For example, the book describes obvious topics like hawkers' shouts, their honesty, their amusements and their earnings (put at one shilling and sixpence a day for costermongers). But it also treats their religion, education, marriage, concubinage, politics and language and the education of their children. It even gives their numbers, which it puts at 30,000 in 1841, commenting that the official number (presumably licensed?) was 2,045, a figure that the text rightly calls absurdly small.[57] None of these kinds of information fell within the power of images to capture, now eclipsed and relegated to extraneous adornments. In Mayhew, words in the form of sociological description combine with numbers in the form of statistics to illuminate liminal people as never before.

Children's books

When London Cries made their debut, they were first designed by foreign and domestic engravers before being taken over by established artists who sold them to wealthy amateur artists and print collectors such as Pepys, von Uffenbach and others. But, as early as 1723, toy shops entered the business of selling prints, when the Great Print and Toy Shop in St Martin's Lane advertised designs by Rubens and van Dyck as well as the Cries of London 'proper for Dining Rooms, Parlors, Stair Cases or Closets'.[58] Inspired by the yoking of toys and prints, John Kirk turned to a neglected clientele, publishing the first Cries aimed exclusively at children in 1754. Selling for a shilling plain or two shillings coloured, his first publication, titled *The Cryes of London Engraved and Sold by I. Kirk in St Paul's Church Yard. Also all sorts of English and Dutch Toys* (fig. 24), was announced in the *Public Advertiser* as 'The most humorous CRIES of London … very fit to amuse Children and help them forward in their Learning' (here 'humorous' means 'whimsical', or 'odd'). Kirk's innovation, growing to three volumes, added a dramatic new offshoot to Cries.

24. Beginning in the mid-eighteenth century, Cries began to appear in the form of children's books. John Kirk's is one of the earliest and most influential of the genre. John Kirk, *The Cryes of London Engraved and Sold by I. Kirk in St Paul's Church Yard*, 1754.

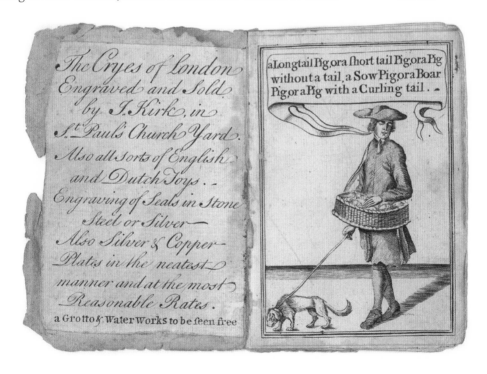

Indeed it changed their direction in the mid-eighteenth century but especially in the nineteenth century, according to the titles documented in my unpublished 'Hand List of London Cries', compiled over thirty years of visiting libraries and private collections, and on deposit at the Guildhall Library, London. In the years 1800 to 1824, about ninety-nine suites of Cries appeared, twenty-three of which were aimed at adults and seventy-six of which were designed for children. From 1825 to 1899, about eighty-four ensembles of Cries were published, five for adults and seventy-nine for children.

These figures tell two stories. First, Cries became overwhelmingly a genre for children from the mid-eighteenth into the nineteenth century, when twenty-eight sets were aimed at adults but 160 at children. These statistics are confirmed by anecdotal information. Mrs Boscawen, a founder of the Bluestocking Society, writing to her husband Admiral Edward Boscawen in 1755, told him about how she distracted their son as he recovered from his inoculation against smallpox: 'the chief service I can do him is to provide him such amusements as will keep him still and quiet. So that, instead of waggons, carts and post-chaises, we shall deal altogether in mills, pictures, dolls, London cries, and such sedentary amusements.'[59]

Second, the production of Cries declined dramatically after 1824, when only eighty-four suites appeared for both adults and children. The last publication to use the words 'London Cries' was John Leighton's *London Cries and Public Edifices from Sketches on the Spot*, published by Griffith and Farran at the Corner of St Paul's Church Yard. No date appears on the book, but Griffith and Farran's shop at the Corner of St Paul's was in business there from 1856 to 1884. Numbers are not the only important feature of Cries to have changed in this period, and not all such changes are auspicious. Kirk's pioneering 'Little Books' for children, approximately the size of a modern credit card, features twelve illustrations on each leaf and a facing commentary. Seven of these illustrations are copies of Laroon's designs from his *Cryes*. Elizabeth Newbery's *Cries of London, as They are daily exhibited in the Streets; with an Epigram in Verse adapted to each* (1771) is more typical of late eighteenth- and nineteenth-century children's Cries. Featuring sixty 'elegant Cuts', it went through ten editions and passed from one publisher to another. Twenty-three of the Cries are copied directly from Laroon, to which backgrounds were added. The practice of pirating Laroon's designs for children's books, making use

of a rough and ready style, was widely followed from the 1760s onwards. This repetition and dependency on designs more than seventy years old indicates the extent to which the depiction of hawkers in children's books was petrified, even moribund. Incapable of changing or renewing itself, the artistic tradition and its practice was stuck in a cycle of redundancy. But, as well as stagnating, the iconography of Cries was also increasingly detached from the realities of hawkers' daily lives (as the picturesque poverty of Craig's *Itinerant Traders* shows). All of these developments, but especially the lack of innovation and vitality, which grows out of and is energized by contact with everyday life, boded ill for the long-term future of Cries.

Technological innovations

Technological innovations also played a role in the decline of Cries. The first such innovation was the invention of the daguerreotype, which was in broad use across Europe after 1839. When Mayhew came to illustrate *London Labour and the London Poor* he was drawn to this novel technology, then at the centre of a frenzy of public enthusiasm and espousal. He illustrated his four volumes with woodcuts made from daguerreotypes by Richard Beard (1801–1885). Beard's method was to cruise around London in a cab picking up street vendors and ferrying them to his studio where he posed them in thirty-second sittings. He then gave his plates to an engraver who cut woodcuts with which Mayhew adorned *London Labour*. This shift from the street to the studio deracinated hawkers, further removing them from the realities of their lives. And, paradoxically, the photographic ritual involved in the production of these illustrations often made them dependent on the iconography of earlier Cries. Beard's 'The Jew Old-Clothes Man' (fig. 25) borrows the pose, dress, sack of clothes and physiognomy of Craig's Jew, as well as its wrought-iron fence topped with spear-like rails. The implied measures to bar the Jew and his troublesome ilk from the doors of the well-to-do have more than a touch of xenophobia.

Beard's engravings of wooden figures in poses that look stiff against sketchy backgrounds were not well received. Perhaps they reflected Mayhew's views of the pedlars, street sellers, street performers, beggars and prostitutes, whom he lumped together as one and impugned for

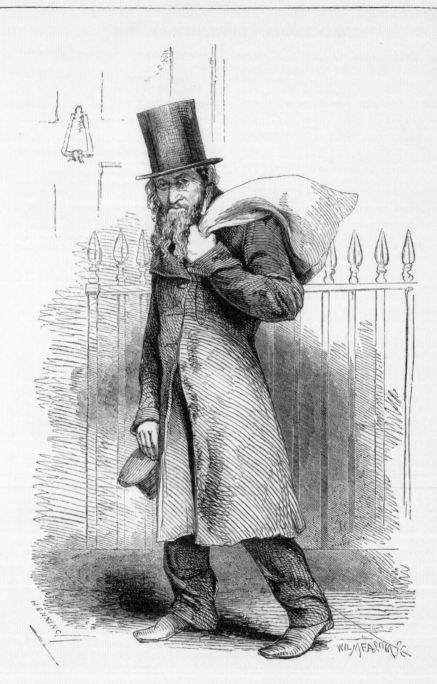

THE JEW OLD-CLOTHES MAN.

CLO', CLO', CLO'.

[From a Daguerreotype by BEARD.]

'their use of a slang language – for their lax ideas of property – for their general improvidence – their repugnance to continuous labour – their disregard of female honour – their love of cruelty – their pugnacity – and their utter want of religion'.[60]

By 1860 the daguerreotype had been replaced with cheaper techniques that yielded sharper, more legible images. The Woodburytype duplication of photographs attracted the attention of the social documentarians Adolphe Smith and John Thomson, whose *Street Life in London* appeared in 1877. Issued in parts, this title paired Thomson's 'street incidents' with Smith's literary vignettes, closely following Craig's formula of text facing image. Smith and Thomson's publication inaugurated a tradition that replaced the artistic representation of hawkers in prints with photographs of them. As it quickly became the chief medium of visual reporting, it broadened its scope and specialized in street photography, photography of work and labour, social-culture photography and forensic photography, all of which flourished and have survived to the present day in the United Kingdom and the United States.

left
25. 'The Jew Old-Clothes Man' is made after a daguerreotype by James Beard to illustrate Henry Mayhew's *London Labour and the London Poor* (1851–4).

below
26. This drawing depicts a dramatic street scene from eighteenth-century Dublin. Hugh Douglas Hamilton, 'Three Papist Criminals going to Execution', from *The Cries of Dublin*, 1760.

Three Papist Criminals going to Execution.

THE CRYES
of the City of
LONDON
Drawne after the Life.
In 74 Copper Plates.

Les Cris
de la Ville de
Londres
Designez apres la Nature.

L'Arti Comuni
che vanno p̃
Londra
Fatte dal Naturale.

P. Tempest excudit

Cum Privilegio

Mauron delin: Printed & Sold by · LONDON. 1711 · P Tempest exc:

The Cries

The order of the plates in this book follows their sequence in an early copy of Marcellus Laroon's *Cryes of the City of London Drawne after the Life*, printed in 1711. Laroon followed no grand scheme in ordering his images but he did pay attention to which images appeared next to one another. First, he adjoined images of hawkers who appeared together in the streets of London. Thus, the merry milkmaid is adjacent to the merry fiddler who accompanied her on her Mayday rounds and played the music to which she danced. Likewise, the hawker of wax and wafers is followed by the ink seller, both of whom were stationers. Second, he located contiguous figures who complemented or contrasted each other, either formally or sartorially. So, next to figures who face us he situated those who display their back. Or, focusing on fashions in dress and the art of tailoring, he linked hawkers exhibiting the front of their dresses with those showing off their backs. Finally he placed figures who were not strictly hawkers, but rather charlatans, rogues and quacks, more or less together at the very end of his suite.

A SOW GELDER

Sow gelders, like most hawkers, were jacks of all trades, taking work wherever it was offered. In this print, the gelder's hat, decorated with a cockade, is battered; his coat, once elegantly tailored with hounds'-ears sleeves, is patched at the elbows and its hem has been eaten away. He wears an apron to protect it from his bloody business. Standing with his back to the viewer, he holds in his hand a sow gelder's horn. An early edition of the *Cryes* carries a manuscript note calling this figure a 'horse leech and cow doctor'; sow gelders were also farriers. Theirs was a penurious calling: Giles Wilcox, a gelder of repute, offered to teach the traditional orthodox method of his mystery for a mere two shillings and sixpence.[1]

Sow gelders had a reputation for mischief. A report in the *Evening Post* of 1719 describes how John Hulston, a sow gelder and 'a middle sized Man, thin tawney Visage, black Hair, sometimes wears a grey Coat and other Times an old blue Coat with brass Buttons, formerly belonging to the Welch Fusileers', stole the black mare of the Revd Mr. Popkins, who offered a guinea for its recovery.[2]

Laroon's sow gelder carries a club, which evokes his business with its ties to violence and blood. The *London Evening Post* of 1737 carried a report of an aggressive Hereford gelder, who, partnering with a tinker (his brother) and their dog, fixed a kettle for Mrs Chaddock, who declared their charge extravagant. When she refused to pay, they

> us'd her very roughly, and caus'd her to cry out: Her Husband coming to her Assistance, they push'd him down and his Wife upon him, threatning that their Bitch should tear their Guts out; to prevent which the said William Chaddock went for his Gun to shoot her, which the Sow-Gelder perceiving, told him he would teach him to handle a Gun, and accordingly laid hold of it, and beat him with an Oaken Cudgel; and in the Struggle the Gun went off, and unfortunately kill'd the Sow-gelder.[3]

The sound of the sow gelder's horn was distinctive and carried far. Joseph Addison, in his *Spectator*, wrote a spoof in which he proposed himself as 'Comptroller General of the London Cries'. He divided these into vocal and instrumental, complaining:

> A Freeman of *London* has the Privilege of disturbing a whole Street for an hour together, with the twancking of a Brass Kettle or a Frying-Pan. The Watchman's Thump at Midnight startles us in our Beds, as much as the breaking in of a Thief. The Sowgelder's Horn has indeed something musical in it, but this is seldom heard within the Liberties.[4]

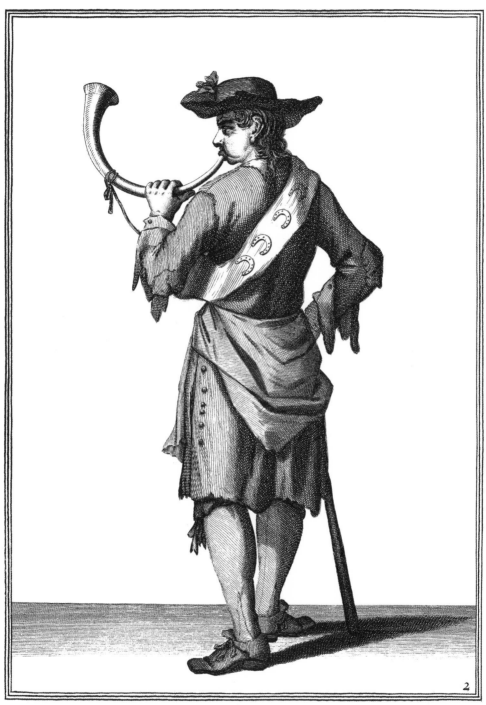

2

A Sow Gelder

Le Chatreur de Chiens
Castra Porchetti

Mauron delin :

P. Tempest exc :
Cum Privilegio

Any Card matches or Savealls

The vendor of card matches and save-alls (metal candle-holders), just out of adolescence, is one of the youngest figures in the *Cryes*. In the preliminary sketch for the print, preserved in the collection of the duke of Marlborough at Blenheim Palace, Woodstock, Oxfordshire, she looks younger still, a child barely past puberty and the only female to display her own hair. In this engraving, she covers her head with a scarf knotted behind. She exposes her shoulders, which are partially hidden by her chemise's collar. Her dress is neat and in good repair, which is notable since her trade is marginal. Match vendors were among the most destitute of street vendors: they tended to be old men, so-called cripples, the maimed, orphans, abandoned wives and children or young, as she is. Perhaps her modest prosperity is due to her energy:

she marches forward with elan and drive. Her rolled-up sleeves, forward gait and capacious basket show her purpose and enterprise.

This hawker sells card matches, spills of paper or wood coated in wax and tipped in sulphur. Invented about 1632, and produced at home (often by children), the matches were introduced into tinder boxes where sparks from flint striking steel ignited the sulphur. This young girl stores her matches in a pouch made by rolling up her apron. In the seventeenth century, the matches sold for about a halfpenny a bunch. Her save-alls are metal holders with spikes to fix candles in place and allow them to burn safely all the way down. They were cast by candlestick makers and sold to hawkers. These she stores in her capacious wicker basket.

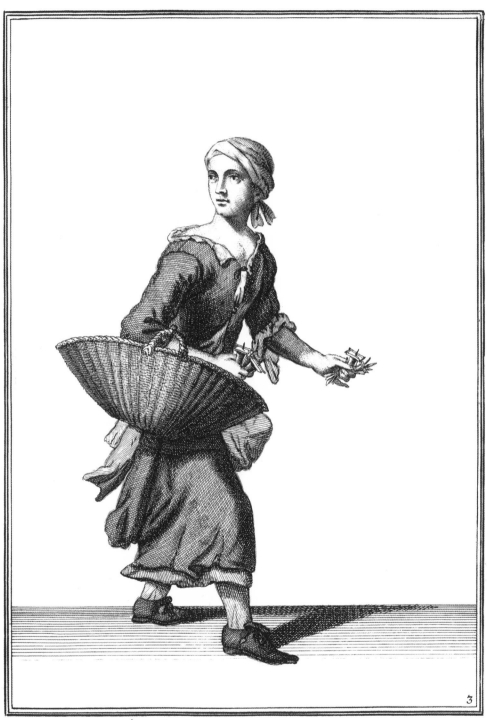

Any Card matches or Saveaals

Aux Allumettes et Binets

Lesca e Solfanelli da vendere

Mauron delin:

P Tempest ex
Cum Privilegio

3

PRETTY MAIDS PRETTY PINNS
PRETTY WOMEN

This hawker's rhyme is a flattering nonsense jingle, easy to recite and based on the associations between the pins he sells and the women who buy them. The seller is old, shown in the half-steps by which he shuffles along; his poverty appears in the state of his coat, out at the elbow and torn or patched at the shoulder. He sports a chemise with buttoned cuffs and wears two forms of headgear, a battered hat and a wide headscarf knotted at the back. Two types of headdress were common in the seventeenth century; some hawkers wore headscarves for warmth, others for show; he wears his items against cold weather. His left sock has a large hole in its heel; both show clocks, the triangular pieces produced to shape the heel.

The hawker is one of the few to specify his customers: maids and women. Pins played essential roles in the lives of rich and poor, who used them to make, mend and adjust dress.[5] Women were said to buy a hundred pins a year. Businessmen and booksellers used pins to bind, repair and gather leaves and papers as we use paper clips. Some women kept pins in their pockets and used them to ward off sexual predators like Samuel Pepys.[6] The pin trade was in the hands of street vendors consisting of

> poor and indigent People, who have neither Credit nor Mony to purchase Wyre of the Merchant at the best hand, but are forced for want thereof, to buy only small Parcels of the second or third Buyer ... and to sell off the Pins they make ... for ready Mony, to feed themselves, their Wives, and Children.[7]

The *London Chronicle* of 24–26 December 1761 touted English pins, which were 'esteemed in all respects the best in the world'. The excellence of English pins lay in the stiffness of the wire and in the blanching, and 'this is of so great consequence, that by the manner of doing it, some pins are of so poisonous a nature, that the slightest scratch by them will fester and prove very troublesome.'

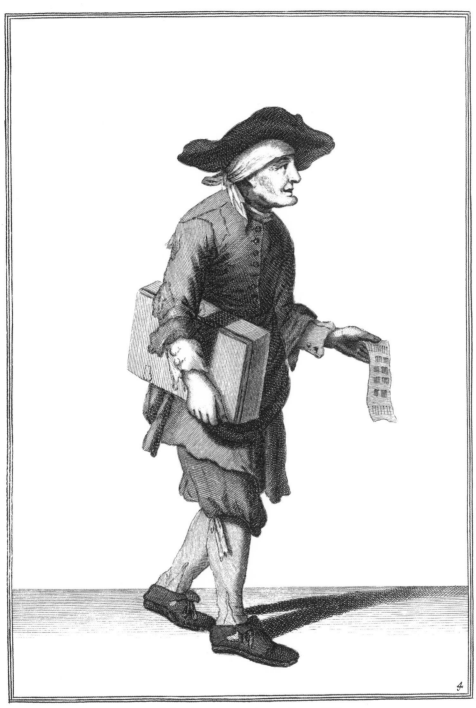

Pretty Maids Pretty Pinns Pretty Women
Belles & Bonnes Epingles a vendre
Spille grandi e picciole da vendere

Mauron delin:

P Tempest exc
Cum privilegio

Ripe Strawberryes

The strawberry seller is one of the most elegant and stylish of women vendors. Her face is friendly and pleasant, artfully framed with a stray curl called a *passagère*. She is tall and willowy, and her graceful pose is accented by her delicate footwork. Her dress is fashionable and clean, as her dazzling white apron shows. She wears two head covers, a hat and a full scarf or hood to express her sense of flair. Her frontal pose is dominated by three bows. The first is the large, bright-coloured scarf tied in front of her neckerchief. This stands in contrast to the tiny ribbon of her apron, which in turn, contrasts with the floppy knots with which she ties her shoes.

Her fine dress may be connected with the popularity of her strawberries and with her own industriousness, which is indicated by her energetic step and her rolled-up sleeves. Samuel Pepys was excited at seeing and tasting strawberries in the garden at Kirby Castle, Bethnal Green: 'A noble dinner and a fine merry walk with the ladies alone after dinner in the garden, which is very pleasant. The greatest Quantity of Strawberrys I ever saw, and good.'

In another place, he records paying 1s/2d for strawberries in Oxford, probably a pottle, holding two quarts.[8]

The popularity of strawberries and their high price drove Ann Hanshaw, a hawker, to an ingenious method of acquiring them. According to the *General Advertiser* for 18 July 1750, Hanshaw was

> remanded on Monday last ... concerning her defrauding Mr. Shuttleworth of divers quantities of Strawberries, Apricots, and other fine Fruits, under false Colours and Pretences; it seemed she had gone several Times to Mr. Shuttleworth's and ask'd for such and such Quantities of Fruits, and said she came from the Lord Mayor's, and answering several Questions about the Servants, he made no scruple, but sent what she ask'd for; 'till at length being watch'd, and not going the usual Way from thence to Goldsmiths-Hall, she was detected and found to belong to a Gang of five or six who had invented this Method of getting Goods and use to sell them about the Streets; for which she was Yesterday committed to Jail.

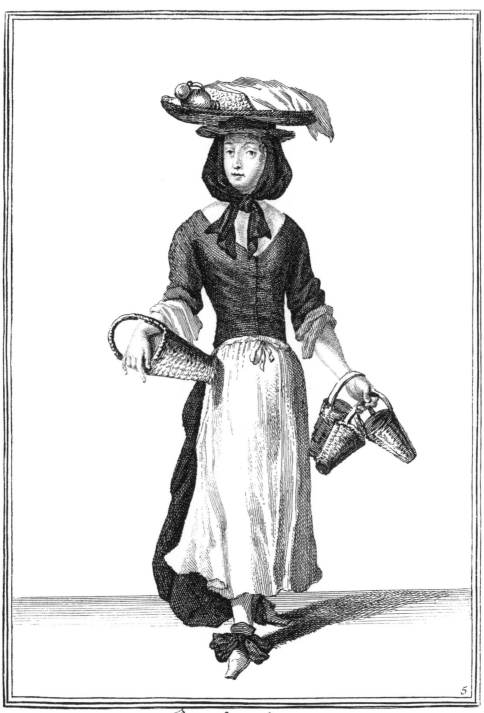

Ripe Strawberryes
Achetez mes Fraises
Fraüole Fresche

M. Lauron delin:.

5

P. Tempest excud:
Cum Privilegio.

A Bed Matt or a Door Matt

The mat vendor is a ragged but hard-working crier. His coat is worn through at the right elbow as well as eaten away and torn at the hem. In a tiny detail at which Laroon excels, the hawker's left stocking is loose and bunched up above his shoes. He carries heavy mats on two sticks and a smaller one tucked into his belt, torqueing his body to the right to better manage his burden. Despite his weighty load, he moves forward with an energetic step as he cries out to advertise his wares. The empty stick in his left hand suggests that he has already disposed of half his merchandise.

Samuel Pepys recorded that a Mr Bland 'presented me yesterday with a very fine Affrican Matt (to lay upon the ground under a bed of state), being the first fruits of our peace with Guyland'.[9] The wares of this hawker, much more common, are woven locally, perhaps even by his wife and children. His bed mat, which he carries behind his back, is a large cover in the style of an eiderdown or comforter. In June 1761 John Cope made a daring escape from Newgate with two accomplices, but was quickly discovered 'wrapped up in a Bed-Mat, who surrendered without making any Resistance'.[10]

G.F. Handel, the composer of 'God save the king', was said to have taken the melody for England's national anthem either from a man who cried 'Old Chairs to mend' or from another who cried, 'Come buy my door-mats'.[11] He is also said to have been inspired by hawkers' cries picked up in the street in some of his best cantatas.[12]

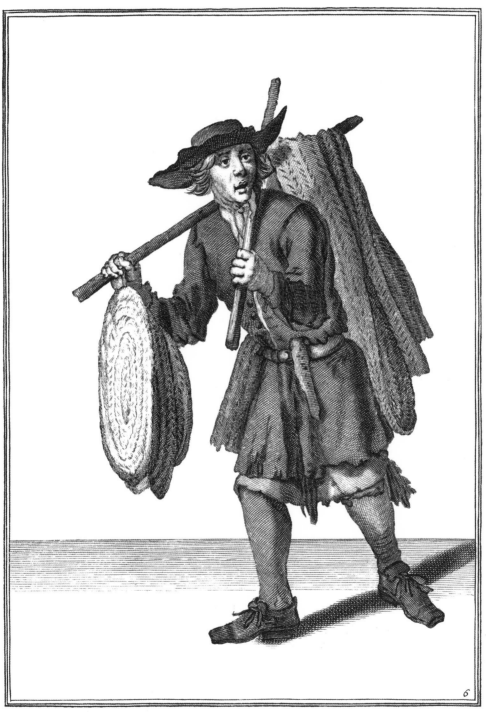

6

A Bed Matt or a Door Matt
Achetez des Nates
Chi uuol Storioli da letto

MLauron delin: P.Tempest ex
Cum privilegio

BUY A FINE TABLE BASKET

The basket vendor and the mat seller both hawk handcrafted objects, produced locally or perhaps even within their families. However, he is poor while she is better off, his countenance is solemn and earnest while hers is pleasant and sunny, and his appearance is ragged while hers is stylish. She wears a fine hat and a loose linen scarf, not for fashion's sake, but to ward off the inclement weather. Her bodice is open, laced across stays or over stiffening in her gown. Her neckerchief, apron and gown sail out, caught by a blustery wind. They would have made balancing her burden on her head difficult; she steadies her load with her left hand. Her basket contains pottles like those of the strawberry vendor and small omnibus baskets, as well as several large, close-weave baskets like those used by fishmongers. Clearly, she serves other hawkers. But her cry is for table baskets going to those who are better off, which perhaps is why her trade is thriving.

Laroon's inventiveness appears in the taxonomy of baskets and basket weaving, which is encyclopedic. He shows speciality baskets like the flounder seller's and the deeper container of the broken bread beggar; he depicts shallow, flat, rimless baskets to show off strawberries. His baskets come with or without handles, and with or without legs or feet to allow them to be placed on the ground. He pictures baskets of great amplitude like the matchseller's, and deep, round baskets like the satin and taffety woman's; he draws miniature baskets like the wax and wafer seller's, pottles filled with strawberries and a different kind of pottle for cherries on skewers. The singing-glass seller has a small but capacious basket for hats. And, finally, he pictures open-weave baskets displaying baskets in all varieties, large and small, sold by this table basket seller who also sells woven hats.

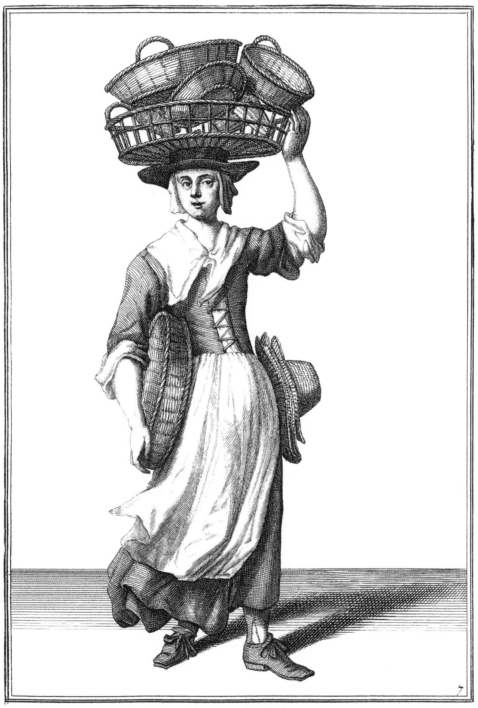

Buy a fine Table Basket.

A mes beaux Paniers.

Chi Compra cesti.

Mauron delin:

P Tempest exc:
Cum Privilegio.

Ha Ha Ha Poor Jack

This man's enigmatic cry, begun as 'Hey Hey Hey Poor John', by repetition became corrupted to 'Ha Ha Ha Poor Jack'. Poor John or Poor Jack is a small cod, salted and smoked. Trekking around England in the late seventeenth century by horse with two servants, Celia Fiennes described how Scarborough residents cured and cooked Poor Jack and how it tasted:

> they drye a large fish like Codlings and salt them and, when you dress them, water them, then they string them on wire and so rost them before the fire and make good sauce for them, they eate very well and [are] as tender as a fresh Codling and very sweete iff they were well cured when they were first taken, else they will taste strong.[13]

According to contemporary reports, Poor Jack came to London from Newfoundland: 'About 40 hundred Weight of choice, dry Newfoundland Fish (commonly call'd Poor Jack) lately arriv'd, being of this last Summer's taking and making, which for the Conveniency of Gentlemen will be sold for 28s. per hundred weight.'[14] The trade in Poor Jack and herring was a boon to England's economy: 'What vast Profit now does accrue to our Kingdom, by the Herring and *Newfoundland* Fishery! The Herring and poor Jack being exported to foreign Countries, become our Staple. And consider again how much of this Profit is owing to the Observance of *Lent* in the Popish Countries, where we trade?'[15]

This couple makes an artful contrast to the eel vendor on p. 96. But the disabled duo, perhaps maimed in their calling, are also a strikingly mismatched couple themselves. He is lame while she walks with the aid of crutches; his mouth is open crying while hers is closed; he looks out for customers while she stares down and inwards; his hair is full, visible and unkempt while hers is veiled by a loose hood. His knotted neckerchief clashes with his torn apron and missing jacket buttons; her outfit, from her wide-brimmed straw hat to her pleated gown and neat shoelaces, is elegant. But the supreme features of her dress – the billowing chemise sleeves tied by bows matching her apron knot and her long white gloves – declare her remoteness from the wet and dirty business of fishmongering.

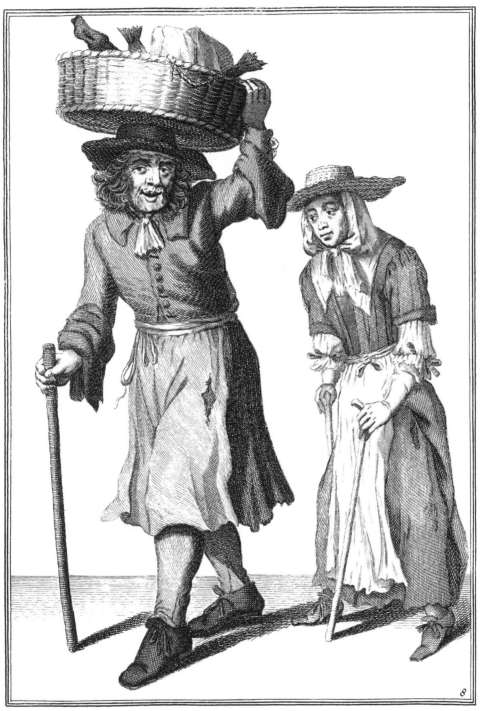

Ha Ha Ha Poor Iack

A ma bonne Merlüe

Merluzzo e Pesce salato

Mauron delin:

P Tempest exc:
Cum Privilegio.

BUY MY DISH OF GREAT EELES

'Ha Ha Ha Poor Jack' and 'Buy my Dish of great Eeles' are complementary portraits of fish vendors. The eel vendor works alone while the dried-cod man is dogged by his companion; the insouciant young woman sails along with her hand in her pocket while the older couple hobble by, he with the aid of a stick and she with two canes. The eel woman, glancing over her shoulder for customers, balances her basket on her head effortlessly, holding her measuring dish against her hip while he grips his basket with his hand to steady it. He hawks dried cured fish which seem to leap out of his tall basket while she sells live wet fish, covered to prevent them slithering from her shallow pannier.

While dried cod were sold by the piece, eels came by the dish. Unscrupulous vendors hid dead eels (given to them free by wholesalers) among the living. Eels were cheap, less expensive than cod, and large specimens were prized, thus 'great' eels. Pepys paid a shilling

an eel: 'we have three eales, that my wife and I bought this morning of a man that cried them about, for our dinner.'[16] In Worcester, Samuel Curwen, an American loyalist sojourning in England during the Interregnum, 'supt on spitchcock Eel nearly as big as my wrist, cost being only 1/8'.[17] Vendors sold eels alive but skinned them for their customers.

Laroon's original sketch for the eel vendor, preserved in the collection of the duke of Marlborough at Blenheim Palace, shows that the printmakers placed the drawings directly on the plates and indented them; thus, when printed, the engravings reversed the drawings. In the sketch, a heavy line made by the indenting is visible along the hem of the young woman's dress. The original drawing shows a childlike hawker who is wide-eyed and more expressive than the slightly petrified figure in the engraving shown here.

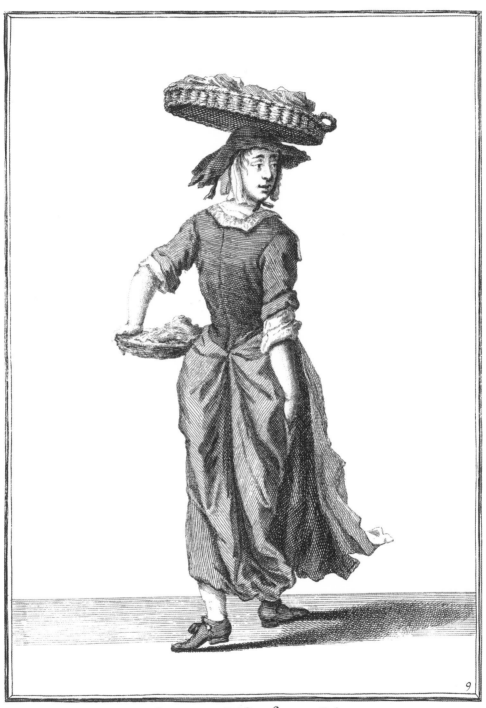

Buy my Diſh of great Eeles.

A mes belles Anguilles freches.

Anguille fresche, Anguille.

M.auron delin:

P.Tempest exc
Cum Privilegio.

9

Buy a fine singing Bird

The distinctive face of the vendor of singing birds is strong evidence against the assertion of some that the faces of Laroon's vendors all look alike. The bird-seller's eyes are dreamy, and his upper lip has a sharply defined cupid's bow and an upturned oral commissure. His head is cocked and his chin is cleft, while his hair is full and wavy. His dress is equally distinctive. His hat is a tricorn with an odd split at the front. A small scarf is knotted under his chin. He wears knee bands and small metal buckles, which impart a stylish air.

This notice from the *Post Man and The Historical Account* (26–29 July 1718) gives a sense of how intense the interest was in pets of all kinds at this time:

> A fresh Parcel of the finest Song Scarlet Nightingales, both Cocks and Hens, of the Sort for breeding as well as singing, as ever was seen in England, and Parrokeets of several Sorts, Amerdevates from the East Indies, fine talking Parrots of several Colours, and fine Cohowen Geese with black Necks, large breeding Pheasants, large Hamborough Fowls, small Indian Fowls and Geese, Muscovy Ducks, all Sorts of fine Pidgeons, Peacocks and Peahens, fine small Monkeys, fine spotted Sheep from Buenos Arres from the South Sea, breeding Turtle Doves with other Rarities. To be Sold by Michael Bland, the Owner of them, at the Sign of the Leopard and Tyger.

Domestic and foreign birds were sold by both hawkers and retailers. The best known of the latter was 'J. Meyer the German' at the Bird Cage in Long Acre, selling ornamental cages, pulleys, lines, maw seeds and all manner of bird seed. His advertisement in the *Tatler* warned that 'Those Cages that are proffered about the Streets, are not of his Making, nor the same; neither will they keep their Beauty'.[18]

Pepys kept a sparrow in his house, which entertained him and his family. It was 'so tame, that [it] flies up and down and upon the table and eats and pecks, and doth everything so pleasantly, that we are mightily pleased with it'.[19] Coffee-house proprietors also kept birds to entice customers: in 1695 Don Saltero's coffee house in Chelsea was among the earliest to exhibit exotic birds, indifferently dead or alive.[20]

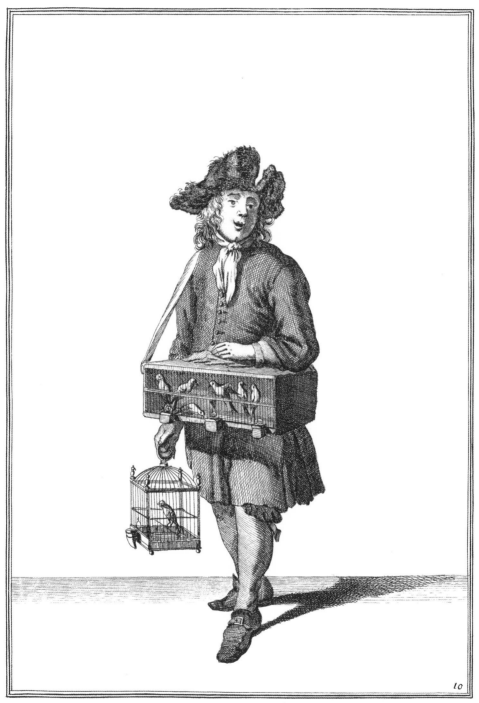

Buy a fine singing Bird

A mes beaux oyseaux qui chantent

Uccelletti che canta uccelletti

10

Mauron delin

P. Tempest exc:
Cum Privilegio

Buy any Wax or Wafers

The wax and wafer vendor and the ink seller (see p. 102) are antiphonal portraits of figures, male and female, following complementary trades, both commonly advertised together as stationery items. She sells sticks of wax (the French legend calls them 'Spanish wax'), the most elegant and secure method to seal letters and papers, envelopes not coming into general use until the middle of the nineteenth century.[21] Wax was commonly sold in red, but black wax was used to mark deaths and mourning.[22] She also carries, clutched in her left hand, rush candles or spills to melt the wax. In addition, she offers wafers, a cheaper and much simpler way to seal folded letters and documents; these differently coloured thin discs were made of an adhesive paste of flour and gum. She sells writing paper, which she urges on her (invisible) customers, such sheets being the most essential, costly and profitable of her lines.

The wax seller and the ink vendor are perhaps a couple; she is pregnant. Both of them are destitute from the evidence of their dress; her sleeve and especially her skirt are tattered, though her shoes are in good condition and have high heels, a fashionable feature. She wears two pieces of headgear, a straw hat and, for warmth, a loose linen scarf. The most puzzling aspect of her dress is her elaborate left cuff with a vent closed by five buttons. She has no corresponding right cuff, so this garment may be either the sleeve of a waistcoat worn for warmth or a cobbled sleeve attached to her gown. The poverty of these two people is perhaps due to the fact that literacy, especially the ability to write, was rare among their customers.

The *London Evening Post* (20–22 May 1731), in an advertisement, reported 'a dangerous Practice or Art whereby to open all Letters, Packets, &c. howsoever sealed by Wax, Wafer, or both', lately taught in London. A gentleman going only by the name A. B. proposed a remedy to guard against this iniquity: 'If any Person is desirous to be Master of this Discovery, and will leave a Line for A. B. at the Bedford Coffee-House in the Great Piazza, Covent-Garden, he shall be treated with.'

Buy any Wax or Wafers.

Cire d'Espagne, et oublies.

Ostie e cera spagná.

11

Fine Writeing Inke

While the previous portrait of the wax and wafer seller shows her in profile, this ink vendor is seen from behind. The iconoclastic choice to hide his face has the effect of emphasizing the destitution he shares with her. He goes in rags; his hat is battered and its rim partially gone. His left elbow is out, and the back of his coat has been repeatedly patched. The vent in his ill-fitting trousers is open and wants buttons, his stockings have been eaten away and his shoes have been made by a cobbler.

He sells quills and ink carried all day long in a heavy wooden barrel strapped to his back and weighing perhaps forty pounds. Quills were made by the vendor and his family from the feathers shed (probably moulted) by large birds – geese, hawks, crows and turkeys. This hawker's quills are notable for being fully plumed, their barbs producing a decorative effect that made them spectacular and easier to market. The tips of these are not square but sharply pointed and flexible, the sort that was favoured when writing became more common in the 1600s.

Ink was made according to various recipes or produced from a powder sold by manufacturers such as Charles Holman. His advertisement directed at hawkers and mercuries appears in the *City Mercury* for 4 July 1692:

> Holman's London Ink Powder for Records. Being a Whitish Powder that maks the Best and Strongest Black Writing Ink, by Dissolveing one 6 penny Paper thereof in a pint of Rain or River Water, by Shaking or stiring it well together, and when once it is made the Blacker and stronger it grows … The Powder is Seal'd up in 6 penny Papers, with the makers Coat of Arms … Made and Sold by *Charles Holman*, at the sign of the *Hare* near the *George-Inn* in *Southwarke*, he haveing his Majesty's Patent Granted him under the Great Seal of England, for makeing the Same.

Hawkers sold their ink for seven pence a bottle to customers supplying their own pots or wells.

Fine Writeing Inke

A ma bonne Ancre

Inchiostro fino da scriuere

Mauron pinx:

P Tempest exc:
Cum Privilegio

12

A Merry new Song

This plate features two balladeers, a couple. Couples in Laroon's *Cryes* often depict dramas, both positive and negative ('Ha Ha Ha Poor Jack', for example, on p. 94, shows a duo diverging in dress, relationship and work). This couple are dressed fashionably and dance harmoniously together. Her outfit stands out, with its full headscarf, laced bodice, cinched chemise sleeves and especially its elbow-length gloves. Her practicality is evoked by two large apron pockets. His hat and coat are pristine. His round-brimmed hat is perilously angled and looks as if it is falling off his head; hers is perfectly horizontal. The different angles of their hats are marketing ploys to draw crowds. He wears a tiny neckerchief over his coat, dramatic hounds' ears and triple vents open to dance. The prosperity of both balladeers contradicts their trade's reputation as mean and criminal. Allegedly, these hawkers gathered crowds for confederates to rob. Some of them begged as well as selling ballads.[23]

Ballad singers were lumped with vagrants and those of 'idle conversation', and were punished severely, as this notice shows:

> Whereas by an Act of Parliament, Intituled *An Act against unlicensed and scandalous Books & Pamphlets, and for better regulating of Printing*: It is Enacted and Ordained, that no such vagrant persons of idle conversation, who after the manner of Hawkers, doe cry about the streets, and sell Pamphlets and other Books; and under colour thereof, disperse all sorts of Libels, be permitted, but that all such Hawkers, and Ballad-singers, wheresoever they be apprehended, shall forfeit all Books, Pamphlets, Ballads, and Papers by them exposed to sale, and shall be seized upon, and conveyed unto the house of Correction, there to be whipt as common Rogues.[24]

A Merry new Song
Les Chanteurs de Chansons
Cantarine & Strada

Mauron delin:

P.Tempest exc:
Cum privilegio

13

OLD SHOES FOR SOME BROOMES

This man is not selling his wares but offering to barter new brooms for old shoes. The only other example of this in Laroon's *Cryes* is the man exchanging swords for old clothes (p. 140). As a barterer, the broom man serves customers of his own low status or menials labouring for those who are better off. A ragged fellow, he wears a tie or garter on his right stocking but none on his left. He is a bearded hawker, when the custom throughout the seventeenth century was to be clean-shaven. He carries seven brooms and, beneath them, a bag full of his old shoes: heavy, awkward burdens. His brooms are large and small, probably handmade by himself and his family. By contrast, the Parisian vendor (fig. 4) carries fifteen brooms borne on a donkey, which suggests that he is backed by a much larger artisanal operation.

Shoes were costly items. According to a notice in a contemporary London advertiser, Richard Croucher, shoemaker, offered 'a Pair of old Shoes, without Soals, for their Trouble' to anyone turning in his runaway apprentice, George-Mander Harris.[25] Not a single hawker in the *Cryes* goes barefooted, though the cock-horse vendor comes close.

Other criers looking to acquire wares to sell include the purchaser of old iron (p. 192), the cunny skin buyers (p. 112) and the satin and taffety woman (p. 150). These hawkers would buy objects from rich householders or their servants, to whom they would offer small money or trinkets.

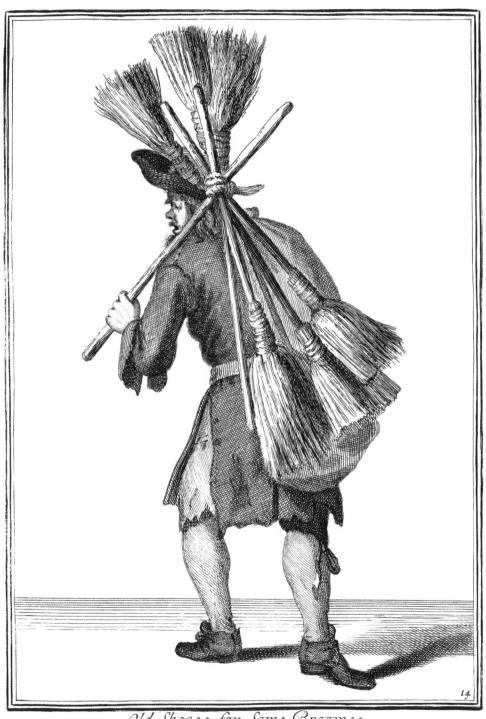

Old Shooes for Some Broomes

Balais

Chi cambia scope per scarpe vecchie

M.ʳ Lauron delin :

P. Tempest ex:
Cum Privilegio

14

HOTT BAK'D WARDENS HOTT

This woman hawks a small cooking pear called a warden. The Black Worcester Pear had been cultivated from the thirteenth century by monks of the Cistercian abbey near the village of Old Warden, Bedfordshire. Its hard, granular texture meant it had to be boiled before eating, and it was known as the 'iron pear'. This woman is selling the pears ready cooked as well as fresh. The fruit is mentioned in Shakespeare's *Winter's Tale*: 'I must have Saffron to colour the Warden Pies.'[26] When baked, the pear was seasoned with mace, ginger and sugar.

The pear seller, the most simply clothed of hawkers, dresses in plain winter garb which has been well looked after. It makes no fashion statement except perhaps for the three buttons on a sleeve. The coster hails from the country, from the evidence of her short cloak (these came in bright reds, scarlets or crimsons). She bears a large, heavy pot of pears in liquor on her head. Her balancing act is extraordinary: the day is stormy, as indicated by the winter wind whipping up her cloak; she is pregnant, but, most astonishingly, she walks on pattens

that elevate her from the street and that are treacherously slippery in wet conditions. Unlike the pattens of the cunny skin seller, the warden hawker's have soles made of flat metal rings.

The seller's balancing act is further complicated by the fact that she holds up her apron to make it into a sack, no doubt to carry ripe wardens to sell to those who wished to make pies. Nor is her task aided by the fact that the base of her pot is narrow. In the original drawing, the pear seller holds her left arm out from her body, gesturing to or enticing a customer with a warden. In a striking departure from the sketch, this engraving shows her adopting a maternal gesture, resting her hand on her belly and drawing attention to her pregnancy. In his *Journey to London in the Year 1698*, Samuel Sorbière comments on the custom of selling 'ready-to-eat' foods on London's streets: 'Though I take Pease to be too windy for Supper meat, and am inclinable to believe, that Hot Ox Cheek, and Bak'd Wardens, cried at the same time [every night] may be wholesomer.'[27]

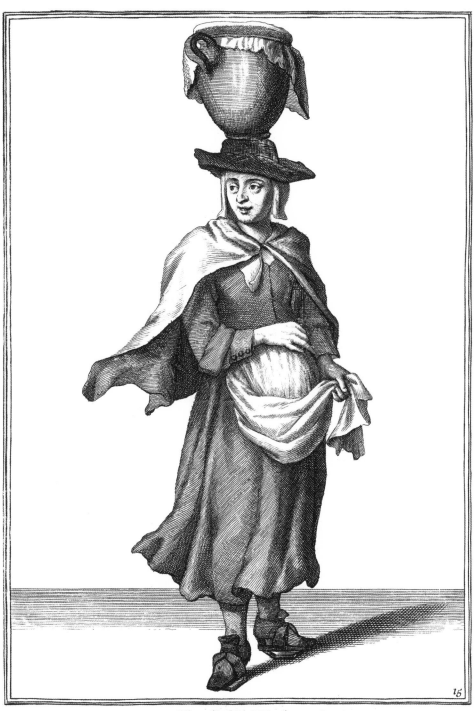

15

Hott Bak'd Wardens Hott
Pommes cuites Poires cuites
Mela e Pera cotte

Mauron delin:

P Tempest exc:
Cum Privilegio

SMALL COALE

Londoners spoke of three kinds of coal: sea coal, now called mineral coal, but also coal that came to London by sea from Newcastle; charcoal, produced from wood; and small coal, also called slack, which was refuse coal composed of dust and grains. By the late seventeenth century, coal was indispensable to London's masses and manufacturers: brewers, bakers, distillers, dyers and refiners. Pepys records that some 200 'sail' (boats) supplied London with coal. Coal prices fluctuated and he recorded those shifts. In 1666–7, when a labourer might earn fourteen pence a day,[28] it rose from four pounds a chaldron in March to five pounds ten shillings in June.[29] A chaldron is about twenty-five hundredweight or 1,287 kilograms.

This vendor carries a sack weighing several hundredweight, an immense burden to bear about London all day long; his powerful legs show that he is young and strong. He sells his coal by the peck (two gallons). Despite his filthy calling, he is well dressed in a long coat, which is fitted at the shoulders and loose below the waist where it billows out behind him.

Samuel Curwen, visiting the coal mines of the duke of Bridgewater, offers an insightful economic overview of the business in two pithy sentences: 'An 100 men are every day employed; and each man is able to turn out a ton a day; the miner's wages 2/− and the laborer's 1/4. The price of Coals at the pit 2d [a peck], if bought at the key 3½d, at the door 4½.'[30]

Women as well as men sold small coal. Elizabeth James, wife of the deceased Thomas James, hawked small coal around the Old Bailey. On 26 April 1697, however, she turned to theft, robbing a house in New Fleet Street of money in gold and silver, as well as a child's gold chain, the owner of which, Richard Barnes, offered two guineas 'and reasonable Charges' for her apprehension.[31] Nevertheless, the coal trade could be lucrative: when Thomas Wale, a small-coal man, died he was worth between £6,000 and £8,000 partly from wholesale coal selling and partly from lending money at interest.[32]

Small Coale

Qui veut du Charbon
Chi vuol Carbonella

Mauron delin:

P Tempest exc:
Cum Privilegio

16

Maids any Cunny Skinns

The cunny skin woman asks if maids have rabbit pelts to sell ('des peaux de Lapins à vendre'); she and the rabbit seller (p. 114) are a team. Their front and back poses are antiphonal: he walks forward, looking to his right, while she walks away from the viewer, glancing to her left; her sack is empty but his poles are full. She identifies her sellers as 'maids', the servants from well-off households, where menials made a little money from hides.

The cloth Laroon's vendor carries over her right arm and her own robe are torn and patched. On her feet, she wears pattens, from the Old French *patte*, meaning hoof or paw. Hers are made of metal and have a blade to them; they are tied over her shoes with bands of cloth. Used chiefly by women, they raised their wearers' feet and dresses above the mucky, wet and befouled streets when paving was rare; in snow, they provided traction. Poor women employed them to prevent wear and tear on their shoes, which were costly articles.

The cloth draped over her right arm holds her pelts. Cunny skin dealers were viewed as persons of ill repute, especially if they bore sacks or baskets, for which reason they were nicknamed 'baudy baskets'. Thomas Dekker, a chronicler of London's criminal underclass, defined baudy baskets thus: 'these will buy Conny-Skinnes, and in the meane time steale linnen or pewter: they are faire-spoken, and will seldome sweare whilst they are selling their waires; but will lye with any man that hath a mind to their commodities.'[33]

A notice in the *Public Advertiser* of the death of a nameless cunny skin dealer (buyers also sold skins and rags) reveals, with some bias, the lives these hawkers lived:

> On Monday last a Woman, who used to buy and sell Rabbit Skins, &c. about the Streets, went into a Public-house … when she complained of a Pain in her Stomach, and expired in a few Minutes. On searching her, nine Guineas were found sewed up in her Cloaths, and in her Room near an hundred Guineas more were discovered, grown black and tarnished. The above Woman is a remarkable Instance of Avarice and Nastiness: she scarce allowed herself the common Necessaries of Life; her Dress and the Bed she used to lie on were nothing but a Parcel of Rags, which swarmed with Vermin, and her Room was so offensive, that the Persons who attended her Funeral were unable to support it.[34]

17

Maids any Cunny Skinns.

Qui a des peaux de Lapins a vendre.

Chi ha pelle di Conigli.

Mauron delin:

P. Tempest exc:
Cum Privilegio

Buy a Rabbet a Rabbet

Among the seventy-four vendors in this edition of Laroon's *Cryes*, six sell fish but only two hawk flesh: the man selling live chickens and this one offering dead rabbits. He carries just four fully dressed carcasses (they perished quickly) and eight unskinned, gutted animals. The vendor's gutted rabbits are large specimens, weighing as much as twenty pounds apiece. Dressed coneys weighed half of that. Even if his rabbits weighed less than the heaviest, twelve animals would come to about seventy-five pounds, which the hawker carried all the way from Norfolk, Cambridge or Lincolnshire and then hawked about the streets of London. Hawkers undersold butchers, who charged ninepence or ten pence in the seventeenth century, but the price fell to fourpence in the early eighteenth century, when the cost of living plummeted.

Rabbits were enjoyed by the well-to-do. Samuel Pepys ate them together with another meat: a hash of rabbits and lamb or with two lobsters or a dish of steaks. The French travel writer Henri Mission expresses the traditional Gallic disdain for English food, including rabbits 'not delicately served':

Among the middling Sort of People, ... they have ten or twelve Sorts of Common Meats, which infallibly take their Turns at their Tables, and two Dishes are their Dinners; a Pudding, for instance, and a Piece of roast Beef: Another time they will have a Piece of boil'd Beef, and then they salt it some Days beforehand, and besiege it with five or six Heaps of Cabbage, Carrots, Turnips, or some other Herbs or Roots, well pepper'd and salted, and swimming in Butter: A Leg of roast or boil'd Mutton, dish'd up with the same Dainties, Fowls, Pigs, Ox-tripes, and Tongues, Rabbits, Pidgeons, all well moisten'd with Butter, without larding.[35]

Rabbits were hunted, raised and stolen: in one account a warren keeper's burrow was plundered by a father and son who were attacked by the owner's bulldog. The father assaulted the warrener with a hook 'and cut him so severely in several Places over the Head, that it is thought he will not recover ... [while] the Dog so worry'd the young Man that he was left in as dismal a Condition as the Warrener'.[36]

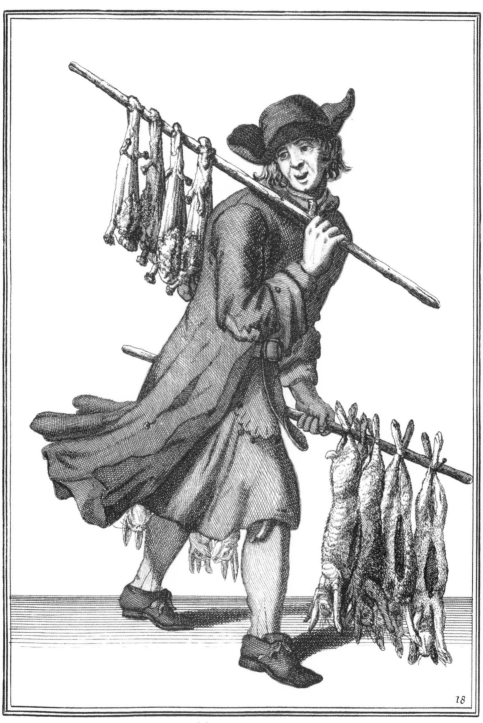

Buy a Rabbet a Rabbet

Qui veut des Lapins

Chi uuol Conigli grassi

Mauron delin:

P Tempest ex:
Cum Privilegio

18

Buy a Fork or a Fire Shovel

Hawkers' outfits play a large role in the *Cryes* and in the commentaries to the plates, constituting a visual encyclopedia of costume and showing in rare detail the dress of commoners in the late 1600s. In all seventy-four prints, Laroon never repeats the attire of any hawker, varying what the figures wear and, more importantly, how they wear it, as the costume of the fork and fire-shovel seller shows. Her distinctive dress is both remarkable and unremarkable. Its most striking item is her sugarloaf hat, with its tall crown sloping to a broad brim decorated by a band and cockade. This hat was worn with her white coif or plain under-scarf tucked into her gown, which suggests that she is a country woman. The hat, which had strong Puritan associations, was about forty years behind current fashions in 1687. Such hats were worn both outdoors and indoors; Pepys recorded that taking his hat off at dinner was a mistake, which caused him to get a cold.[37]

In other respects, hers is a plain, simple country outfit, use of which has eaten away at the hem. Her apron is short and pulled back to allow her access to her leather purse. Old and infirm (she uses a walking stick), she hawks in an engaged, direct and energetic style, carrying a shovel, fork and gridiron made by a blacksmith (perhaps a family member).

Such items appear regularly in contemporary newspapers, not as domestic implements but as weapons. According to a report in the *Morning Post and Daily Advertiser*, a pair of tongs, a fire shovel and a poker were carried to a Master in Chancery for purposes of litigation, which ended in an uncommon comedy. En route, words were exchanged between the defendant and the plaintiff, and the latter,

> being very much enraged, seized the poker, and made a violent blow at the defendant's head, which, if he had not been lucky enough to ward off, would probably have proved of bad consequence: however, the defendant, in return for this violent assault, immediately snatched up the tongs, and, seizing the plaintiff therewith by the nose, led him in triumph, braying like an ass, to Symond's-inn.[38]

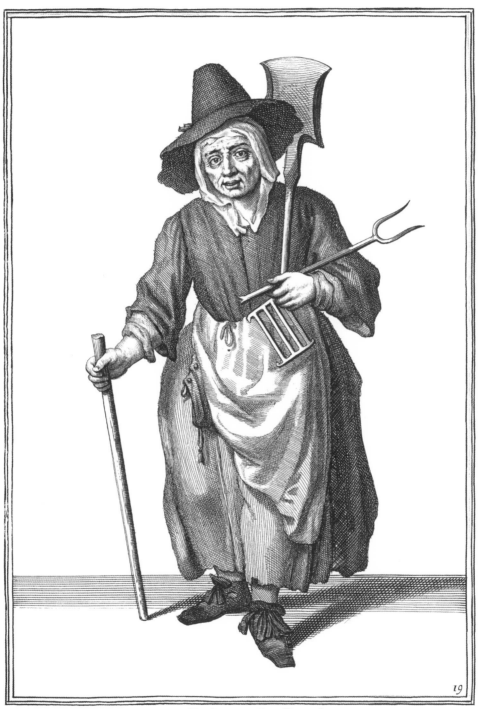

19

Buy a Fork or a Fire Shovel

Aux fourches et Paeles a feu

Palelle e ferri da fuoco

Mauron delin:

P.Tempest exc
Cum Privilegio

CHIMNEY SWEEP

The small-coal man, the seller of fireside implements and the chimney sweep are linked by their trades around domestic hearths. Sweeps advertised their services by a cry so raucous it drowned out other hawkers, according to Swift's 'Description of the Morning': 'The Smallcoal-Man was heard with Cadence deep, / 'Till drown'd in Shriller Notes of Chimney-Sweep.'[39] Though their cry was 'Sweep, sweep', they made more money extinguishing fires, a task that required small sweeps to enter flues that were still blazing hot.

The boy depicted here served as an apprentice, labouring for seven years, probably far from his parents' care and supervision. Masters recruited apprentices, some said to be as young as seven, from orphanages, destitute parents and magistrates caring for the poor. This apprenticeship could be extended for another seven years, after which they were dismissed because they were too big to enter London's narrow chimney flues. Nine by fourteen inches, flues made turns and twists but also branched and split before reaching the chimney tops. This configuration of linked flues came about because taxes were levied on the number of chimneys in a dwelling, the annual rate being two shillings a chimney in Pepys's day.[40]

To clean a chimney, the sweep had to crawl into the flue. Climbing up and down dark, narrow ducts meant that children breathed in soot, bruised their arms and knees, and got stuck in the mazes and warrens of chimneys. The *Public Advertiser* of 23 August 1776 reports the common fate of sweeps:

> Yesterday morning a chimney sweeper's boy being sent up to sweep a stove chimney in a counting house at Mr. Freer's, distiller, in Ratcliff-highway, the boy stuck in the narrow part of the chimney, and trying all his might to disengage himself, he missed his hold, and fell to the bottom; by which he was so terribly bruised, that he expired almost immediately.

Sweeps also died of carcinoma of the scrotum, the first reported form of occupational cancer, which was identified in 1775 by the British surgeon Percivall Pott, who noticed it among sweeps as young as eight.[41] Adults fared better than boys: '[There] died at his House near the Seven-Dials, Mr. Kent, a Blackmoor, Chimney-Sweeper to his Majesty's Palaces, a Place of considerable Profit. He is succeeded by Mr. Fatt, a Gentleman of the same Complexion that his Predecessor had.'[42]

Chimney Sweep
Ramonner la Cheminee
Spazza Camino

20

Mauron delin:

P. Tempest exc:
Cum Privilegio

CRAB CRAB ANY CRAB

While fishwives were often depicted as idle and debauched, this young woman appears energetic and spirited. She sweeps forward, her basket tilted to preserve her equilibrium and her rolled-up sleeves bespeaking her industriousness. Her prim, neat dress and apron (remarkably clean given her filthy, wet trade) sweep back, blown by her quick gait and a breeze. Prosperity and fashion surface in her shoes, which have high heels and are fastened by tiny laces. Her fastidiousness is reflected in the way she has lined her basket to prevent the salt water from ruining her hat. All in all, this is an idealized view of a young hawker.

The faces of Laroon's hawkers have long divided scholars; some claim that the visages are generic while others assert that many hawkers share the same face and that they are more mannequins than people. Laroon's original sketches at Blenheim Palace show that he paid minute attention to faces. He redrew several hawkers' visages on small slips of paper that he pasted over their original depiction when these did not meet his standards. The crab seller's face wears a smile that betokens a focus on making contact with customers. Her countenance is friendly and open if a little naive. Her face is lightly individualized. To judge if she has the same stereotyped face of other hawkers,

compare her visage with that of different fishwives, the mackerel seller or the eel vendor, for example (pp. 160 and 96).

Of the seventy-four vendors, one couple sells salted fish, two men flounder and oysters, and three women eels, mackerel and crab. Crabs were costly, going for about sixpence or even a shilling each in 1697. Celia Fiennes, the English travel writer who rode side-saddle through every county in England in the late seventeenth century, dined in York on 'Crabbs bigger than my two hands, pence apiece, which would have cost 6 pence if not a shilling in London, and they were very sweete'.[43]

The *London Journal* of 9 September 1732 reported:

> a remarkable Thing [that] happened here this Week and last. One John Clarke, a Fisherman, who lays Stalkers or Pot Nets for catching of Lobsters and Crabs, all the Summer, his Nets being pestered with Conger Eels … he contrived a Way to be revenged on them, and for that purpose baited large Swivel Hooks with Pickled Herrings … . [But a fox took the bait and, engulfed by the tide, drowned. Clarke caught two more foxes this way, and] went to the Churchwardens of the Parish of Huffham, who paid him for the Foxes according to Law.

21

Crab Crab any Crab

Qui veut des Cancres

Granci freschi

M.auron delin

L'Tempest ex:
Cum privilegio

OH RARE SHOE

The French caption for this engraving, 'Rare chose a voir', suggests that 'shoe' is intended as 'show'. This deliberate misspelling reflects the showmen playing on an exotic foreign element to draw an audience. Savoyards – itinerant musicians originating from Savoy in France, or those so denominated by artists and writers – were either reviled or romanticized. They were the chief impresarios of magic lantern shows and peep-shows in England. This showman, marginal and impoverished by his wandering life and nomadic calling, wears a battered hat, while his unkempt hair falls below his shoulders. His coat is torn and patched in several spots, ragged at the hem and secured at the waist by a rope.

He seems to have lost his teeth, which would make uttering his cry difficult. Using a drop cloth to cushion the burden, he carries his peep-show on his back, whose immensity and weight cause him to stoop. This device is handmade and decorated on the side to draw audiences; perhaps it represents a grand house, a theatre, a palace or a city. Scenes from the Bible and history were also common. Such peep-shows appealed to the inquisitive young and to their elders who were interested in recent discoveries in perspective and optics. Savoyards travelled to fairs and markets, gathering audiences with an act and persuading bystanders to pay. They twirled their batons, recited or sang, giving a performance that was both verbal and visual, and often promising something salacious or religious, as this German example shows:

> So I put up my box
> Each one pays a Dreier
> See here the fine rarity:
> How there holy Madeline stands.
> There find the three frail holy kings
> With white, red, and brown beard
> The pretty Catherine on her throne
> She shines like the moon and stars.[44]

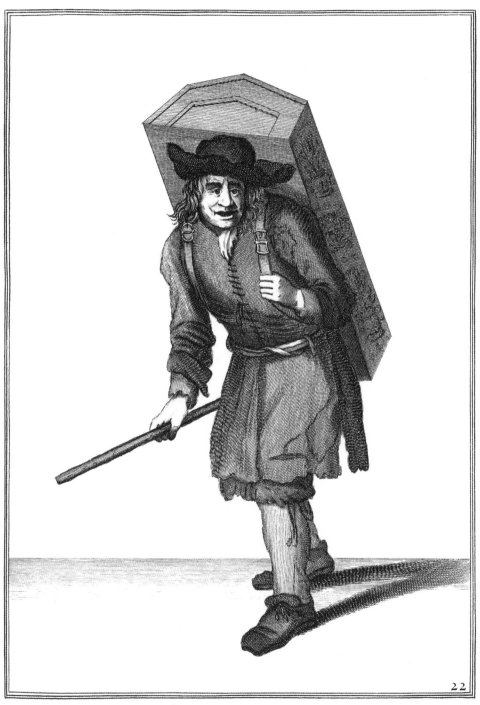

Oh Rare Shoe

Rare chose a voir

Chi vuol ueder merauiglie

Mauron delin :

22

P Tempest exc
Cum privilegio

THE MERRY MILK MAID

'The merry Milk Maid' and 'The merry Fidler' are pendant images showing these two celebrating May Day. According to Henri Mission,

> On the first of *May*, and the five and six Days following, all the pretty young Country Girls that serve the Town with Milk, dress themselves up very neatly, and borrow abundance of Silver Plate, whereof they make a Pyramid, which they adorn with Ribbands and Flowers, and carry upon their Heads, instead of their common Milk-Pails. In this Equipage, accompany'd by some of their Fellow Milk-Maids, and a Bagpipe, or Fiddle, they go from Door to Door, dancing before the Houses of their Customers, in the midst of Boys and Girls that follow them in Troops, and every Body gives them something.[45]

This 'pretty sprightly girl', identified as Kate Smith, is dressed in her Sunday best: an elegant full scarf under her hat, a bodice adorned with shoulder knots and square-toed shoes tied with floppy ribbons.[46] The most picturesque of all Laroon's street sellers, the milkmaid is remarkable for her statuesque figure and energetic jig, and her portrait has a strong element of the theatre or spectacle of her calling. She has dressed her hair in artful 'crutches' (curls making a fringe) and 'favourites' (ringlets by the side of her face).

The everyday graft of milk selling, which was dominated by hardy Irish and Welsh women, is reflected by her sturdy arms and the load she carries on her head. London dairymaids milked between ten and twelve cows each and serviced their animals twice, sometimes thrice, daily.[47] Early in the morning, milkmaids trudged to a cowshed, milked their cows, and hauled the beverage home by means of a yoke (not shown). They bore this heavy burden from house to house, up and down stairs; in the afternoon they repeated the same gruelling routine. They were also tasked with collecting debts, or 'dunning', a challenge William Hogarth caught acerbically in his painting *The Distrest Poet* (1736). The aggravation caused by debt collecting led to action, according to a notice in a contemporary journal:

> Whereas several of us who deal in Milk, have join'd together in order to have our Customers pay us when there is Due for Milk serv'd them to the Value of Two Shillings … by Reason that we are oblig'd to pay ready Money for our Milk, and our Circumstances will not permit us to give much Credit. We desire all Milk Men and Women to meet at the Blew-Boar at Mile End on Thursday the 25th of this Instant at eleven o'Clock in the Forenoon, to agree to the above Proposals. Made by John of Islington.[48]

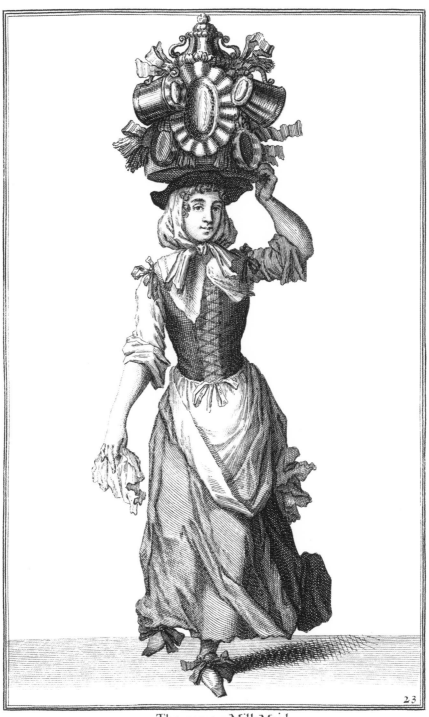

23

The merry Milk Maid
La Femme au Lait
Allegra Contadinella

Mauron delin:

P Tempest exc:
Cum Privilegio

THE MERRY FIDLER

The young fiddler, like the milkmaid (p. 124), is elegantly costumed. To announce the May Day festivities, he sports a cockade on his stylish hat and a second one on the neck of his fiddle. He wears a knee-length coat with open vents at the side and back. Their buttons are decorative, though some of them are missing, which suggests that he is not as prosperous as the milkmaid. Beneath the coat he wears a fancy shift with a puffed sleeve gathered by a drawstring. His breeches are full and tied with ribbons below the knees.

A somewhat darker version of the milkmaid and fiddler's May Day celebration records that, instead of borrowing silver from generous customers or trusting silversmiths, milkmaids rented their silverware from pawnbrokers who charged them by the hour. In turn, customers who did not volunteer tips were threatened by chimney sweeps and other youths who joined the milkmaid's parade. This carnival gradually moved from a gendered celebration to a 'begging holiday' in which men and women participated. Samuel Curwen witnessed a variant of this ancient custom in the capital and recorded it in his journal:

> Returned back to dinner; after which I again walkt up to London; in my way, in Ave Mary Lane saw a garland so called, being a pyramid consisting of 7 or 8 stories in the 4 angles of which stood a silver tankard; and in the sides, between each, lessening in heigth, as the stories rose, stood a silver salver the top crowned with a chased silver tea kettle round which were placed sundry small pieces of plate … carried on a bier and handbarrow.[49]

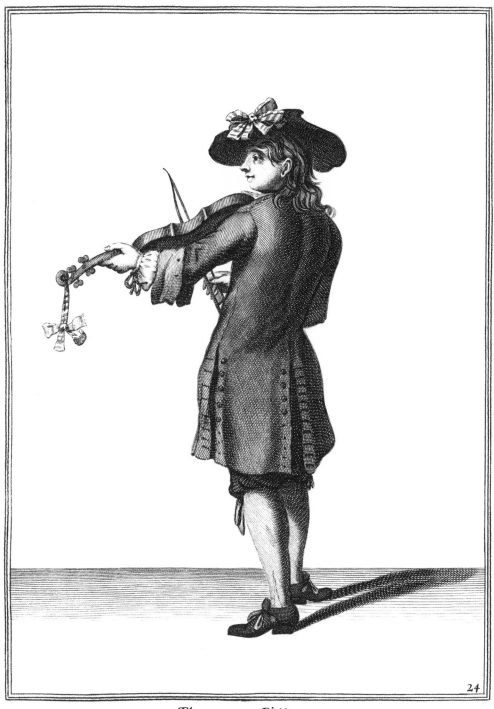

The merry Fidler
Le Violon
Suonatore di Violino

24

Lilly white Vinegar
3 pence a quart

The donkey is the star of this image. The animal's head is fully realized; even the nails in its hooves are depicted. It bears a wooden yoke with two casks of about ten gallons each. The vinegar seller is a rustic. Every other male hawker wears some kind of necktie, but this hawker exposes his neck and unbuttons his jacket, reflecting a long journey on a warm summer day. It was the custom for young people from rural England to wear flowers on their person or dress, and he wears a rose in his hair. Carl Moritz, travelling through England by foot and coach in 1782, remarked on a postilion travelling to London wearing a bouquet of flowers by his breast.[50]

Vinegar distilling was taxed and controlled. In 1688 the making of vinegar at home was banned in favour of commercial productions like those of William Turner who sold French vinegar at the Wine Vaults under the Royal Exchange, or of Mrs Prigg who sold wine vinegar for a shilling a gallon.[51] But the hawker likely sold his 'lilly white' brew without collecting the tax. Vinegar's chief use was as a piquant sauce consumed with all manner of foods. When he dined with the duke of York, Pepys reported that the duke

> did mightily magnify his Sawce which he did then eat with everything, and said it was the best universal sauce in the world – it being taught him by the Spanish Imbassador – made of some parsley and a dry toast, beat in a mortar together with vinegar, salt, and a little pepper. He eats it with flesh or fowl or fish.[52]

Because he owns a donkey, the vinegar seller belongs to a special legal category of vendors. The Act for Licensing Hawkers and Pedlars (1697–8) charged pedestrian criers four pounds a year plus a shilling for a licence. Those who owned a mule, ass or horse paid four pounds more plus two shillings for a licence. Commissioners for licensing hawkers, pedlars and petty chapmen held office over against the Bull and Gate daily (except Saturday and Sunday) from 9 a.m. to 12 p.m. and from 2 p.m. to 5 p.m., posting advertisements in the press about their attendance.

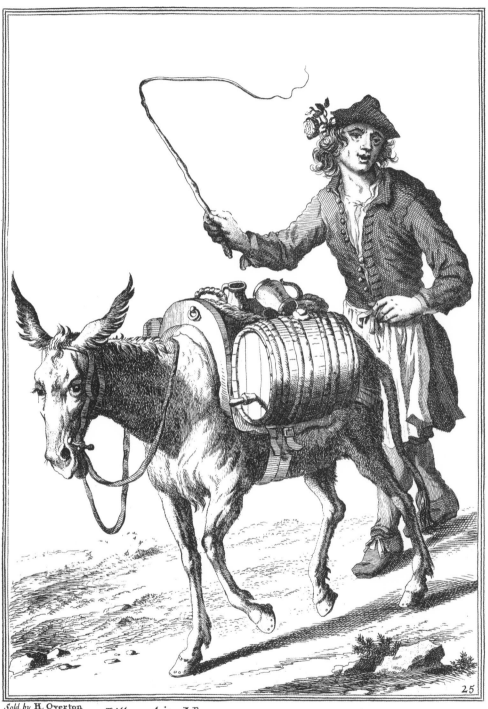

25

Lilly white Vinegar 3 pence a quart
Bon Vinaigre a trois Sols la pinte
Aceto forte tre soldi la misura

Mauron delin:

P. Tempest exc:
Cum Privilegio

BUY MY DUTCH BISKETS

The biscuit seller is one of the few women to sport just a large loose scarf covering her neck and hair, though wisps and curls appear at her brow and cheek as fashion statements. She wears her apron off to the right to protect her dress from biscuit flour. Her gown is a plain short frock worn over a long petticoat. In the seventeenth century shoes were markers of status and fashion; hers are modish, with half-moon toes and large tongues. They are also snug fitting, tied with large bows. The heel of her right shoe seems about two inches high. Her shoes were produced on straight lasts so that they were interchangeable, fitting either foot. They were made of leather or wool, while those of wealthy women were produced from fine cloth and choice pelts.

The vendor sells two kinds of spiced biscuits: warm ones in the small basket covered with a cloth and cold ones in the wicker carrier. She bears a heavy burden in both hampers; the principal one is immense, holding fifteen pounds or more of pastries. Her confections probably owed their popularity in England to the followers of the Dutch William of Orange. They date to the mid-1600s when the East India Dutch Company acquired a twenty-one-year monopoly on the spice trade. This monopoly on cloves, ginger, cardamom, cinnamon and nutmeg gave rise to their use in spiced biscuits. Called speculoos and popular on the feast of St Nicholas, they survive today in the form of popular Dutch windmill biscuits. No recipes for them appears in Gervase Markham's *The English Huswife* (1615), but Pepys reported calling 'for a biscuit and a piece of cheese and gill of sack'; and he served biscuits and 'burnt claret' at his brother's funeral, where the wine cost two pounds two shillings and sixpence, the biscuits four pounds eleven shillings and the coffin one pound nine shillings.[53]

Women bakers were prohibited by law from selling pastry, bread and biscuits, which was the sole prerogative of members of the Companies of Bakers. Those wishing to sell baked goods were required to serve an apprenticeship of seven years and to become a member of the Companies of Bakers, from which women were excluded. Women were allowed to serve as helpers to their husbands and could inherit their husbands' guild membership upon death. This biscuit seller is fastidious: her clothing is neat, perfectly preserved and clean, inspiring confidence in the wholesomeness of her food. She is probably not among the legion of women hawking bread baked illegally at home or in neighbourhood ovens.

26

Buy my Dutch Biſkets

A mes bons Biscuits d'Hollande

Chi uuol Biscottini Thedeschi

Mauron delin:

P.Tempest exc:
Cum privilegio

Ripe Speragas

The asparagus seller is one of the few vendors pictured in a restful pose. Her arms folded contentedly, she utters her cry and looks off to her right in a casual search for customers. Her headgear is particularly complex; she wears a hat, a scarf knotted at the back and a neckerchief under her chin. Her poverty can be deduced from the state of her coat, which is torn at the shoulder and eaten away at the sleeves and hem. Worn open in the spring weather, it lacks most of its buttons, as does its side vent. She wears a short apron and a long petticoat, equally decayed.

Penniless hawkers like the asparagus vendor commonly borrowed a small sum of money from an alehouse, bought their end-of-the-market produce cheap and repaid their loan with interest at the end of the day. Her vegetable is 'ripe'. Perhaps what she sells is wild asparagus, which is less expensive than the farmed variety. Both domestic and wild spears were common in England. In a manuscript treatise c.1614 Giacomo Castelvetro reported that English asparagus was both small and pricey as its cultivation was not well understood.[54] John Parkinson reported in 1640 that 'the poore people doe gather the buddes or young shootes, and sell them in the markets of Bristow, much cheaper than our garden kind is sold at London'.[55] Retail greengrocers and markets such as Covent Garden offered asparagus while pedlars hawked 'ripe speragas' in the streets.'[56] Wild asparagus has a fern-like appearance and produces red berries; domestic asparagus that is allowed to flower and go to seed looks like the wild variety. This hawker probably offers cultivated plants gone to seed tied in neat bunches and remaindered.

Pepys, a dedicated gourmand and a tireless accountant, bought asparagus at Fenchurch Street market, recording the cost of what he purchased: 'a hundred of sparrowgrass, cost 18*d*, we had them and a little bit of salmon which my wife had a mind to, cost 3*s*'.[57] Commonly paired with chicken, asparagus was reputed to be a diuretic.

Ripe Speragas

A mes belles Asperges

Sparesi freschi

Mauron delin:

P Tempest exc:
Cum Privilegio

27

Maids buy a Mapp

This hawker of mops identifies her customers as 'maids'. The term may be a generic designation for 'young woman' but probably refers to female household servants performing a variety of domestic tasks. This form of employment was more common than any other kind of labour available to women in London in the late 1600s, when employing one or more such servants was a sign of status, and domestics were not confined to elite or better-off households. In *A Harlot's Progress*, William Hogarth depicts Moll Hackabout keeping a domestic even when she is dying in destitution. This vendor does not work as a servant, though some did, for example Pierre Brebiette's 'Marchand de Plumeaux'. The London hawker's cry is for 'Mapps', a spelling evoking her regional pronunciation.

Her dress indicates that she is modestly prosperous. She wears a straw hat over a tight-fitting scarf, from which tiny wisps of hair and small ribbons escape. Such fine hats, when lined in the brim, were expensive, costing one pound four shillings in 1632.[58] In a sartorial flourish, she ties her skirt back to flaunt her petticoat, and secures it behind with a button or pin. Every item of her dress is in good repair. Over the petticoat she wears an apron; the way she rests her hand maternally on her belly shows that she is advanced in pregnancy. The wax and wafer woman is also pregnant, but her mood and circumstances are, in contrast, dire.

This hawker balances four mops on her head. These have perhaps been produced by her husband, though, according to the *General Evening Post* (18–20 October 1748), such items were available from 'John Speer, at the Three-Brushes without Bishopsgate, London; who furnishes Country Chapmen with all Sorts of Leghorn and other Hatts, Sieves, Brooms, Mops, and all other Turners Wares, Wholesale, as cheap as any Dealer in London'.

Maids buy a Mapp

Achetez de mes Mappes

Mappi ỷ lauar terrazzi

28

Mauron delin:

P. Tempest exc:
Cum Privilegio.

Buy my fat Chickens

Who is this ragged, bearded fellow and what is his story? Is he a country hawker or a forestaller and an engrosser? Forestallers and engrossers, who were city dwellers, bought up foodstuffs in large quantities and resold them at higher prices, demanding whatever the market would bear. A hated group of people, they followed a trade that was illegal, but were rarely caught and seldom prosecuted. This man's hat is battered and his once fashionable coat, with its buttoned vents, is out at the elbow as well as patched and re-patched at the shoulder. His beard is untrimmed, something that was rare in the seventeenth century.

Forestallers sold dead chickens as a matter of convenience. This man offers the more desirable live birds. His equipment shows that he is a professional; he hauls twelve fowls in three purpose-built cages, two suspended on a stick with nails at each end to prevent the coops from slipping off. But the most revealing clue to his identity appears in his shoes: trapped in the heels are wisps of grass, picked up when this country vendor trudged across the fields on his journey to London.

His pullets, a delicacy, would have fetched two or three shillings each in London but fivepence in the country. The well-to-do Pepys enjoyed cold fricassee and roast chicken at home and at the Sun Tavern in King Street.[59] In early *Cryes*, the chicken vendor appeared next to the asparagus hawker: the two foods were served as one dish, both being at their prime in the spring. Laroon's asparagus seller and chicken vendor display, symmetrically, a carefully devised contrast between the man hurrying away from us in a theatrical contrapposto, or counterpoise, and the woman facing us in a motionless pose.

Because chicken was prized, poultry theft was common but seldom in acts as violent or dramatic as the episode described in the *London Evening Post*:

> a Horseman riding along the Road at the Skirts of the Town [of Northampton], with his Whip catch'd up a Chicken and put it in his Pocket; which a Boy about five Years old perceiving, cry'd out, *Mamme, a Man has got our Chicken*; at which the Villain was so exasperated that he turn'd his Horse about, rode up to the Child, and at one Blow with the Butt-End of his Whip kill'd him on the Spot.[60]

Buy my fat Chickens

Jeunes poulets gras

Polaſtri Groſsi Polaſtri

29

BUY MY FLOUNDERS

Fishmongers are among the most numerous hawkers in the *Cryes* because of their prominence in London, where citizens abstained from flesh on fish days: Wednesdays, Fridays, Saturdays, all of Lent and certain vigils such as the Epiphany. But the supply of fish was also abundant in London because of the Thames, as reported in the *Weekly Packet*:

> On Thursday Morning last a great Quantity of all Sorts and Sizes of fresh water Fish, but chiefly Barbels, Flounders, and Eels, were taken up in the Thames, between the Bridge and Lambeth as they were floating, some quite dead, and others almost dead, on the Surface of the Water.[61]

Flounder, valued for their delicacy, were also caught on the Thames, where 'several Fishing-Nets that were lately seiz'd on the River were burnt before *Guild-Hall*, as being illegal, and under Size, and Flounders caught in them not so big as a Half-Crown were there produced'.[62]

The flounder seller is a young man in a trade requiring endurance and energy. This vendor needed to show up at Billingsgate fish market no later than 7 a.m.; once there, he tarried until privileged wholesale buyers and servants from 'great' houses and inns had taken their pick of the day's catch. This picking sometimes lasted into the afternoon, by which time street hawkers risked missing the important midday meal. At the end of the market, hawkers took what was left over: small, damaged and rotting fish. Their day then began as they carted their heavy baskets through London's streets and up and down stairs. Ambulant fishmongers' days ended as late as ten at night, later on Saturdays. Their baskets, weighing over fifty pounds when full, weighed hawkers down, while the handles of the containers bit into their shoulders, sometimes injuring them permanently. This man uses two baskets, a large one to carry his fish and a smaller one to measure out and offer them to his customers in a gesture of politeness. This is in strong contrast to the blunt manner of the aged mackerel seller, who holds a single fish passively in her hand, perhaps the last one in the market (see p. 160).

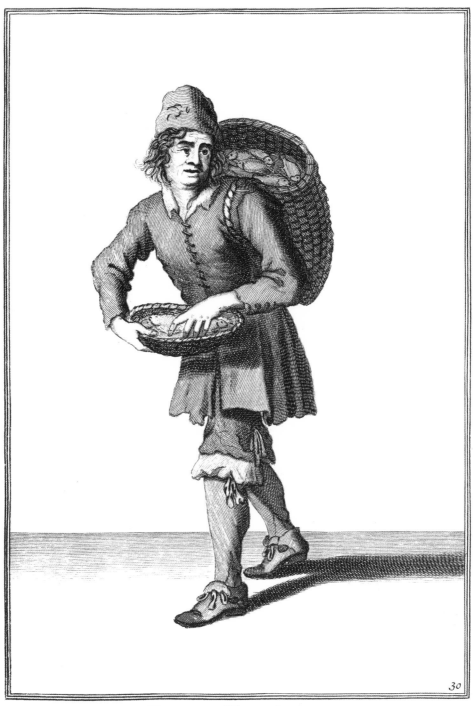

30

Buy my Flounders
Achetez de Plies ou Pluyes
Paſſerini da latte Paſſerini

Mauron delin:

P.Tempest ex:
Cum Privilegio

OLD CLOAKS SUITS OR COATS

This hawker seeks to buy, not sell, old clothes, according to the caption in French: 'Qui a de vieux habits a vendre?' Such cast-offs were valuable and marketable in the seventeenth century and later, when servants received them in part payment for their services. These transmissions were called 'castings' and came about as a result of changes in fashion and of a death in the family, which required people to wear mourning. The universal hallmarks of clothes hawkers were the several hats they wore on their heads, which made them easy to spot. This man wears a mix of fashionable and tattered clothing. His coat has torn sleeves and a ragged hem, but he wears a long, elegant cloak with a flat collar; this mantle, one of the items he solicits, is in fine repair. Among the items he has bought is a round nightcap with no brim; these were worn indoors for warmth. Trading in old clothes was not confined to the poor; the better-off Samuel Curwen sold his cast-offs to

a hawker he knew by name, and bought other items he desired: 'Sold to Jew Slate coloured suit and 8 pair stockins, purged my trunks of useless lumber. Took in 3 annual registers, second hand at 4/– each.'[63]

This vendor engages in barter, offering swords for clothing, a system of exchange then in decline. The system brought a greater range of goods and options to people working in menial trades. The man's customers would have been chiefly young males, to whom swords, with their status appeal, were more attractive than petty cash. On 3 February 1661 Pepys started wearing a coat and a sword 'as the manner now among gentlemen is': tellingly, his dress weapon was a used one.[64] About a year later he equipped his servant with a sword.

Old clothes buyers were accused of abuses at the Inns of Court: 'the Encouragement of Servants to pilfer, and annoying the Gentlemen in their Studies.[65]

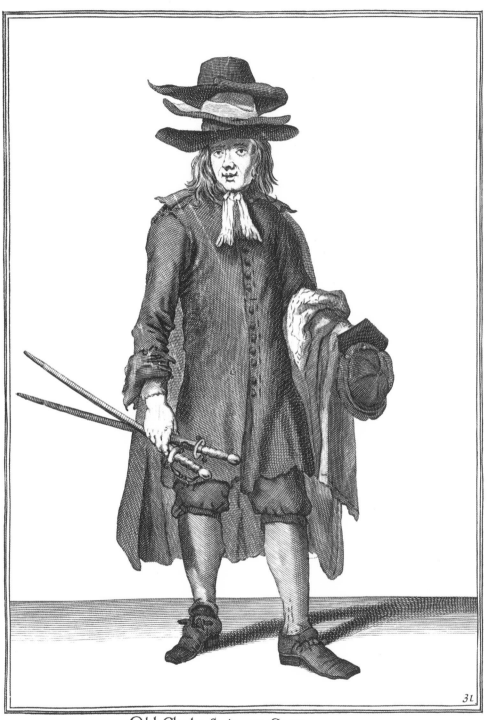

Old Cloaks Suits or Coats
Qui a de vieux habits a vendre
Panni vecchi drappi vecchi da vendere

Mauron delin:

P Tempest ex:
Cum privilegio

Fair Lemons & Oranges

The pose of this seller shows off her gown and the way she wears it. It is so detailed that a dressmaker could tailor it today on the basis of the print. With distinctive flair, she pins back her skirt to form a bustle displaying her petticoat, which was an item of public dress at the time. She rolls up her sleeves, indicating her industry and diligence. The effort to walk, carry, balance and steady requires formidable skill, especially when both baskets are full.

Lisbon, China and sour oranges were in general use in cooking and for snacking in the seventeenth century. At first all were luxuries costing a shilling apiece; by mid-century oranges cost three shillings a dozen. An advertisement of 1703 reads:

> Choice China Oranges, Sowre Oranges and Lemons, are to be Dispos'd off at very Reasonable Terms, by the Chest, or by Retail, at a Cellar under the Slop shoop, at St. Mary-Hill Corner, near Billings-gate: Where Attendance will be given every Day from Six in the Morning till Twelve at Noon, and from 2 till 5 in the Afternoon.[66]

In the theatres, these oranges were peddled by fetching women, like the celebrated Mary Meggs, a former prostitute nicknamed 'Orange Moll'. Mrs Meggs had been granted a licence for thirty-nine years to 'vend, utter, and sell oranges, Lemons, fruit, sweetmeats, and all manner of fruiterers and Confectioners wares' at the Theatre Royal, Drury Lane. She hired Nell Gwyn and her elder sister Rose as scantily clad orange girls to hawk the fruit at sixpence each.[67]

This orange seller seems honest and hard-working, though her profession was of ill repute. Some sold dried-out fruit that had been rehabilitated by boiling. Others carried gin or dice to tempt customers to wager for fruit or cash. In the theatres they delivered love letters or variously schemed to make money. One of their victims was Samuel Pepys. On one occasion a particularly brassy hawker demanded the price of twelve oranges from him, claiming that she had delivered her fruit to some ladies at his command, 'which was wholly untrue, but yet she swore it to be true; but however, I did deny it and did not pay her, but for quiet did buy 4s worth of oranges of her – at 6d a piece.'[68]

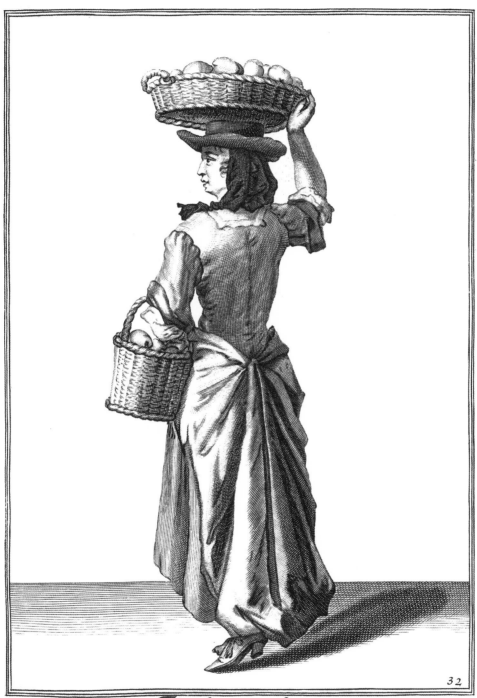

32

Fair Lemons & Oranges
Oranges & Citrons
Limoni e Aranci da vendere

M Lauron delin:

P Tempest excud:
Cum Privilegio

OLD CHAIRES TO MEND

The chair menders' trade was commonly carried out by a man and a woman, but this print perhaps shows an apprentice, whose more skilled master is no doubt nearby, demonstrating his skill. This hawker carries rushes or canes. Though the trade of mending old chairs is commonly reputed to be pinched and marginal, this perambulating marketer is well dressed, wearing a fine hat and silk cravat. He has more fasteners on his outfit than perhaps any other hawker in the *Cryes*: his chemise has buttoned sleeves, as does the coat. The latter also has buttoned side vents and a full line down the front of his coat, which sports two low horizontal pockets, both buttoned.

The strengths and weaknesses of Laroon's pencil are in full display here. The face of the chair mender is distinctive: its round countenance has clear features individualized by a tuft of hair by his ear, and his nose and lips are carefully moulded. But the man's hands are not as well drawn. The right hand is small but the left is disproportionately large, resembling a giant fist.

Because they were itinerants, old chair menders were reputed to be vagrants. Near Sevenoaks in Kent, two fires, which destroyed Farmer Lambert's and Farmer Powell's barns, were thought to be the contrivance of vagrants and 'strolling strangers' spotted lurking nearby. Four men and two women were examined. One of the men confessed that he was a brother of the notorious Burnworth, who had been hanged for murder, and that he and one of his companions travelled about with sham briefs,

> pretending to be dumb … [he] doubled his Tongue down his Throat before the Justice very surprisingly; he then stript up his Sleeve and shew'd a made Sore, which was effected in the following manner: They used to intoxicate themselves with Liquor, and then sear'd their Arms with hot Irons, after which, by applying proper Plaisters, they made Sores, in order to move Compassion … Another said he got his Living by mending old Chairs; but confessing before the Justice that he had sometimes begg'd, he was deem'd a Vagrant; and the four men were committed to Maidstone Gaol … When they came within sight of Maidstone one of them cry'd out, *Chairs to mend*, which alarm'd their Accomplices, who seeing them in Custody made their Escape.[69]

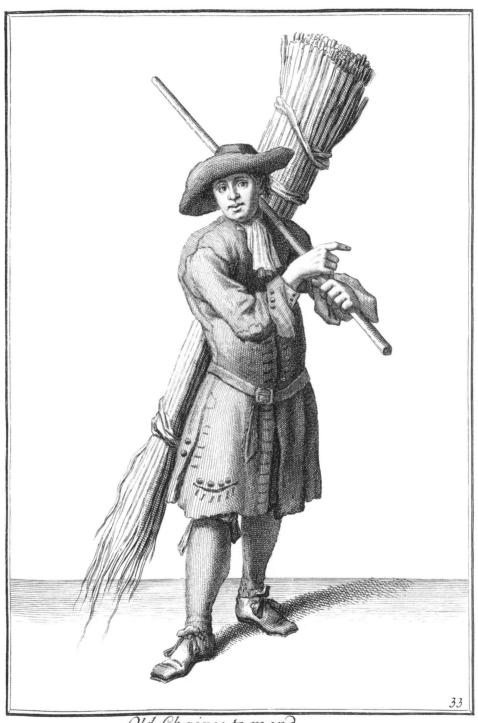

33

Old Chaires to mend
Qui a des vieilles Chaises a racomoder
Ha, Ha, Conciar Sedie

M Lauron delin: P Tempest excud:
 Cum Privilegio

Twelve Pence a Peck Oysters

The oyster vendor is comparatively well off. He owns a costly piece of equipment, an impressive machine, down to its complex wheel and the tiny metal brace holding his shucking knife, so his dishevelled dress may be due to his temperament (note his use of a piece of rope for a belt) or to the conditions of labour in his wet trade rather than to poverty. To propel this heavy contraption, he leans forward, using his body weight to wheel the wooden barrow. He offers his shellfish at twelvepence a peck but the pricing and classification of oysters was complex and vexed, as this reproachful notice shows:

> That no Person may be impos'd upon in the price of Colchester Oysters, Tho. West Fishmonger in Honey-lane Market at Blossoms Inn Gate, will for this Season, sell the largest pickt Fat and Green Colchester Oysters, per 3s. a Barrel, the next size Fat and Green, 2s. 6d. of the same sort, Fat and Green, some what smaller, 2s. the large White Fat 2s.
> 6d. the next size White Fat 1s. 8d. they are of every price, the true Colchester Oysters, each price is branded on the Cask side at the Oyster Pits, which I desire all Persons to take notice of, for it is to prevent Cheats.[70]

When labourers earned five shillings weekly, oysters were for the wealthy, which means that some hawkers, such as this man, served elite households. But perhaps he sold cheap or damaged oysters to all. His calling allows him to indulge in a personal luxury, tobacco; his clay pipe is tucked into the waistband of his apron. His dress is careless and worn, his hat torn and misshapen, his breeches unfastened, and his jacket is out at the elbow, lacks buttons and is tied by string at the wrist. In a curious nod to fashion, he wears a small scarf knotted about his neck. His face is individualized by a cleft palette and no teeth, afflictions that would have made his attempts to cry difficult.

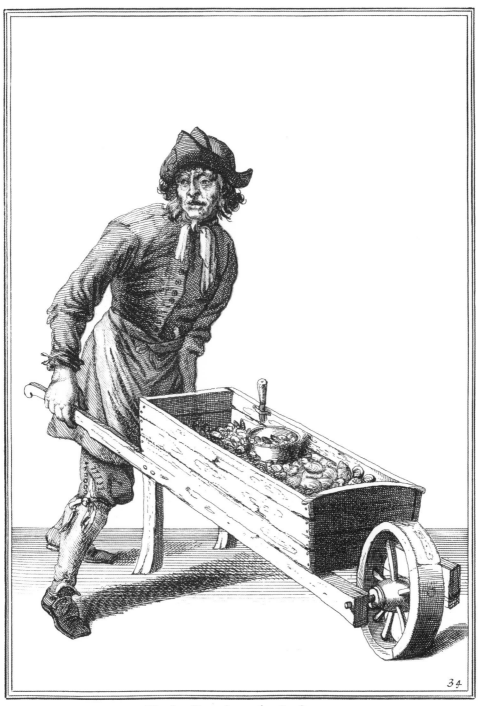

34

Twelve Pence a Peck Oyſters
Qui veut des huitres
Dodici baiochi il scorzo l'ostreghe

M.auron delin:

P.Tempest exc
Cum Privilegio

TROOPE EVERY ONE ONE

Selling children's toys was an impecunious business. The trade was not well established, most children's toys being made at home by parents, borrowed from adults' pastimes or repurposed from household gadgets. Others were devised by children themselves, as the young people in Hogarth's *Enraged Musician* show. So toys made for children were luxuries, bought only if there was money left over after household necessities like food, clothing and shelter had been supplied.

The best index of wealth and poverty in Laroon's time was the state of people's footwear. This man's toes stick out from his right shoe, the front of which is missing. Also missing is the toe of his sock, though the upper part, covering his thigh, is intact. His trousers fall off him in rags.

The vendor sells hobby-horses, which the French legend calls 'horses for children', altered from the English 'Buy a troop horse everyone'. Such toys were popular playthings from the Middle Ages on, when images such as 'St Dorothy with the Christ Child riding a Hobby Horse' (by an anonymous printmaker) appeared. Images of all kinds abound that show boys riding around with stick horses between their legs. Others show boys playing with them in mock jousts and fighting rival children or adults.

Because he blows a horn, this vendor was subject to the authority of Gervace Price, Sergeant Trumpeter to the king, who entered the following notice in the London press:

> Whereas several Persons do presume to Stroll about the Countries to make Show of Lotteries, Plays, Rope-Dances, Dumb Shows, Models, Mountebanks, Ballad-Singers, News-Hawkers, Scotch Pedlers, and other Unlicensed People; And also those that make use of Drums, Trumpets, Fifes, and other Wind-Musick, without License from Gervace Price Esq; Serjeant and Comptroller of all his Majestie['s] Trumpets, who is Intitled th[e]reunto by His Majesties Patent under the Great Seal of England. These are Therefore to desire all Mayors, Bayliffs, Sheriffs, Justices of the Peace, and Constables, to apprehend and Imprison all such Persons that shall presume to Act herein without License in Print under the Hand and Seal of the said Gervace Price Esq.[71]

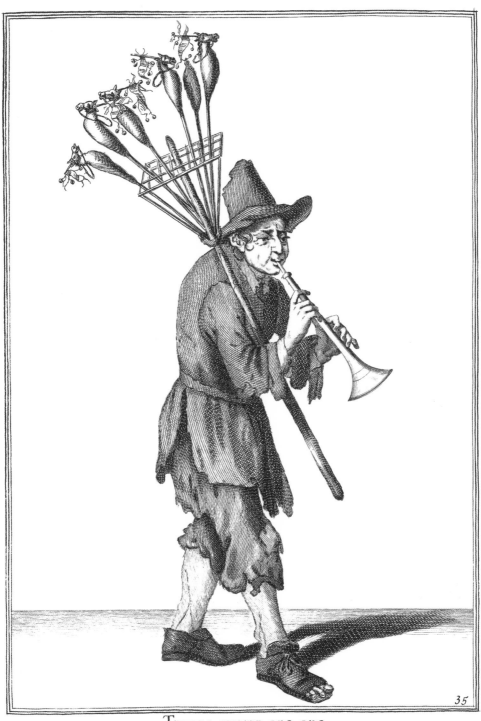

Troope every one one

Chevaux pour les Enfans

Ciufoli e galanterie ragazzi

M. auron delin:

P. Tempest ex:
Cum Privilegio

35

Old Satten Old Taffety or Velvet

This woman is the female counterpart (and perhaps partner) of the man crying, 'Old Cloaks Suits or Coats' (see p. 140); these two prints may originally have been tandem images. It is impossible to reconstruct the publication history of the *Cryes*, which was expanded from forty plates in 1687 to fifty in 1688, and subsequently to sixty, and finally seventy-four in 1689, and so it is not clear what the original order of the designs was. Both figures buy old clothes, specializing in luxury garments, and both dress in fashions beyond the means of common street dealers. The woman's emphatic and peculiar style, a form of professional deformation, sets her apart from every other female in the suite as befits a prosperous dealer in a lucrative trade. Her outmoded sugar loaf hat has a wide brim and a cockade worn over a full headscarf, which would have been brightly coloured. Her tailored bodice is fitted, pleated over her shoulders and joined in the front by a stomacher of echelles tapering to her waist. Its short puffed sleeves, with frilled fringes and turned-up cuffs, emerge from a chemise. She wears her dress that is pinned back and finishes above her ankles.

Wealthy families sold used clothing to seamstresses and dealers like this woman. Or they passed them along to upper servants in intricate ways: as wages, in castings or in fashion revolutions. Grace Ridley, waiting woman to Sarah, duchess of Marlborough, gained half her lady's wardrobe by formal bequest, the other half going to two maids who would have been free to sell these items, at least in part.[72]

Though this vendor is a figure of bourgeois elegance, most dealers like her were marginal or criminal types, like the Bayly family. The *London Journal* reported that two men, their wives and five children, setting out from Perth by foot, carried only a bundle of old clothes which the men bore on their backs. When they were apprehended near Worcester, they had 'two Horse, and an Ass well loaded, about Fourscore Pounds worth of Cloth, besides some Lace, Stockings, a Diamond Ring, Twenty Guineas in Specie, and Threescore Handkerchiefs that had been used; all which, 'tis supposed, were stolen'.[73]

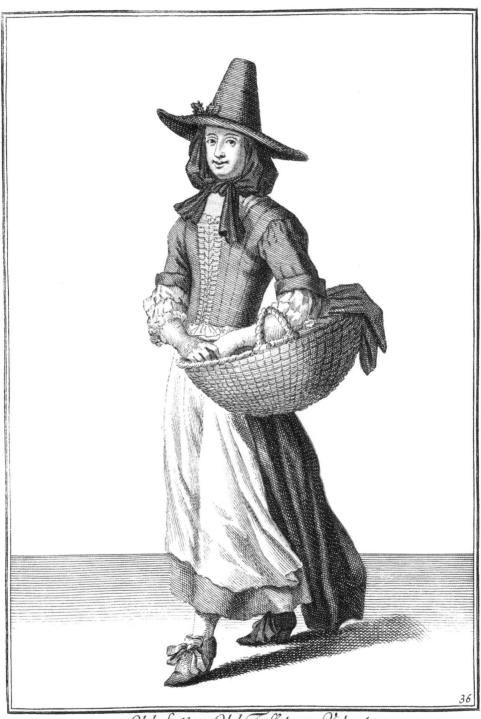

36

Old Satten Old Taffety or Velvet
Qui a des vieux Taffetas a vendre
Chi ha Robbe di Seta da vendere

M Lauron pinx:

P. Tempest excud:
Cum Privilegio

Buy a new Almanack

Laroon shows the effects foul weather has on the lives of street vendors, particularly in hawkers' dress and hands. Almanacs were sold in the winter, so this hawker bundles up against cold, wet weather. She wears a straw hat and, knotted tightly under her chin, a protective scarf that is blown back by the strong winter wind. She wears a short cloak wrapped around her right hand. Like her scarf, her cloak is whipped back by a gust. She lacks gloves, so her left hand is blue, as suggested by cross-hatching. She carries her basket by means of a strap running under her cloak. The basket is weighed down with almanacs, from bound copies between tooled leather boards to rolled sheets and broadsides. The latter were commonly stuck to the walls of public houses.

Thomas Nash claimed that 'prognosticating' almanacs were 'readier money than ale and cakes'.[74] In that age, the Bible and almanacs constituted the entire library of most families. The Bible provided moral and religious wisdom, while almanacs offered practical and utilitarian information: daily, weekly, monthly and yearly calendars; the phases of the moon; lists of English kings and queens; the dates, times and places of fairs; saints' days, holidays and holydays; advice on planting and reaping; weather forecasts; prognostications about the lives of the rich and famous; optimal days for taking a purge; health advice; and more.

The business of (publishing and selling) almanacs was strictly controlled by the Stationers' Company:

> If any others are published or sold, except those published at the said Hall, they are Counterfeits, and the Sellers of them will be prosecuted at Law by the Company of Stationers, as soon as discover'd. N. B. In the late Act of Parliament for Stamping Almanacks, there is a Penalty of 10 l. upon all such as shall sell any Almanacks, or any thing that may serve for the Purpose of an Almanack, not Stamp'd according to the Direction of the said Act.[75]

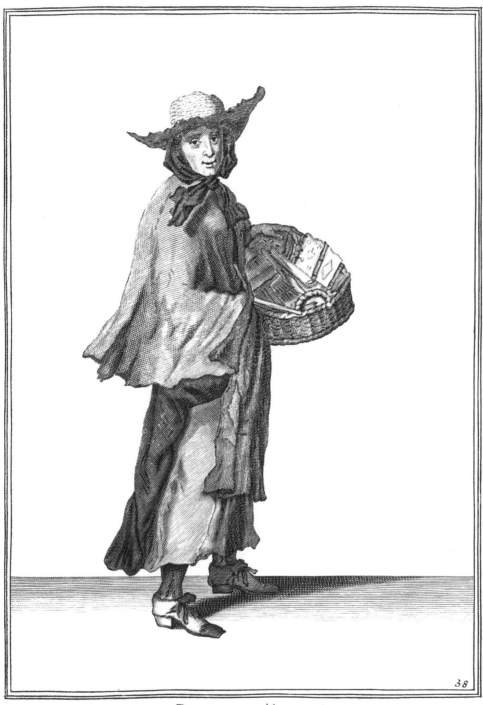

38

Buy a new Almanack
Almanachs Nouveaux
Lunarij dell'Anno Nuovo

M.auron delin:

P.Tempest exc:
Cum Privilegio

Buy my fine singing Glasses

While most of the objects hawkers sell survive to the present day, singing glasses have vanished without trace. Neither the objects themselves nor any written record of a musical performance involving them has survived, so, while we know a little about what kind of sound they made, we know nothing about the music they produced. This man plays and sells a long glass trumpet with a wide mouth. He also vends a short horn with a wide, closed mouth punctuated by a small central aperture. Both instruments are made of thin glass, so they must be exquisitely delicate.

While the objects and tales of their musical use have perished, an account of their manufacture survives in the diary of Samuel Pepys whose curiosity about technical processes and para-scientific things was unquenchable. Late to see a drama at the Duke of York's playhouse, Pepys amused his visiting cousins instead at one of the twenty-four glass-blowing houses operating in London and Southwark:

> and there showed my cousins the making of glass, and had several things made with great content; and among others, I had one or two singing-glasses made, which make an echo to the voice, the first that ever I saw; but so thin that the very breath broke one or two of them.[76]

Another reference, this time to the two smaller horns in the vendor's right hand, appears in the diary of Samuel Curwen, who saw and heard one in the possession of a boy, which may suggest that these glasses were children's toys:

> In field road met a boy with a thin glass in his hand of the shape of a bottle and size of 2 quarts, flatted at bottom, a hole in center about 2 inches over, and a small opening on one side squared to which he applied his mouth, making thereby an agreeable sound. He called it a music glass.[77]

The stick tucked into the hawker's belt suggests that he performs to draw audiences to his music by way of supplementing his sales; his basket and box intimate that he sells small glass objects or trinkets such as the tiny bottles in which the mountebank (p. 206) sells his medicines.

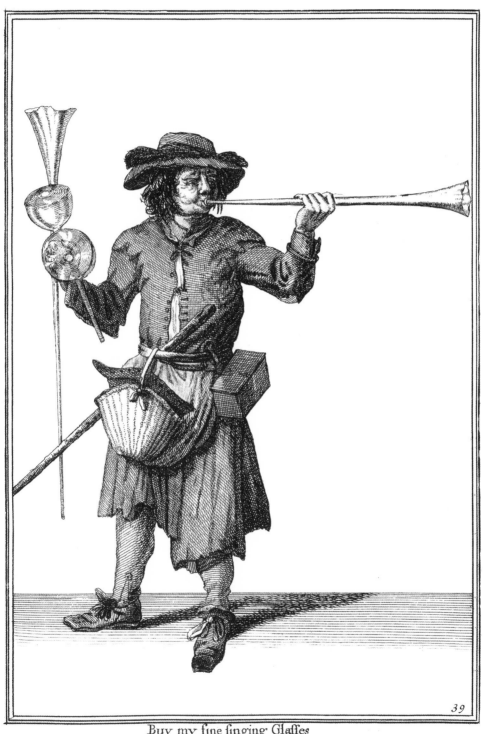

Buy my fine finging Glaffes
Achetez des Trompettes de verre
Chauob Trombette di uetro

M.auron delin:

P Tempest exc:
Cum Privilegio

Any Kitchin Stuffe
have you maids

This elegant young woman bought 'kitchen stuff' or tallow for small sums of cash from maids supplementing their wages of twelvepence a day.[78] The trade was crucially important owing to the vast consumption of tallow in soap making, but especially in candles, which were a necessity at this time. These woman sold their 'stuff' to aggregators who in turn sold it in large quantities to chandlers, some of whom were small general merchants and others of whom were wholesalers. Richard Towne, a London tallow chandler, was indicted for fraud relating to his trade. At his trial it was revealed that he intended to abscond to Holland or elsewhere, having shipped goods there beforehand. A Mr Jefferies declared under oath that he had delivered to Towne:

> a great Quantity of Tallow, amounting to about 100 Tun, worth at that time about 40s. a Hundred, for Mr. Vos and Partners; to which also the Prisoner was Debtor … Upon the whole Matter, the Jury, after having withdrawn for sometime, found him Guilty of the Felony, as laid in the Indictment; and he receiv'd Sentence of Death accordingly.[79]

The hawker, despite her clammy business requiring her to transfer fat from domestic pots into her tub using the knife lodged in its metal hoop, wears a spotless outfit with touches of fashion. Her headgear, composed of a carefully blocked hat and two scarves, one light coloured and the other dark, is especially elaborate. Her full black hood is knotted beneath her square collar. The layered headgear suggests a winter day, which is confirmed by the way she hides one hand under her apron and the other by her arm. Working with slimy, frigid grease turns her arms blue, which is indicated by cross-hatching. To keep her chemise clean, she pushes up her eye-catching puffed, pleated sleeves. She steps forward briskly, balancing her tub of grease without the need of her hands. In the kind of tiny detail that is characteristic of Laroon, her scouring knife appears to have been worn down a stave by repeated cleaning.

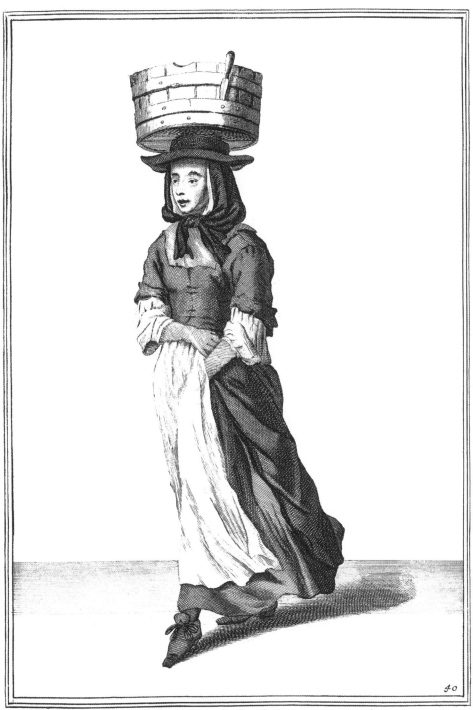

Any Kitchin Stuffe have you maids

Qui a de la Graiße a vendre

Chi ha Graßo da uendere

Mauron delin:

P Tempest exc
Cum Privilegic

40

KNIVES COMBS OR INKHORNES

The knick-knack vendor is one of the few male hawkers to look classy and commanding, in terms of both costume and bearing. His eye-catching hat is in perfect condition, his cravat is stylishly knotted, his chemise's cuffs are ruffled and turned back, the sleeves are pleated and his trousers are banded below the knees. His bearing and demeanour equally suggest prosperity and social standing. Not only does he lack the deferential, submissive or simply vacant attitude common in hawkers, but he is confident and graceful in the sway of his body and the gesture of his arm.

He carries a stout walking stick that has a hint of menace. Travelling pedlars like him who carried prized goods were sometimes the victims of thieves, according to contemporary reports:

William Moore, a Ropemaker, was committed to Ivelchester Gaol for robbing a Scotch Pedlar of his Pack, after they had been drinking together at the Weavers-Arms in Bedminster. It seems they walk'd together … when Moore took an Opportunity to push the Scotchman over the Bank, and forcibly took away his Pack and made off with it.[80]

And all hawkers carried cash. According to a report in the *Penny London Post*, Mr Park,

a pedlar, was robbed of thirteen guineas, one moidore (a Portuguese gold coin worth twenty-seven shillings), a thirty-six shilling piece and three shillings in silver by two highwaymen.[81] The ample stock and high value of Laroon's figure suggest wealth comparable to that of Joan Dant of Spital Fields, London. Dant was married to a weaver; when he died, in a common professional move she became a pedlar. She specialized in hosiery, mercery and assorted haberdashery. When she died in 1715 at the age of eighty-four, she left a fortune of over nine thousand pounds, saying as she made her will, 'I got it by the rich and I mean to leave it to the poor.'[82]

The *London Gazette* for 13–17 May 1686 published 'A [Royal] Proclamation' reaffirming an Elizabethan Act of Parliament against pedlars and petty chapmen 'unless they be Licensed according to a Course lately taken by Us in that behalf. *James R.*' The proclamation declared 'That all Pedlars, and Petty Chapmen wandring abroad, should be Taken, Adjudged and Deemed Rogues, Vagabonds, and Sturdy Beggars, and be Punished, as by the said Act is Directed', including by imprisonment and whipping.

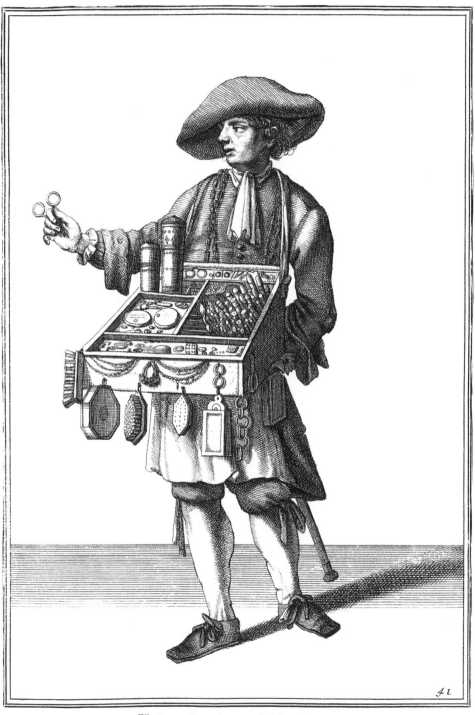

Knives Combs or Inkhornes.

Couteaux Peignes Ecritoires.

Calamari Petteni e Coltelli.

Mauron delin: P. Tempest exc: CumPrivilegio.

FOUR FOR SIX PENCE MACKRELL

The mackerel seller is a sympathetic study of a fishwife in old age and poverty. She is both an archetype of outcast humanity and a compelling human being, as particularized by her dress, her stance and her face. Like every other female hawker in the *Cryes*, she conceals her hair with a hood out of modesty. Even the prostitute (p. 178) covers her hair partially with a large diadem and a black scarf. The rope dancers (p. 204) are exceptions, but they too wear large ribbons that cover some of their hair.

The winter weather is evoked by her layered dress – perhaps she wears most of the clothing she owns. All her garments are patched and repaired, not in a slapdash way but neatly and carefully. This sartorial restoration testifies to her determination, as does her stolid pose; she is one of the few vendors to be depicted motionless. She owns no utensils of trade, holding her mackerel in her hand, limply by her side.

Rooted to the spot by both feet and her thick stick, she hawks her single fish passively; instead of seeking out customers, she waits for her regulars to come to her. She may trade on sympathy but she does not beg. Though impoverished, she is not homeless: the key to her dwelling hangs by her side. Her financial competence is betokened by her fat purse closed with a long string. What she lacks in energy she makes up for in resolve. The hard, punishing life she has lived is represented by the loss of her right eye, perhaps in a fight with a competitor. As a result of age or misfortune, she has lost all her teeth. She recalls the figure of old woman Lent, who is allegorized as a hag with a fish in her hand.

Because mackerel swim in shoals they were often caught in vast quantities: in Portland, according to the *British Journal* (4 May 1723),

Fishermen had caught such vast Quantities of Mackerel, that they were sold in that Town 3 or 400 for a Penny; … such infinite Numbers of them were taken, that the Fishermen threw Multitudes of them into the Sea again, it not being worth their while to carry them away.

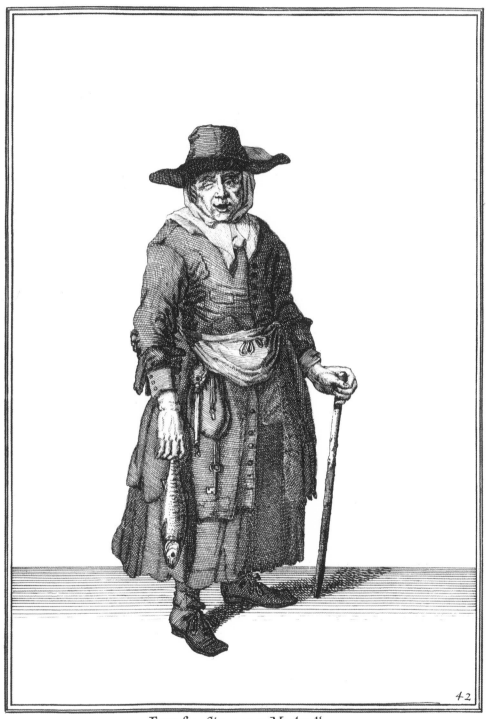

42

Four for Six pence Mackrell
Maquereux quatre pour Six Sols
Quatro Sgombri si sei Soldi

Mauron delin:

P.Tempest exc:
Cum Privilegio

Any work for John Cooper

The portrait of the cooper (barrel maker) emphasizes his professional identity in the striking geometry of his hoops, saw, drill and sack. Neither a master nor an apprentice, he is a journeyman cooper, who, having served out an apprenticeship or otherwise acquired the skills of his trade, seeks work where he can find it, performing small tasks for householders, including coopering and general carpentry.

Coopers were among the most skilled craftsmen of the pre-industrial age, making entirely by eye a vast variety of vessels for general and specific purposes: casks, barrels, pipes for wine, tuns, churns, hogsheads, butts, firkins and more. These could not leak or explode from ferment; they had to hold precise legal quantities, and they needed to withstand rough handling in different climates, as they were used for shipping. The trade was organized into four categories: dry and tight coopers making vessels to keep water out; wet and tight coopers constructing containers to keep liquid in; dry and slack coopers producing receptacles to store or transport dry goods; white coopers who produced tubs, pails or churns with straight staves to contain water but not ship it.

Prosperous coopers were also vintners and alehouse keepers.

Capturing a representative moment in time, Laroon's designs seem to suggest that hawkers followed a single calling continuously. In reality, they took work where they found it, even seizing or manufacturing their own opportunities, legal or illegal. According to contemporary reports, a ring of men, one improbably a blind man called Cooper, was arrested 'for their Dexterity in splitting of Farthings, silvering them over, and passing them for Six-pences: The Gang consisted of nine, but five of them escaped for that Time: One of these taken, is Wife to Cooper the blind Man, formerly try'd for coining'.[83] A bill of indictment was found against the blind man, named John Cooper, and his wife, alias Elizabeth Reeves, for high treason, namely, counterfeiting a moidore, a gold Portuguese coin worth twenty shillings. The punishment for counterfeiting the coin was death. At the trial, Cooper and Reeves were acquitted, but one of his accomplices was convicted and fined twenty pounds, capital punishment commonly being rejected when it was judged disproportionate to the crime.

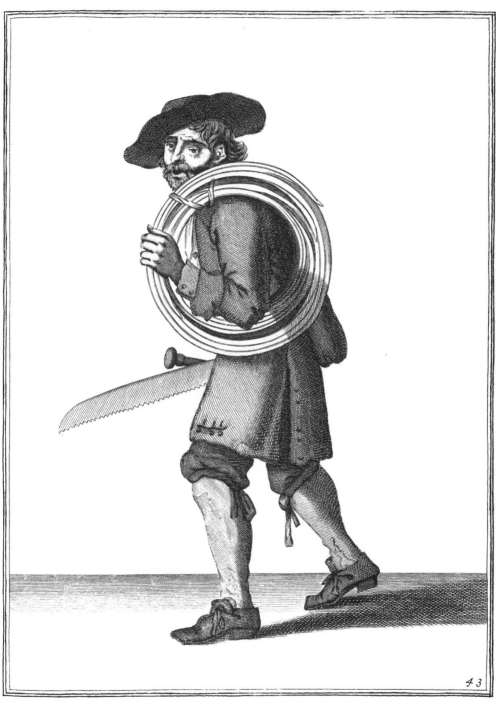

43

Any work for Iohn Cooper

Vieux Tonneaux vieux Poincons
Concia Mastelli

Mauron delin

P Tempest exc
Cum Privilegio

4 PAIRE FOR A SHILLING HOLLAND SOCKS

This vendor is uniquely professional. She carries a purpose-made coffer to keep her socks dry and to display them. She exhibits her wares for customers to see, a new style of selling condemned by John Stow who denounced dealers like her who 'made such a Shew in the Passengers Eyes, that they could not but gaze on them, and buy some of these Knicknacks, though to no Purpose necessary'.[84] Her box, attached by a string to her dress, has double locks. She is also a clever marketer, offering her merchandise at a discount for purchases in parcels of four. To underline the lure of her discount, she specifies her price. These strategies show that she knows her buyers are rich. This woman sells footwear on a cold winter's day, which is indicated by her being bundled up against the wind blowing back her apron. She also wears a full scarf under her hat and, most unusually, often colourful gauntlet gloves that reach to the sleeves of her dress.

To prove that visitors to London's Ranelagh Gardens were classier than those at Vauxhall, Carl Moritz pointed to their hose: 'I saw no one in all that throng who did not wear silk stockings.'[85] Holland socks, by contrast, were woven from linen thread. People sometimes wore these over silk stockings to preserve the latter. This hawker's socks are either homemade or were bought at auction.

With its tale of adoption and its narrative of a firm purpose of amendment, the life of Roger Moor, a sock vendor charged with breaking into the house of John Barton and stealing 'two coppers and an Alembick', may be taken as typical of poor hawkers' sagas:

> He said, he was about 20 years of age, born —— he could not tell where; for he knew nothing of his Parents, nor how he was first brought up; but only, that an Old Woman living in Temple-street at Bristol took care of him, as her own, when he was but a Child: That after he had receiv'd some Education, and was become capable of Business, he apply'd himself to the Pedlars Trade, selling Stockings &c up and down the Country, by which he could get an honest Livelihood; and so did, till the Evidence against him induced him to do ill things, and particularly the Fact he now stood condemn'd for; which he said was his first, and would be his last, where he to live never so long in this World.[86]

He was nevertheless condemned, and hanged at Tyburn.

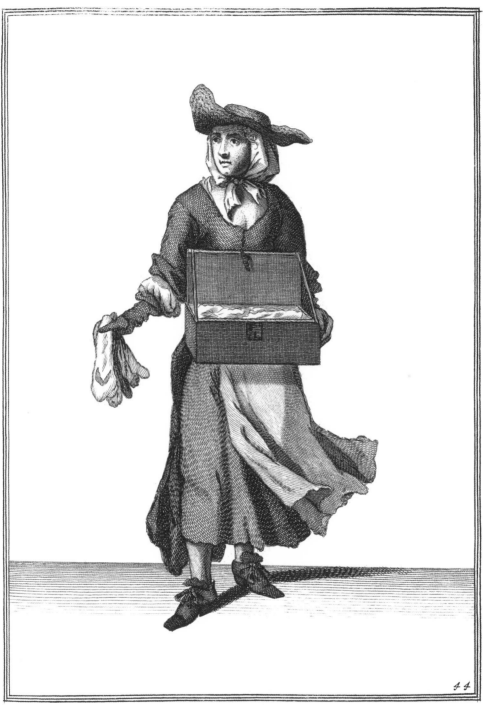

44

4 Paire for a Shilling Holland Socks

Achetez des Chaussons

Chi uuol Scapini d'Holanda

Mauron delin:

P. Tempest exc:
Cum Privilegio

COLLY MOLLY PUFFE

To accommodate Continental buyers the French caption for this cry reads, 'Bonne Patisserie a vendre', while the Italian declares, 'Torte e Pasticci da vendere'. The vendor's pastries were tarts, gingerbread, custards and the puff pastries of his name. In his *Biographical History of England*, James Granger identifies the man by the appellation given him in the title and writes: 'This little man, who had nothing at all striking in his appearance, and was but just able to support the basket of pastry which he carried upon his head, sung, in a very peculiar tone, the cant words which passed into his name.'[87] Actually, his appearance is singular because of his misshapen condition; he appears to have no neck so that his head sits forward on his upper chest. He is able only to carry his basket on his head with the help of his walking stick. Colly Molly Puff was a hawker of renown in his own day. He is mentioned twice in Addison's *Spectator*, both times by name. The periodical refers to him as a man of 'agreeable and noisy Memory' and calls him Mully Mully Puff; another piece singles him out 'by the Name of the Colly-Molly-Puff' for having invented a melody and lyrics of his own.[88]

The pastry man wears a broad-leafed hat, a cravat, trousers tied at the knees and a long coat protected by a flowing apron. His coat is open to show multiple buttonholes; it is looped behind at the bottom and tied back by a single clasp. Both his coat and his strong shoes are in fine condition. He covers his goods with a cloth to preserve them from rain and filth, as well as to keep them fresh and safe from the jests of street urchins who stole and spat on them. Rain was just one of the many hardships affecting vendors such as this man. A heavy downpour could spoil his pastries while three or four days of rain could discourage householders from venturing out of doors. A sore throat could be ruinous. So too could a cold, a painful foot or a gimpy leg.

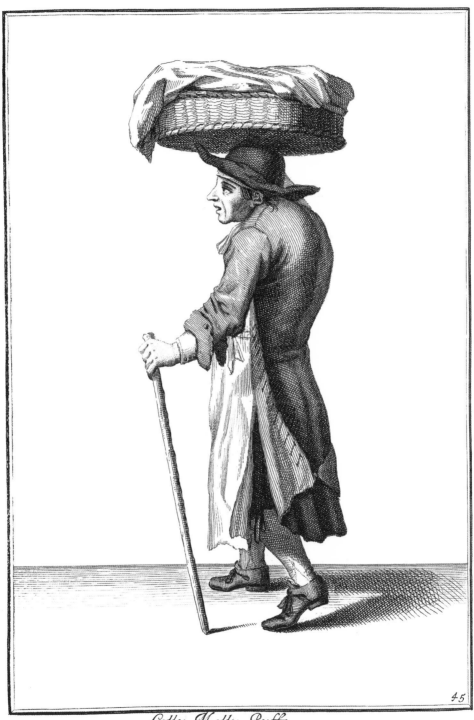

Cotty Motty Puffe
Bonne Patisserie a vendre
Torte e Pasticci da vendere

M. Lauron delin

P Tempest excud:
Cum Privilegio

45

Six pence a pound fair Cherryes

Laroon depicts hawkers such as the cherry seller as pleasant, industrious people labouring single-mindedly and in solitude. This woman, pretty, young and respectable, dresses in a prim, plain style. She wears her headscarf loose and knots her light-coloured kerchief over a round collar. The sleeves of her dress and chemise are rolled up for work. Like the seller of lemons and oranges, she wears her dress pinned back, but it is depicted frontally to display her petticoat and apron.

Her style of selling is visual, not auditory. Mouth closed, she draws clients by catching their eye. She displays her fruit on sticks with different kinds of points. Some hawkers cried 'Cherries in the rise', offering fruit still attached to twigs. This vendor's sticks are mounted on a small basket by which she measures her fruit. By this method she perhaps intends to tempt her customers to purchase by a sample. Or perhaps she sells cherries by threes and fours or so to children or poor people. At sixpence a pound, cherries were a luxury, especially since a labourer earned only eight pence a day. In her journal of 1702, Celia Fiennes describes riding through Gravesend,

> which is all by the side of Cherry grounds that are of severall acres of ground and runs quite down to the Thames, which is convenient for to convey the Cherries to London; for

here the great produce of that fruite is, which supplyes the town and country with the Kentish Cherrys, a good sort of Flemish fruite.[89]

The business of this cherry vendor and other costermongers required abundant physical powers, reserves of energy and mental acuity, which is why so many hawkers were young and so few old. First, hawkers had to possess the stamina to carry one or two heavy baskets through the hazardous London streets. This exercise exposed them to the perils of the weather. In Kent in 1717 twenty hours of heavy rain, followed by a terrible wind storm, produced a 'Slaughter likewise among the Apples and Pears [which] is so great, that our Costermongers look very melancholy'.[90]

A London newspaper retails an outlandish, mildly francophobic and apocryphal tale from Paris: a debtor in the Chatelet was observed to be melancholy,

> a thing very common in France, upon which the keepers refused him the use of knife or fork, lest he should be tempted to do himself a mischief; but he desired he might have some cherries to eat, accordingly a pound was brought him every day; he wove the stalks of these cherries together in such a manner, that in a little more than a week he made a rope, with which he hang'd himself.[91]

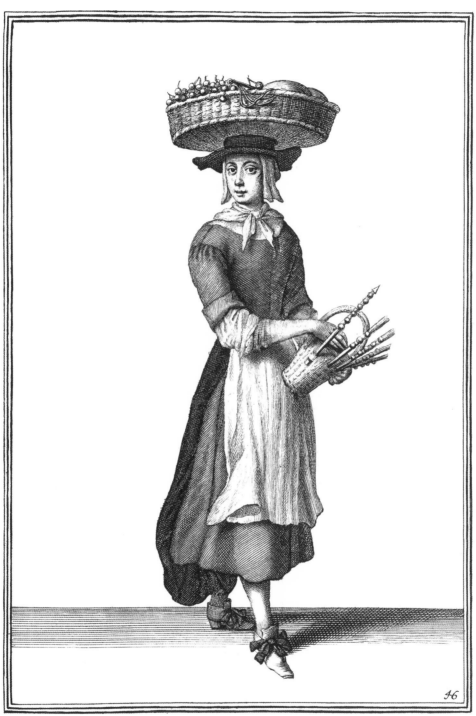

46

Six pence a pound fair Cherryes.
A mes belles Cerises.
Sei Soldi la libra le Cerase.

Mauron delin:

P Tempest exc:
Cum Privilegio

KNIVES OR CISERS TO GRINDE

The knife grinder is the proprietor of a large, complex and expensive machine. This engine is so cumbersome and heavy that he must strap it over his shoulder to trundle it along London's filthy, soupy, pocked streets. He served householders who needed knives, razors, hatchets, tools and scissors sharpened or fixed. However, his most profitable clients were slaughterers, fishmongers, butchers and cook-shop keepers.[92]

Laroon was a careful delineator of occupational dress. In this case the man wears an apron and spatterdashes, also employed by the chimney sweep. His machine's large wheel has gobbled up his apron, made of leather or canvas. Both wheels have shredded the bottom of his two coat sleeves, an observation 'after the Life' typical of how Laroon shows the ways in which costume is shaped by particular trades. Next to the machine's large grinder sits a holster holding polish, water and a ladle; behind it, a protective splash-board diverts spill from the two wheels.

His is a vexed calling, physically demanding and filthy. The run-off from his wheels dirty and wet his hands and feet as well as soiling and consuming his clothes. Grinding utensils demanded that he constantly stoop over his task to guide his blades along the stone while pumping the treadle with his right foot. In addition, he had to endure the deafening noise of his machine, a racket which, together with his cry, made him a hated presence to all who did not need his services.

These inconveniences he bears with equanimity, smoking his pipe as he labours. An advertisement in *Applebee's Original Weekly Journal* (29 July 1721) details the many health benefits of taking tobacco:

> for the Head, Eyes, Stomach and Lungs … It so strengthens and restores Ancient Sight, and preserves Young Eyes, that, by the Use of it, Persons may (thro' the Blessing of Almighty God) never come to wear Spectacles … it brings away in a singular manner those Rhumes and Humours that cause Deafness, and Difficulty of Hearing, Defluxions, Vapours, Headaches, Toothaches, the Rheumatism, sore, weak, wa[t]ry, and dim Eyes, &c.

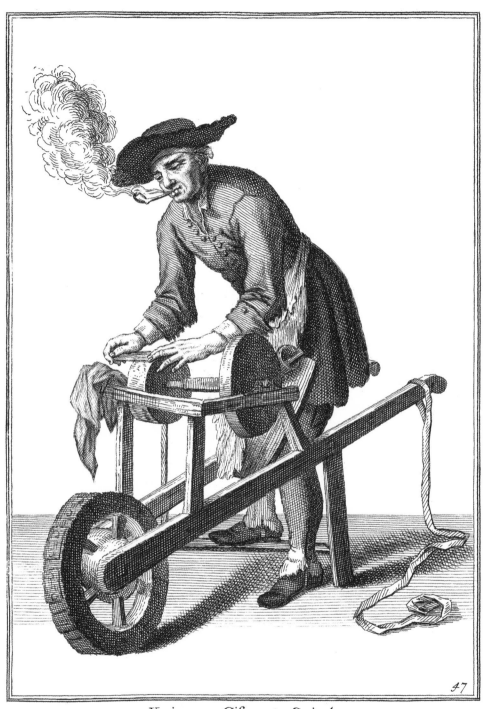

Knives or Cifers to Grinde
Cauteaux et Ciseaux a Moudre
Ruota Coltellini

M.auron delin:

P.Tempest exc
Cum Privilegio

47

Long Threed Laces Long & Strong

These children are selling laces, mercery or cloth goods like those that the merry milkmaid has used to knit up the front of her bodice. Such items were also used in stays, corsets and boots. The children's cry promotes the material their goods are made from (probably a fine linen) and their length, as these laces needed to be long to close dresses like the milkmaid's. The white-line seller mentions additional uses for these items in clocks, hair and clothes lines.

Such children appear in Laroon's 'Chimney Sweep' (p. 118), 'London Begger' (p. 214) and here. However, this image alone features unaccompanied children, which indicates that they are abandoned. Such 'Charity Children', reported to number between five and six thousand, have been cast off by their parents or set adrift by masters to whom they were apprenticed.[93] Benjamin and Grace Collier, living in a tenement in St Katherine's parish that cost three pounds yearly, 'privately made away with their goods and run away, leaving their children destitute'.[94]

Before Captain Coram's Foundling Hospital was established in 1739, children were deposited at the doors of the wealthy (with intimations of paternity) or cast off randomly: 'Wednesday Night a Female Child was dropt on the Bulk of a Hatter's shop in Fee Lane, with these Lines pin'd to its Breast: "By Chance begot; by cruel Fate am hurl'd, Unhappy Lot! into a sinful World."'[95] Children were targets for kidnappers who sold them to be transported. Some were exploited by other children. According to one contemporary report, a boy of seven was apprehended in Fenchurch Street with two young pickpockets:

> On his being ask'd, How he came in Company with these Boys? Reply'd, as he was coming from School, they enticed him to go with them, which he agreeing to, on Mondays and Fridays they pick'd Pockets in Smithfield, and a Woman who buys old Clothes us'd to attend them, and give a Trifle for what they had pilfered.[96]

But the fate of others was unspeakably worse:

> An ancient Gentleman of 74 Years of Age, having taken a young Child to bring up as his own, is charged with having committed a Rape upon the Body of it: The Child was not 4 Years of Age, and had been so abused as that it turned to a Mortification, of which she died: Before her Death, she was several times asked, who had hurt her? and she declared, her Papa; so it seems she always called the Old Gentleman.[97]

Long Threed Laces Long & Strong.

Lacets de fil

Stringhe da uendere

Mauron delin:

P Tempest exc:
Cum Privilegio

48

Remember the Poor Prisoners

Inmates of prisons could send out for food, have friends bring in victuals or order provisions from their jailers. Many jailers kept public houses and detained prisoners for extortionate victualling fees after their original charges had been settled. The destitute and those unable to afford the crippling fees imposed in places like Newgate Prison relied on the money and leftovers brought in from begging by the parish almsman (or basket man) – considered a vile but necessary post. One news sheet reported that in Halifax Gaol in Yorkshire 'there have lately died five insolvent Debtors, for want of the common Necessaries of Life'.[98] The *London Chronicle, or, Universal Evening Post* reported that 532 prisoners were confined in the King's Bench Prison and 67 in the Marshalsea Prison for debt, where many had nowhere to sleep.[99]

The young basket man shown here, begging for broken bread and coins, is the official parish almsman: the heart-shaped medallion on his coat proves that he has been properly deputized, unless that medal is counterfeit. The almsman is himself destitute: his coat is defaced, ripped and patched, and the right cuff of his shirt is decayed. Perhaps he was recently imprisoned for debt or he has been granted a day-long liberty to beg. In Charles I's time, almsmen earned two shillings a week but were seldom paid on time. In 1647 the 'Poor Prisoners in the Gatehouse of Westminster' petitioned the Justices of the Peace 'to take some speedy course for the payment of the said wages [of their basket man] with the arrearages unpaid for a yere and a halfe, or else the petitioners must needes perish'.[100] The almsman, though young, walks with a stick, which indicates a limp: he drags his right foot, which is torqued far to the side.

The right of prisoners to beg was sometimes abused: monies were embezzled, and broken bread, the object of a vital, furtive public market, was sold or bartered for cloth at Rosemary Lane rag fair.

Sold by H. Overton
without Newgate.

Remember the Poor Prifoners
Ayez Souvenance des Pauvres Prisonniers
Ricordateui di far carita a Poueri Carcerati

P Tempest exc:
Cum Privilegio

THE SQUIRE OF ALSATIA

The squire, the courtesan, Madam Creswell and Merry Andrew were common London characters, not hawkers. In picturing these city types, Laroon broadened the reach of the Cries to include people who earned their living on the streets by a variety of means, some as entertainers and most as malefactors, delinquents and swindlers. The squire is a swindler, an identity he attempts to obscure by his dress, which is a paragon of court fashion at the time of William III. Wearing a cocked hat trimmed with a glittering hatband and decorated with an immense feather, he sports gauntlet gloves trimmed with long fringes, one of which has unravelled. The customary colours of his outfit made it all the more spectacular: his hat was scarlet, his coat blue or claret and his stockings red.[101] Striking a pose, he carries a cane with a gold tip and a bejewelled head while his pedigree is affirmed by a sword. But the highlight of his costume is his gigantic asymmetrical hairpiece, which would have cost as much as £40 and was ridiculed by Ned Ward, the satirical chronicler of London life, as 'a Wheel-Barrow full of Periwig'.[102]

The coxcomb is an allusion to *The Squire of Alsatia*, Thomas Shadwell's play of the same title. It treated different philosophies of education and was celebrated for its extensive use of cant language. Like Shadwell's character, Laroon's figure is a confidence man from London's Alsatia, a 'theatre of sin' that was the den of outlaws in the 1600s. There he and his ilk used their manoeuvres to lure men into gambling and trap women into false marriages, preying chiefly on country folk. In a late edition of Granger's *Biographical History of England*, this man is identified as the real-life Bully Dawson, a notorious gambler and blackleg of the period. Granger calls him:

> one of the gamesters of *White Friars* [Alsatia], which was notorious for these pests of society, who were generally dressed to the extremity of the mode ... The reader may see much of this jargon, which indeed requires a glossary to understand it, in Shadwell's comedy, entitled "The Squire of Alsatia", which was brought upon the stage in this [James II's] reign.[103]

50

The Squire of Alſatia
Badaux de Londres
Brauaccio di Londra

M. auron delin:

P. Tempeſt exc:
Cum privilegio

LONDON CURTEZAN

According to a report of the 1790s, one in every five working-class city women was said to be permanently or casually involved with prostitution. Hogarth's *Harlot's Progress* (1732) tells the story of a country girl lured into prostitution, going from a young lady kept by a rich businessman to a woman visited in her apartment by various men, to a diseased streetwalker at the end of her tether.

The London Curtezan belongs to the genteel class of prostitutes: she goes by the term 'courtesan', with its aura of sophistication. One of the few women to appear in public without a hat, the courtesan wears a diadem and a headscarf that exposes her own hair. The two moles on her face are beauty spots called 'mouches'. Made popular in elaborate versions by aristocratic women at the start of the seventeenth century, they were adopted by prostitutes to hide sores or syphilitic ulcers. Her lace peignoir reaches down to her knees; though a nightgown, it was commonly worn in public, and even to church. Her petticoat is elaborately embroidered at the hem. She carries a closed fan and a full-faced vizard. Her charge ran to about a guinea.

Daniel Defoe's account of the lives of maidservants, dressmakers, scullery maids and others who followed menial or seasonal labour is instructive, if we look beyond its flippant tone:

> Thus many of 'em rove from Place to Place, from Bawdy-House to Service, and from Service to Bawdy-House again, ever unsettled, and never easy, nothing being more common than to find these Creatures one Week in a good Family, and the next in a Brothel: This Amphibious Life makes 'em fit for neither, for if the Bawd uses them ill, away they trip to Service, and if their Mistress gives 'em a wry Word, whip, they're at a Bawdy-House again, so that in Effect they neither make good Whores or good Servants.[104]

Press reports also show that the life of prostitutes was grim. A young woman supposed to be a prostitute was found in a ditch near Islington, stripped naked and bound hand and foot, with an old handkerchief tied over her mouth. She said that she had been used 'in a bruitish manner by two fellows, who by appearance were drovers; that they stripped her of her cloathes, robbed her of a few shillings that were in her pockets, and then left her in that distressed situation'.[105]

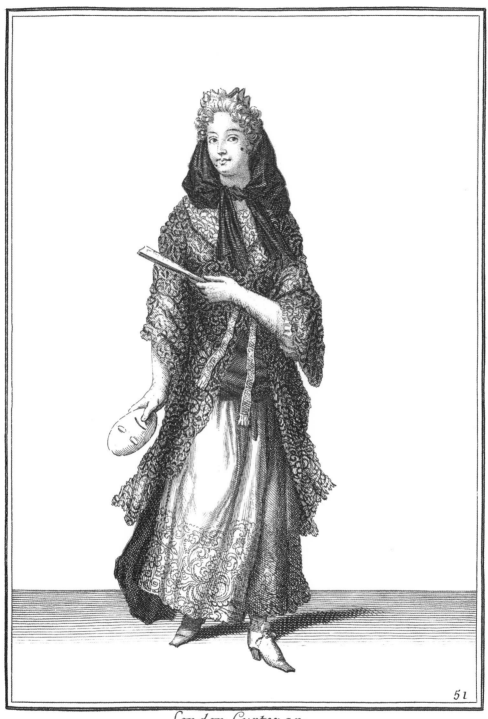

London Curtezan
La Putain de Londres
Cortegiana di Londra

M Lauron delin: P Tempest excud:
Cum Privilegio

51

MADAM CRESWELL

When people like the London Curtezan (p. 178) grew old or disabled by disease, they took up Madam Creswell's trade, that of procuring. Better-off bawds owned bagnios, preferably in or around Covent Garden, commonly known as 'the great Square of Venus' (and, of course, the home of Marcellus Laroon, who lived at No. 4 Bow Street). Less prosperous or fortunate madams lived with their 'nymphs', as shown in Hogarth's *Harlot's Progress*, where the duties of such ladies are detailed. Bawds were the engines of prostitution, running the day-to-day operations of the trade, recruiting, training, coaching and, as the first plate in Hogarth's series shows, dressing homeless and destitute country girls they picked up on the streets of London. Stereotypically, older women (and not men) ran and controlled prostitution at this time.

The offense of bawdry was severely punished, according to law:

> [The punishment] for being a common Bawd, be it man or woman, or wittingly keeping a common Brothell or Bawdy house, shall for his or her first offence bee openly whipped and set in the pillory, and there marked with a hot Iron in the forehead with the Letter *B*.

and afterwards committed to prison or the House of Correction; there to work for his or her living, for the space of three years, without Baile or Mainprize, and untill he or shee shall put in sufficient Sureties for his or her good behaviour during his or her life.[106]

Prosecutions appear to have been rare except when offences were aggravated:

> On Monday last the Coroner's Inquest sate again upon the Body of Mr. Motteaux, the China-Man, who was found dead at a Bawdy-House in Star-Court behind St. Clements's Church; but the Coach-Man that carried him being not found (as was reported) they deferr'd giving their Verdict to that Day Month. The old Bawd and her Daughter, with two or three of her Doxies are committed to Newgate, there being strong Circumstances to believe that they murder'd him.[107]

The likenesses of Madam Creswell and the London Curtezan are pendant portraits contrasting the youthful, flirtatious harlot with the wrinkled hag in a funereal outfit, the two being linked by their embroidered petticoats.

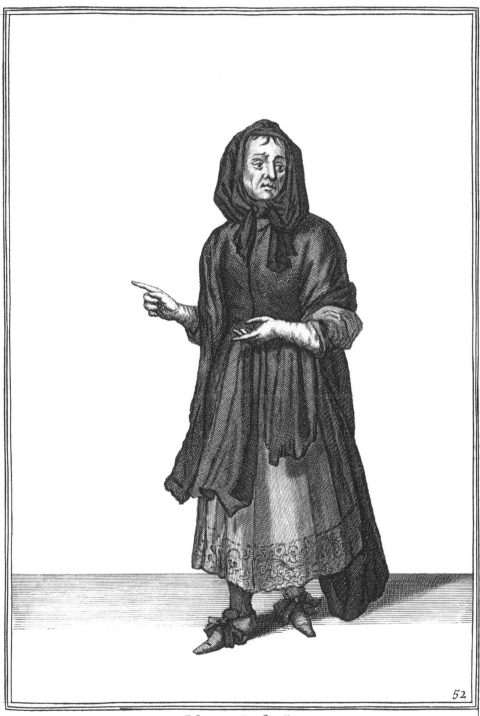

52

Madam Creſwell
Une Maquerelle
Vecchia ruſiana

Mauron delin:

P Tempeſt exc:
Cum privilegio

MERRY ANDREW

The phrase 'Merry Andrew' seems to have come into English about 1670 when it was applied to a clown or assistant to a mountebank. Merry Andrews served any individual who required an audience, such as quack doctors, surgeons, theatrical troupes and vendors of miraculous cures. They were popular at England's great fairs: Bartholomew, Southwark, May and St Katherine's. Merry Andrews and quacks often played the same role. Laroon's mountebank (p. 206) employs a monkey, which was less expensive than a Merry Andrew.

Merry Andrew appears in two images. Here he plays a role that is ominous, appealing to his audience by his grotesque physique, his menacing grimace and the claw-like gesture of his hands, all of which promise mischief and rascality. His practised unpredictability is confirmed by the fact that one foot is shod in slippered ease while the other is bare. By contrast, the Merry Andrew on p. 202 is musically cultured and benevolent.

Samuel Johnson defined 'Merry Andrew' as a buffoon, a zany and a jack pudding, whose chief tricks were to assault his audience physically,

for he 'blows his Powder in their Faces, squirts Water on their Cloaths, and dispenses his Grains with a Mixture, as proper Rewards for their slavish Obsequiousness'.[108] Sometimes, their slapstick humour went amiss:

> A certain Merry-Andrew belonging to a Puppet Show in Southwark Fair, was last Week committed to the County Jail there, for running a Tobacco Pipe into a Man's Eye who serv'd Drink at a Publick House there, which threw him into a Fever, of which he died.[109]

Samuel Pepys, who was addicted to popular performances, went to Bartholomew Fair with two friends on 7 September 1668: 'there saw the dancing mare again (which today, I find her to act much worse then the other day, she forgetting many things, which her master did beat her for and was mightily vexed)'. Pepys also saw 'the dancing of the ropes and also the little stage-play, which is very ridiculous'. Earlier he had called the play 'a ridiculous, obscene little stage-play called *Mary Andrey* [*Merry Andrew*], a foolish thing but seen by everybody'.[110]

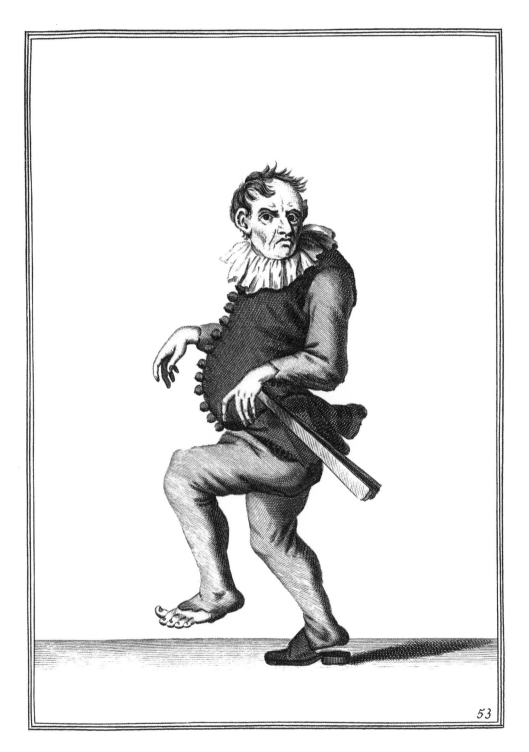

Merry Andrew

53

M. auron delin:

P. Tempest. ex:
Cum privilegio

A Brass Pott or an Iron Pott
to mend

With the 'TINK, TINK, TINK' of their hammer on a brass kettle or frying pan, tinkers could enrage a whole street for an hour. They were among the most marginal of hawkers and vagrants, and their services were little in demand, so their wilful racket may have been intended to persuade 'customers' to pay them to move on.

Laroon's tinker sells second-hand cooking utensils like the heavy cauldron he carries on his shoulder and the small pot he bangs. He totes this pot effortlessly, though its weight and size must be crippling for so slight a man. In the sketch Laroon took pains to individualize the vagrant's face, with his scruffy beard and dishevelled hair. Unhappy with his first draft of the man's face, he cut it out and pasted a blank piece of paper in its place, on which he redrew the face entirely.

Viewed as beggars, thieves, fences and tricksters, tinkers were subjects of deep suspicion, and often appear in contemporary crime reports, such as:

Thursday evening last a tinker and his trull were apprehended and committed to Gloucester gaol, for defrauding a farmer's wife at Hanley, near Upton upon Severn, of a sum of money and sundry wearing apparel, by the stale trick of persuading the farmer's wife to tie up all the gold and silver, and what she had of value, and then to dig for hidden treasure in the cellar.[111]

Many of their offences were darker:

We hear of a barbarous Murder lately committed … by a Tinker and his Wife, who cut the Throats of three Children, and attempted to kill the Mother, but she had the good Fortune to be heard by a Dragoon, who rescued her; the Tinker was killed in the Skirmish by the Soldier, who ripp'd open his Gutts, and the Woman was much wounded. This happen'd at an Alehouse where the Tinker, &c. lodg'd.[112]

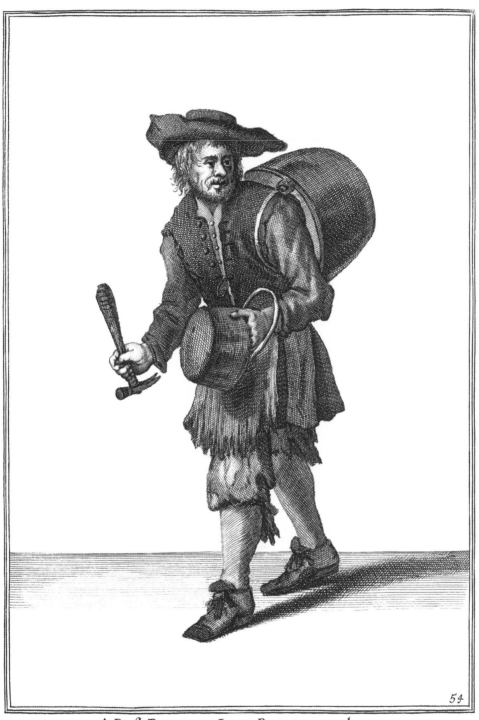

54

A Brass Pott or an Iron Pott to mend
Rabiller les Poelles les Marmites & les Chaudrons
Concia caldare candelieri e Padelle

Mauron delin:

P. Tempest ex:
Cum privilegio.

Buy my 4 Ropes of Hard Onyons

This vendor limits his trade to selling onions by the rope. He has woven them together into striking geometric patterns to catch the eye and to give customers the convenience of hanging them in their kitchens. He carries them on a stick made especially for transporting onions, with pegs attached to both ends to prevent them from slipping off his pole. He promotes his onions as being hard because wary householders knew that soft onions were rotting. Surprisingly he calls on his customers to buy all four of his ropes, so he must have been targeting large households. His trade is not a prosperous one. This man is old and toothless, his hat is battered and his coat, lacking buttons, is worn.

Because they kept well and appeared in many recipes, onions have a long history in English kitchens. Small onions were pickled in the 1700s, while large ones were eaten raw, baked into pies or used for sauces. Thomas Turner (1729–1793), an East Sussex shopkeeper who kept a diary for eleven years, gloated about dining 'on shoulder of lamb, roasted, with onion sauce – my family at home dining on sheep's head, lights [lungs] &c., boiled'.[113]

The onion seller was exempt from the Act for Licensing Hawkers and Pedlars, which required them to pay a year's duty of four pounds and to carry a licence.[114] The fine for selling without a licence was twelve pounds, and that for possessing a forged licence was fifty pounds.[115] Licences were stolen as well as counterfeited. A notice in the *Post Boy* states:

> Two Foot Licences for Hawkers, one in the Name of James Jackson, of Ashford, N°. 417, the other in the Name of Alexander Hunter of Goadstone in Surry, N°. 717, being stolen from the said Parties, or otherwise lost: Whoever brings the said Licences, or either of them, to the Transport-Office upon Tower-Hill, shall receive 10s. for each of them.[116]

Hawkers who were asked to show their licence were known to resist: David Dyas, 'being a Hawker of Goods, was stop'd by the Officers [Richard Crumbleho[l]me and Edward Twist] near Norfolk-street in the Strand, and required to produce his Licence pursuant to the Act of Parliament, but instead thereof raised a Mob about them, and broke Crumblehome's Head, calling them Rogues, Informers, &c'.[117]

Such officers were neither popular nor particularly honest; for example, 'One Tomkins, Cashier to the Office for Licensing Hawkers, Pedlars, &c. having gone off with 44000 l. of the publick Money, the Affair is before the House of Commons.'[118]

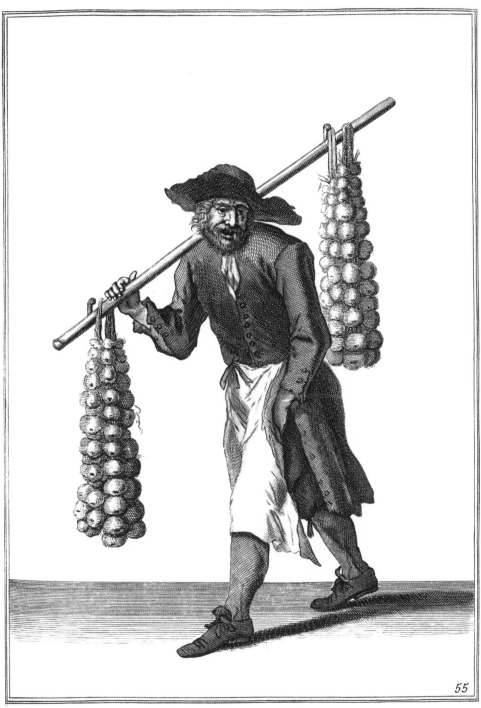

Buy my 4 Ropes of Hard Onyons
À mes groſs Oygnons
Cipolle groſse Cipolle

55

P Tempest exc
Cum Privilegio

Londons Gazette here

This modest young hawker and her ilk, dubbed 'diverse Persons who have no known Habitation', were crucial to the success of newspapers as well as to the spread of literacy during a period that witnessed the flowering of the press in England. Without basket women and so-called mercuries like her to distribute England's newspapers, the press would not have flourished. Most hawkers, largely women, sold multiple papers. The *British Apollo*, for example, noted that its rivals charged hawkers a shilling for twenty-five copies, each of which sold for a penny.[119] Resourceful hawkers found ways to make this near-starvation trade more profitable:

> The Hawkers, who cry the Papers about the Streets, make it their Practice to lend the Papers to Read at so much a Week, to Customers that are willing to know publick Affairs, but at the least Expence, and afterwards return them to the Publisher. To prevent this unjust and wicked Practice, the Author of this Paper has order'd his Publisher to take no more Returns, than two in a Quire, which has provok'd the Hawkers to spread the Report of the Paper's being laid down.[120]

The *London Gazette* (which was and still is the official organ of record of Parliament) first appeared as the *Oxford Gazette* when Charles II fled there to evade the plague, and readers avoided touching papers from London lest they catch the infection. Samuel Pepys records reading the first issue of the journal on 21 November 1665; his estimate of it (but not his attribution of authorship) is just: 'This day the first of the *Oxford Gazettes* came out, which is very pretty, full of news, and no folly in it – wrote by Williamson.'[121]

While the Act for Licensing Hawkers and Pedlars (1697) allowed street vendors to sell 'any acts of parliament, forms of prayer, proclamations, gazettes, licensed almanacks or other printed papers licensed by authority', it prohibited them from vending anything blasphemous, inflammatory, obscene, treasonable, vituperative or contrary to the law – a catch-all category. The fine for this offence was ten pounds, which was shared by the king and the prosecutor.[122]

The *London Gazette* records the harassment these vendors suffered:

> The Lord Mayor and Court of Aldermen, taking notice that the City and Liberties thereof … are much pestered with a sort of loose and idle Persons, called Hawkers … have thought fit, for the regulation thereof, and for the more effectual putting in execution the Laws against such Offenders, to appoint and command the Marshall of the City, as well as the Constables … to apprehend all such Hawkers and Offenders, and to bring them before the Lord Mayor, or some other of His Majesties Justices of the Peace, to be set at hard Labour at *Bridewell*, or otherwise to be dealt with according to Law.[123]

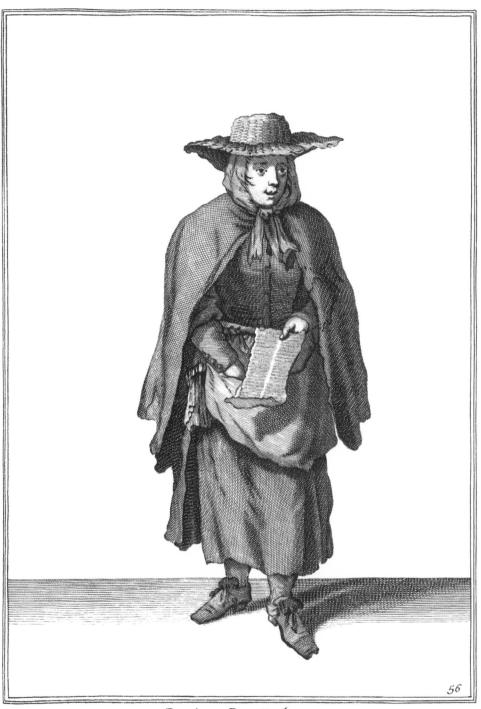

London's Gazette here
Nouvelle Gazette
Chi Compra gl'auisi di Londra

M.auron delin:

P.Tempest exc:
Cum Privilegio

56

BUY A WHITE LINE, A JACK LINE, OR A CLOATHES LINE

A jack line is a thin rope of the kind the hawker holds in his right hand; it was used in rigging ships, for turning spindles in hearths and in sail-making. A white line, on this man's right arm, is an untarred rope for household uses such as hanging weights in clocks and sash cord windows, a recent invention. While he sells three different kinds of ropes, the young hawker's merchandise would not have been profitable. He may have woven his ropes at home. But perhaps he bought them from the wholesaler Richard Outen, who advertised as:

Rope-Maker, Li[n]e-Spinner, and Sacking-Maker, the Bottom of Old-Street Road; makes and sells all Sorts of Ropes and Lines at the following Prices: The best of Brewers Ropes, at 2l. 2s. per Hundred. Stone Masons, Butcher[s], and all Sorts of Crane-Ropes, at 2l. 2s dit[t]o. All Sorts of Jack-Lines, nine and Twelve Threads, at 6s. 6d. per Dozen.[124]

John T. Smith describes how a father and son team drummed up business by turning their cry into a fetching musical duet:

The father, in a strong, clear tenor, would begin the strain in the major-key, and when he had finished, his son, who followed at a short distance behind him, in a shrill falsetto, would repeat it in the minor, and their call consisted of the following words:–
"Buy a white-line,
Or, a jack-line,
Or, a clock-line,
Or, a hair-line,
 Or, a line for your clothes here."[125]

His costume is distinctive in one respect. This vendor cocks the brim of his hat up at a rakish angle, a style popular with young men. Pepys censured this mode of dress when, on 3 June 1667, in Treasury Chambers, he saw 'a brisk young fellow (with his hat cocked like a fool behind, as the present fashion among the blades is)'.[126] When most hawkers constricted their neck with a cravat, a band or a collar to intimate gentility, this fellow exposes his throat to reveal a collarless chemise.

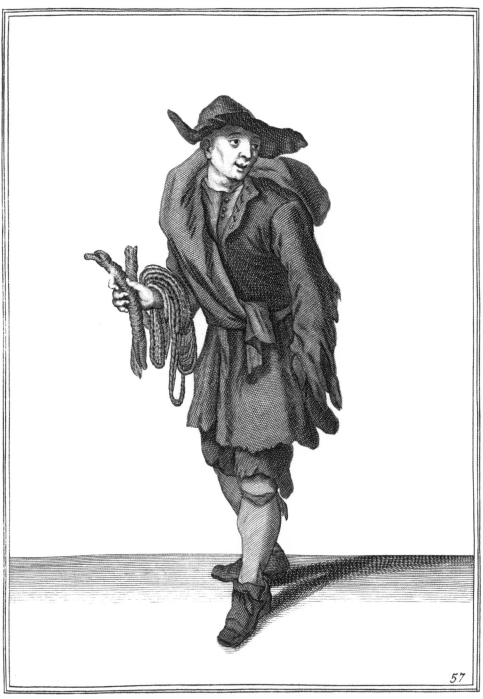

57

Buy a White Line, a Iack Line, or a Cloathes Line
Qui veut des Cordes
Chi uuol Corda & molinel da Speda

Mauron delin:

P. Tempest exc:
Cum Privilegio

ANY OLD IRON TAKE MONEY FOR

The iron buyer is among the most anonymous and baffling figures in the *Cryes*, because of what he shows and what he hides. Turning his back to the viewer, he conceals his face and identity, forcing attention on his twisted body but especially his gimpy leg with its prosthesis. It is just possible that the iron buyer fakes his limp, as the musculature of the right leg is similar to that of the left. His prosthesis, making a loud THUMP THUMP as he walked the streets, may have served to draw attention to his presence and to create sympathy, leading to donations. Indeed, a number of Laroon's hawkers are imposters; those practising hoaxes are so identified by contemporary authorities who claim to know them and their ruses.

But the *Cryes* is an apologia for hawkers, and argues against official, legal, popular and governmental hostility to them. In addition, the overwhelming majority of Laroon's figures are honest and hard-working. The old iron buyer, I believe, belongs to this majority. There is no evidence that he is a beggar. In fact, his sack, repeatedly patched from hard use, proves that he follows his calling assiduously. He carries spare bags over his right arm in case he finds more iron than expected. Perhaps one of the mongers to whom he sells his old iron made this puzzling device for him. Or maybe he went to see Peter Bartlet (sometimes Bartlett), who made 'divers Instruments to help the Weak and Crooked … at the Golden Ball by the Ship Tavern in Prescot-Street in Goodmans Fields, London'.[127] Upon his death Bartlet left a great fortune to London's hospitals. His was a medical family:

> His Mother Mrs. M. Bartlet at the Golden-ball over-against St. Bride's-lane in Fleet-street is Skilful in this Business to her own sex. Her Steel Spring Trusses for Ruptures at the Navel, are not only more effectual, but more easy than those made without Steel.[128]

Going by the title 'the Widow Bartlett, Mother of the late Peter Bartlett', she was still in business in 1739 when she advertised in the *London Evening Post* (27–29 November), still trading on her son's fame.

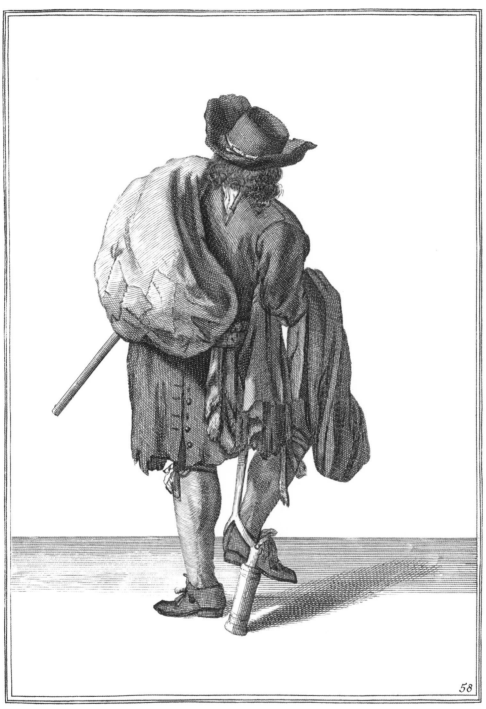

58

Any Old Iron take money for

Qui a de Vieilles ferrailles a vendre

Stracci Piombo Ferraci da vendere

Mauron delin:

Delicate Cowcumbers to pickle

This young and energetic vendor is dressed in a plain gown beneath which she displays around her open neck a white fringe called a tucker or modesty piece. She wears her gown rolled up and stuck in at the front, no doubt to keep it clean and wholesome. The sheen on the gown, its condition and the care she takes of it suggest that it is new. She is one of the few hawkers working without an apron. Her hair peeps out from beneath her hat; these curls betray a hint of vanity which is confirmed by her shoes, tied with elegant, floppy bows.

She carries two burdens, one of which is heavy and overflowing, the second of which is awkward. She totes the small cucumbers on her head without using her hands to steady the basket, her hands and arms being occupied by a sheaf of dill. Her trade would have lasted two months each summer, after which she would switch to another vegetable or fruit. Pickled vegetables, especially cucumbers, were popular in English cuisine. The American loyalist Samuel Curwen enjoyed an extravagant meal in Bath at an inn he reported to be 'famous through England if not Europe' for its food: 'we dined on roast shoulder of mutton, a few slices

cold beef, windsor beans, cucumber, pot cyder and bowl of punch, charge 7/9d.'[129]

Samuel Pepys and others believed that cucumbers were poisonous. He reported that a Mr Newburne 'is dead of eating Cowcoumbers, of which the other day I heard another, I think Sir Nich[olas] Crisps son'.[130] The *British Spy, or, New Universal London Weekly Journal* told of a man who observed

> the beautiful Colour of the pickled Cucumbers, he Eat a Couple of them, and was immediately after taken very Ill: a Doctor being sent for, and informed what he had done, which, by having had Vitriol [sulphates of metal] put in the Pickle in order to give them a fine Green, had poisoned him.[131]

An early nineteenth-century source of unknown reliability reports that a young lady consumed copper-adulterated samphire pickles. Very shortly she 'complained of pain in the stomach; and, in five days, vomiting commenced, which was incessant for two days. After this her stomach became prodigiously distended, and in nine days after eating the pickle, death relieved her from her suffering.'[132]

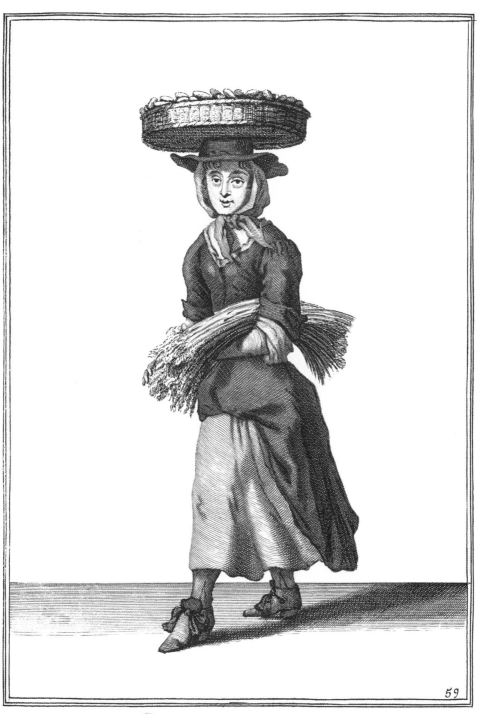

59

Delicate Cowcumbers to pickle

Concombres a confire

Cocomeri ộ mettere in composta

P. Tempest ex:
Cum Privilgio

ANY BAKEING PEARES

This hawker's dress suggests modest prosperity. His coat, open to the late summer weather, is in good condition, with a complete set of buttons on its vents, bodice and cuffs. A small neckerchief is tied beneath his chin. His long apron is dark, as suggested by the cross-hatching. He secures his shoes with straps rather than laces. His basket is unusual in having legs that allow him to rest it on the ground above the filthy streets. A stationary rather than an ambulant vendor, he seems to point to a second basket of pears sitting on the ground nearby.

French pears were considered superior to English baking pears and, accordingly, cost as much as eight pounds eight shillings a hundred for the best sort. But when a cargo of French pears was tasted against English ones, the results were surprising, according to a contemporary report:

It is certainly true, that the countenance of these [French] pears was very beautiful, smooth coats and pleasant to the eye, but after being tasted by numbers of judges, were found inferior to an English baking pear, and scarcely as agreeable on the palate to a common wild quince.– These pears then are truly similar to the modern beau French personages, best in outside.[133]

Pears appear twice in the *Cryes*, sold as cooked or ready for cooking. The fruit was commonly hard and bitter, so it was seldom eaten fresh. Rather, it was boiled and baked into pies. Conspiracy lovers considered pears unhealthy if not poisonous. When Charles II died, rumour had it that the queen had poisoned him with a jar of dried pears – though it was also asserted that the duchess of Portsmouth had killed him with a chocolate drink.

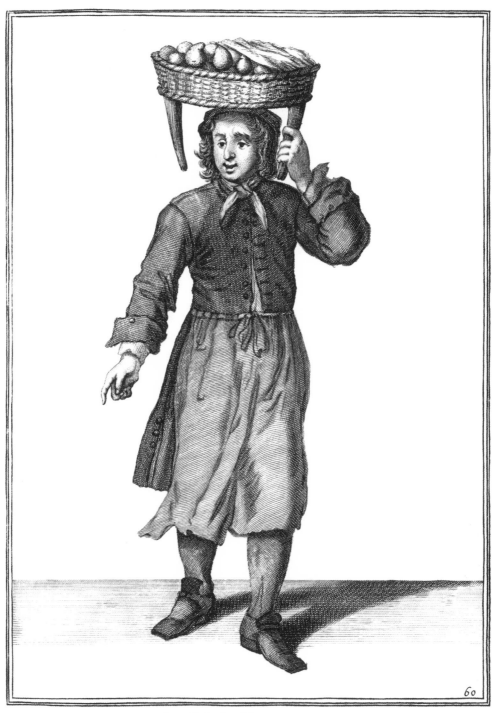

60

Any Bakeing Peares

Poires cuittes au Four

Peri da Cucinare in forno

Mauron delin:

P.Tempest ex:
Cum Privilegio

New River Water

People without servants and large households bought water from street vendors like this man, who also supplied people who were unable to leave their homes, the infirm, the elderly and those living in basements or garrets up six or seven floors. They charged a penny or two a gallon, less for a quart.[134] When London households obtained water at home by pipe, porters struck back with 'Fresh and fair new River-water! none of your pipe sludge!'.[135]

Laroon depicts the man's coat as two long cloths belted at his side. Puzzlingly, he shows the carrier bearing two barrels of water attached to a yoke. London's porters did not fetch water in such barrels, they carried it in special cone-shaped tankards which they toted on their shoulder, as 'A Tanker bearer' does in *The Manner of Crying Things in London* from *c*.1644.[136]

In the seventeenth century, private firms grew up to supply London's exploding population's demand for 'sweet and wholesome water'.[137] The most celebrated of these firms was the New River Company, which engineered a wooden trough, twenty-eight miles long, to bring drinking water from the River Lea, Chadwell Springs and Amwell Springs to Islington. The project was begun by Edmund Colthurst and completed by Sir Hugh Myddleton, who oversaw 600 men, working five years, until the task was completed on 29 September 1613. The New River Company sold directly to consumers, typically on a yearly contract. The water was distributed by quills made of elm to pumps, public conduits and a few wealthy households. But the water was also pilfered by

> several malicious and ill-meaning Persons [who] do frequently Tap or Bore the *New-River* Company's Mains, or Water-Pipes … And often cut the River Bank, in order to let out the Water to serve their own Uses, to the apparent Damage of the said Company, and very great Detriment and Disservice of the Inhabitants of the City of *London*.

To prevent such practices, the New River company offered a reward of ten pounds to anybody who identified such offenders.[138]

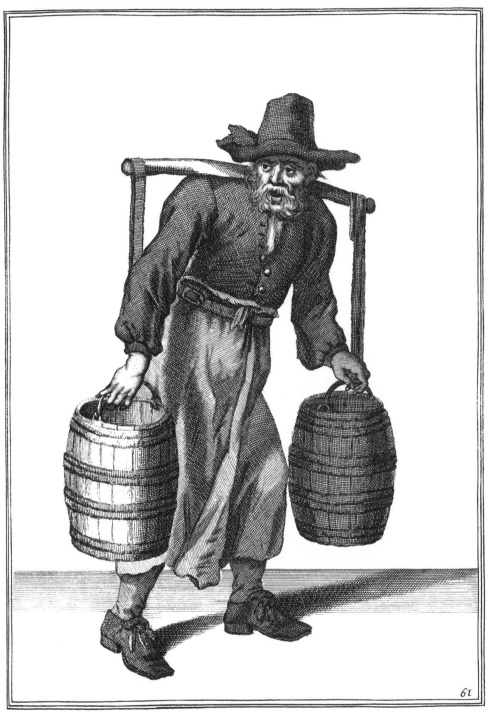

New River Water

Qui veut de l'eau
Chi vuol acqua di fiume

The Spanish Don

The final twelve figures in Laroon's *Cryes* are not vendors but London characters. They fall into three broad categories: charlatans, religious personages and performers. The Spanish Don is a performer, an actor in a *commedia dell'arte* theatre (Italian comedy based on stock characters, performed by troupes). To advertise their performances and draw audiences, actors of all stripes strolled through the London streets and English fairs in full costume, as does this self-styled 'Capitan Spagnuolo'. Sometimes called 'Captain Fearsome of Hell's Valley', he is the English version of Bosse's Spanish gentleman (fig. 9). But while Bosse's Spaniard is reduced by the misfortunes of war to catching rats, the English Don is at the zenith of his career playing a *miles gloriosus*.

His eye-catching outfit announces his dual, clashing roles as soldier and lover. The flashiness of his theatrical outfit and hauteur obscures the reality that he is a false captain and a coward, lacking both military and amatory prowess. His melancholic, pensive expression, delicate mustachio and luxuriant mane underline his sensitive nature, which belies his military posture. His head is turned backwards in retrospection, so that he is seen from the back and front simultaneously, like a character on a playing card. He proudly shows off his spectacular costume. Its highlights are a splendid lace collar and an ostentatious collection of five crimson rosettes, two on his shoes, two on his knees and one on his hat. His shoes, which are customarily red, have high heels and were the prerogative of elites in England and France, where they were symbols of power and status (they made men taller). Aristocrats in France were sometimes referred to metonymically as 'talons rouges'.

But the highlight of his outfit is his immense and comically disproportionate sword, worn in such a manner as to make walking impossible. It has been satirized as resembling the tail of the peacock at mating season. A Toledo rapier of the kind traditionally worn by Spanish captains, it sports a handle wound in copper wire, an ornately scrolled guard and a scabbard with a silver tip. The warlike weapon suggests that this man is a desperado who, like the rat-catcher, makes the whole earth tremble.

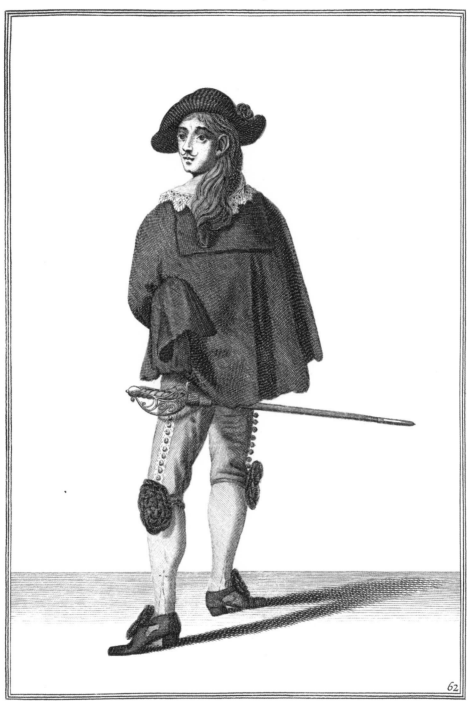

The Spanish Don

L'Espagnol

Capitan Spagnuolo

62

Mauron delin:

P. Tempest exc:
Cum privilegio

Merry Andrew on the Stage

Merry Andrew is the generic name for street entertainers who delighted popular audiences with music and debauched banter, as well as antics and trumpery: grotesque grimacing, distorted faces and ludicrous attitudes. They performed at public amusement spots like Sadler's Wells, the New Wells and especially Bartholomew Fair, and were not always on their best behaviour. At Bartholomew Fair, 'On Thursday the master of a noted booth … quarrelling with his Merry Andrew, a fierce encounter ensued, when they heartily drubbed each other to the satisfaction of several hundred spectators.'[139] Such clowns worked in a troupe, accompanying the street performers whose stock characters follow his: the rope dancer, the mountebank doctor and the contortionist. Merry Andrew is called a comic charlatan and a buffoon in the print's legends. Like the Spanish Don, the Merry Andrew derived from the Italian *commedia dell'arte*. Unlike the first Merry Andrew in the *Cryes* (p. 182), who is hideous and menacing, this man is sympathetic and benevolent and has a kindly, open smile. In a hint of self-mockery, he wears the costume of an ass with immense ears.

An assistant to mountebanks like the quack doctor, Merry Andrew also performed various acts in his own right. The mysterious box on which he rests his bass violin, placed prominently in the foreground, is designed to inspire curiosity and suspense. Closed and locked, who can say what surprises it contains? A talented bass violinist, Merry Andrew is a skilled musician but perhaps also a magician, a snake charmer, a juggler, a dancer, a bawdy comic and whatever else his audience wanted.

James Granger identified this Merry Andrew as a historical person:

> This man, whose name was Philips, was some time a fiddler to a puppet-show; in which capacity he held many a dialogue with Punch, in much the same strain as he did afterward with the doctor his master upon the stage.[140]

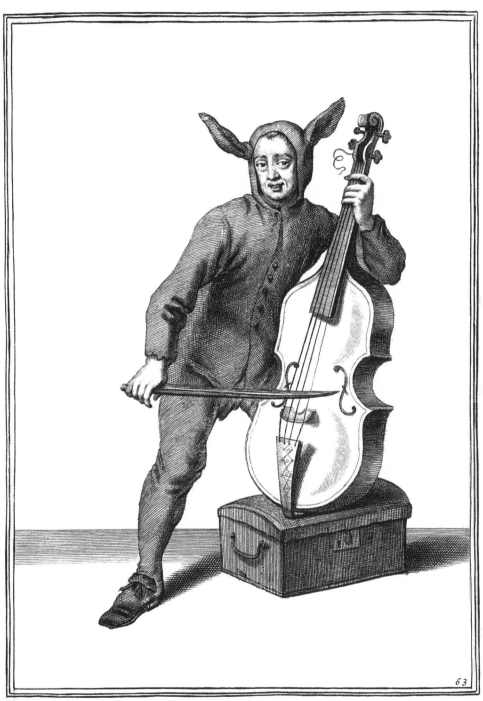

63

Merry Andrew on the Stage

Le plaisant Charlatan

Il Ciarlatano Buffone

Mauron delin: P.Tempest ex:
Cum privilegis

The famous Dutch Woman

Visiting Southwark Fair on 21 September 1668, Samuel Pepys recorded this account of the experience:

> To Southwarke-Fair, very dirty, and there saw the Puppet-show of Whittington, which was pretty to see; and how that idle thing doth work upon people that see it, and even myself too. And thence to Jacob Hall's dancing on the ropes, where I saw such action as I never saw before, and mightily worth seeing. And here took acquaintance with a fellow that carried me to a tavern, whither came the music of this booth, and by and by Jacob Hall himself, with whom I had a mind to speak to hear whether he had ever any mischief by falls in his time; he told me, 'Yes, many; but never to the breaking of a limb.'[141]

The troupes and individuals providing popular entertainments in seventeenth-century London were men. The famous Dutch Woman (also shown on p. 209) is an exception of note. An acrobat and the proprietor of a booth at the fair, she went by the name of Mrs Saftry (sometimes Saffry) and was active from 1677 to 1701. She danced by herself and belonged to a troupe of performers. The only street figure to sport jewellery, she wears tiny earrings.

Her performance is described in the *Post Man and The Historical Account* (19–21 August 1701):

> At the Famous Dutch Womans Booth, overagainst the Hospital Gate, during the time of Bartholomew Fair, where 6 Companies of Rope Dancers are joyned in one, they being the greatest performers of Men, Women and Children, that could be found beyound the Seas, where will be performed such wonderful variety of Dancing, Vaulting, Walking on the slack Rope, and on the sloaping Rope; you will see a Wonderful Girle of 10 years of Age, who walks backwards up the sloaping Rope, driving a wheel-barrow behind her; also you will see the Great Italian Master, who not only passes all that has yet been seen upon the low Rope, but he Dances without a pole upon the Head of a Mast as high as the Booth will permit, and afterwards stands upon his Head on the same. You will also be entertained with the merry Conceits of an Italian Scaramouch, who Dances on the Rope with 2 Children and a Dog in a wheel-barrow, and a Duck on his Head.

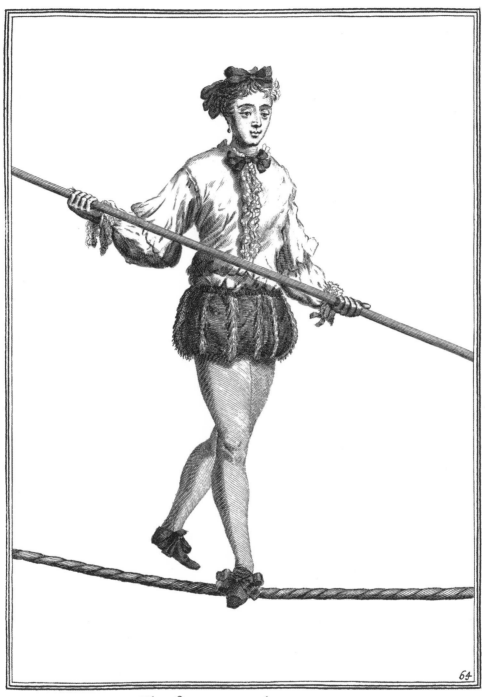

The famous Dutch Woman

la fameuse Hollandoise Danceuse de Corde

Famosa Donna Thedesca

Mauron delin:

P. Tempest exc:
Cum Privilegio

64

MOUNTABANCK

The mountebank (quack doctor) is a character from the *commedia dell'arte*, where he was the most important figure in every troupe. This man's Spanish costume is designed for its theatricality and ostentation; it features a voguish hat, a white starched ruff, a short cloak and, around his neck, a gold chain. He proffers his medicine with the drama of a trained actor, selling liquids because customers can take them more easily than swallow pills. He is armed with an ornamented sword, the head of which is fashioned as an eye-catching conceit, a parrot peeking out as if it were a live bird.

Animals were central to the showmanship of quacks. They kept marmots, vipers and scorpions, but exotic creatures like this man's monkey were the most popular because they drew big audiences. Expensive and difficult to keep, they were sometimes replaced by stuffed animals and costumed boys passing as wildlife.

A testimonial certifying the efficacy of this man's cures lies next to a case of medical instruments. A healer of every ailment, he is an apothecary, a surgeon, a tooth-drawer and an oculist. Mountebanks were also astrologers and prognosticators. Medicine and astrology appear together in a quack doctor's advertisement from 1650, which is preserved in the British Library. In it the quack promises to foretell whether 'a Woman be apt to have Children?' and 'Whether a Man shall prevaile in his Law-suite?'. Its author can also tell whether a 'sicknesse be curable or mortall?' while having to hand and 'ready prepared the most approved Remedies for

all diseases whether outward or inward that are curable'. He declares:

> That I have recovered the 3 yeeres dumbe to perfect speech, cured the dead palsie, the falling sicknesse, Morbus gallicus, confirmed dangerous Ulcers and Fistulaes. [Which] Shall bee apparently proved both by oath, and the testimonies of Honourable Personages. From my House neere Fetter-lane in Gun-powder Alley, the next doore to Master *Corderoy*.[142]

In contrast to such claims, the *Weekly Journal, or, Saturday's Post* offers a shrewd tale of the mountebank and his ways:

> The Mountebank erects a Stage, provides it with Buffoons and Tumblers for your Diversion; in bombast Speeches lets you into his Design of destroying the wicked Combination of Doctors and Apothecaries, against your Money, your Time, and your Health. He has, the sole Benefit of Mankind thereto exciting him, found out a little Pacquet of Physick, that cures all Diseases without Fee or Bill: And as nothing contributes more to Health than uninterrupted Chearfulness, this Great Good Man! this generous Conservator of publick Health! prepares the best Medicine for Melancholy can be invented. Now, you will hardly think it, this fine Gentleman in Velvet employs his Fools for no other End, but to tickle your Ears, and blind your Eyes, while he picks your Sixpences out of your Pockets, and disperses his Poyson among you.[143]

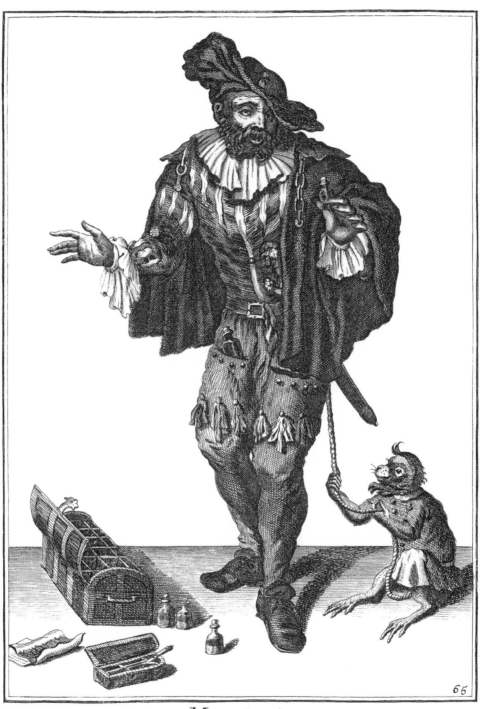

Mountabanck.

Le Charlatan.

il Carlatano.

M. auron delin:

P. Tempest exc:
Cum Privilegio.

The famous Dutch Woman

Mrs Saftry appears in two prints to show the different kind of acrobatics she performed. In the image on p. 205 she walks with a pole on the thick tight-rope strung at a perilous height. Here she vaults, leaps and tumbles on a slack-rope in her booth, where the thin rope is mounted about ten feet above the ground. These performances were held indoors; Punch's Theatre, at the upper end of St Martin's Lane, offered a show 'To begin exactly at 6 a Clock. Middle Boxes 2s. Side Boxes. 1s 6d. Pit 1s. Gallery 6d.'[144]

Mrs Saftry was fined seven shillings fourpence for performing at Stourbridge Fair, Cambridge, 'an unlawful show or Playe', the kind not being specified.[145] Perhaps it was the play advertised in the *Loyal Protestant and True Domestic Intelligence* (29 August 1682), suggestively called *The Irish Evidence, The Humours of Tiege, or, The Mercenary Whore*, with a 'variety of Dances'. The show may have been erotically charged. Here she is dressed in a ruffled Holland blouse, wears her hair uncovered and sports titillating trunks trimmed with fur. Her sheer hose draws attention to her legs, a scandalous but eye-catching display in an age when women's legs were hidden by long gowns. The leering clown in an astrological outfit makes obscene gestures with his lascivious tongue and finger.

Ned Ward's *London Spy* draws out the erotic aspect of rope dancing by foreign women:

The Person that Danc'd … was the *German* Maid, (as they stile her in their Bill) with a great Belly, who does such wonderful pretty things upon the Rope, having such Proportion in her Limbs, and so much Modesty in her Countenance, that I vow, it was as much as ever I could do to forbear wishing my self in Bed with her. She as much out-Danc'd the rest, as a *Grey-Hound* will out-run a *Hedge-Hog*, having something of a Method in her Steps, Air in her Carriage, moving with an Observancy of Time, playing with her Feet, as if assisted with the Wings of *Mercury*. And thus much further I must needs say in her Behalf, that if she be but as nimble between the Sheets, as she is upon a Rope, she must needs be one of the best Bedfellows in *England*.[146]

Rope dancing was organized by masters who took apprentices. In a dispute, the father of an apprentice named Charles Presse charged his son's master, Jacob Hall, with failing to teach his pupil 'the art of music, dancing, and vaulting on the ropes'. Hall had instead deserted his apprentice and vanished beyond the seas.[147]

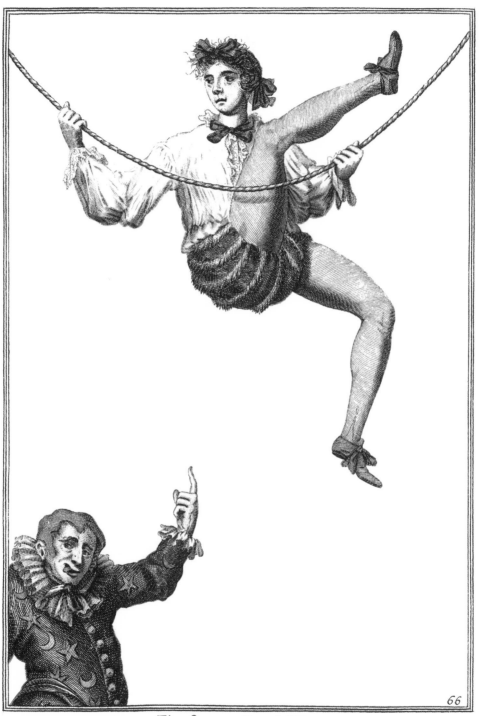

66

The famous Dutch Woman
La fameuse Hollandoise
Famosa donna Thedesca

M.auron delin:

P.Tempest exc:
Cum Privilegio

Josephus Clericus Posture Masterius

Joseph Clark here plays the role of Punch, a short, fat, grotesque, misshapen figure, the chief performer in a puppet show conceived in Italy. Contortionists performed at fairs, theatres and taverns; admission cost two shillings for a box and a shilling for the pit. They were linked to the theatre, where they performed pre-shows. At Lee and Harper's Great Booth, where a comedy called *Female Innocence* was playing, a contortionist performed 'his surprizing Postures and Tumbling'.[148] Contortionists put on stand-alone acts, street corner events, entertainments in movable booths and private events, collapsing the distinction between high and low performance. They were every bit as popular as other celebrated para-theatrical artists – rope dancers and tumblers – with whom Clark appeared and whose tricks he borrowed. Together these performers pioneered popular entertainment as we know it today.

An advertisement in the *Spectator* for 9 April 1712, placed by a successor after his death, gives a sense of the appeal of Clark's performance:

The famous Posture-Master being returned from Cambridge, performs as usual. At the Duke of Marlborough's Head in Fleet-street, in the great Room, is to be seen the famous Posture-Master of Europe, who far exceeds the deceased Posture-Master Clarke and Higgins: He extends his Body into all deformed Shapes; makes his Hip and Shoulder Bones meet together; lays his Head upon the Ground, and turns his Body round twice or thrice, without stirring his Face from the Place; stands upon one Leg, and extends the other in a perpendicular Line half a Yard above his Head, and extends his Body from a Table, with his Head a Foot below his Heels, having nothing to ballance his Body but his Feet: With several other Postures too tedious to mention.

In this portrait, Clark appears wearing his own hair, at a time when even commoners aspired to wigs. Performing an act without song or words, he sticks out his tongue, as if he were a clown, reinforced by the key tied to a tassel on his clown's coat. His hand beneath his belly serves to draw attention to his improbable girth; his contortions suggest that he has dislocated both legs.

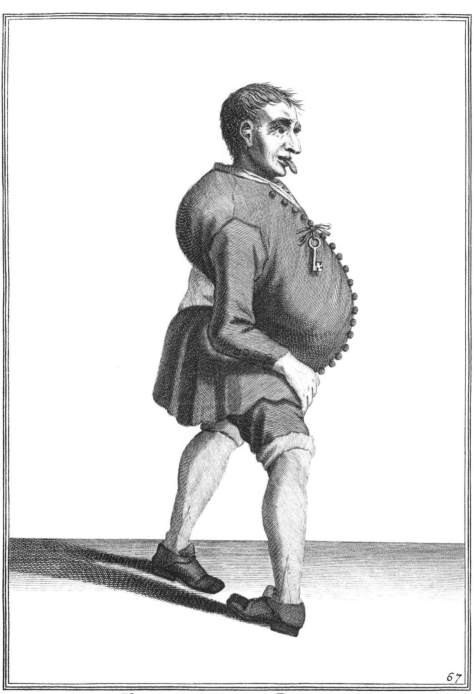

Josephus Clericus
Posture Masterius

M. auron pinx:

P. Tempest ex
Cum privilegio

67

Clark the English Posture Master

Clark appears in linked prints contrasting the metamorphoses in his appearance from one of his shapes to another; the images also evoke a routinized performance unfolding in a specific order to predetermined effect.[149] The features linking the two portraits (see p. 210) are Clark's key which is tied to his coat, his thin hair and his trademark offensive tongue. His trick is to ape the monkey that serves as his clown. In fact, he bests the primate, elevating his leg above his head, violating the picture frame with his finger.

Clark's reputation was the stuff of legend. He was celebrated by James Granger who claimed that 'The powers of his face were more extraordinary than the flexibility of his body'. John Evelyn named him 'Proteus Clark'.[150] He appears in Alexander Smith's *History of the Lives of the Most Noted Highway-Men, Foot-Pads, House-Breakers, Shop-lifts and Cheats, of both Sexes, in and about London*. According to Smith, Clark was ordered to stand and deliver by the murderous highwayman Patrick O'Bryan, but the posture master bamboozled this villain, transforming himself into several confounding shapes, 'sometimes having his Head betwixt his Legs and his Heels upright, sometimes seeming to have two Heads and three Legs, and sometimes no Head at all'. The highwayman was thus unable to collect from the man but, worse still, was himself robbed.[151]

Clark appeared in Paris in the train of the duke of Buckingham.[152] He is chiefly famous for playing practical jokes and was reputed to have been the plague of clothiers. A writer in the *Guardian* (No. 102, 8 July 1713) reminisced that he would call a tailor to his home in Pall Mall to be fitted in one posture but appear in another when the clothes were delivered. The wide range of acts that contortionists offered is suggested by a later account of one Mr Fawkes's

famous little Posture-Master of seven Years old, not to be equal'd in Europe, who likewise performs on the slack Rope to Admiration; his entertaining Musical Clock, with two beautiful moving Pictures, and an Aviary of Birds, as natural as Life itself; also a curious Venetian Machine, allow'd by all Artists to be the finest Piece of Workmanship in the World.[153]

Clark died around 1696.

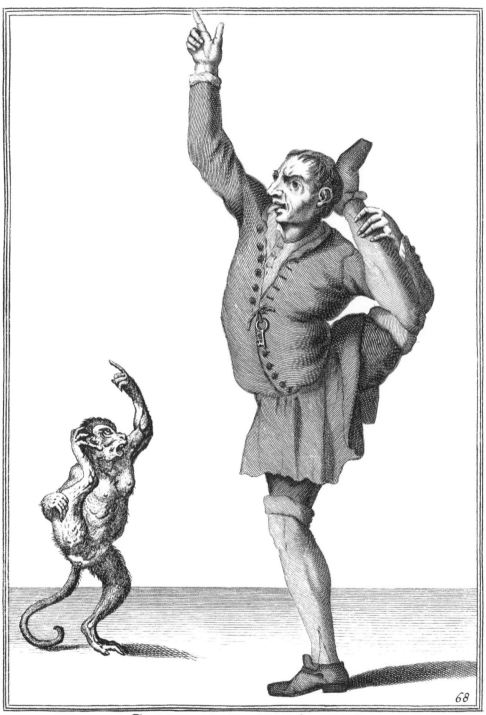

CLARK the Engliſh Poſture Maſter
Le Maiſtre des Poſtures Anglois
Poſtura de Matacini Ingleſi

M.Lauron delin:

P. Tempeſt exc:
Cum Privilegio

68

The London Begger

This beggar is accompanied by two children, an infant who peeks over her shoulder and a young child with whom she walks hand in hand. She gestures theatrically to the latter who is costumed in tatters and hand-me-downs that are too big for him. His hair sprouts through the battered hat he wears.

While the *commedia dell'arte* figures, from the Spanish Don to Clark the English Posture Master, were self-declared performers and personages who put on entertainments before and after plays, the London beggar is, according to the 1794 report of James Caulfield, a covert performer and a charlatan. By all appearances she is typical of the 30,000 or more beggars estimated to have inhabited England in 1688, of whom a thousand died in London each year from starvation.[154] Caulfield's *Portraits, Memoirs and Characters* identifies this figure as Nan Mills:

It is remarked of this woman, that she was not only a good physiognomist, but also an excellent mimic. She knew who were the likeliest persons to address herself to, and could adapt her countenance to every circumstance of distress. Among her other deceptions, it would not be surprising (or unprecedented, in the annals of beggary) if she had stolen or hired the children she dragged about with her, to extort charity; as this has been practised with success by vagrant females, who never had a child of their own.[155]

The *London Daily Advertiser* (21 October 1752) reports a similar narrative:

Begging is now become so profitable a Business, that many of the Beggars of St. Mary's Parish, have lately sold their Badges to Strangers at a very high Price; for which Reason, the principal Parishioners have ordered the Badges to be taken from them until new Regulations be made … Whilst Numbers of reduced Citizens and Housekeepers, are in a starving Condition, who have not the Art of Begging, or moving Compassion as common Beggars do, who often steal Children, blind them, and distort their Limbs to excite Charity.

These banal and didactic generalizations from *Portraits, Memoirs and Characters* and the *Daily Advertiser* stand in vivid counterpoint to the following tale from the *Weekly Journal, or, British Gazetteer* about an actual woman beggar and the real-life consequences of her circumstances:

Last Monday Evening a Woman, who pretended to have a Child sucking at her Breast, stood at the End of Cabbage-Lane near James Street, Westminster, begging Alms … and two Gentlemen passing by, after giving her a Penny, insisted upon seeing the Child, which she refused, saying its Face was scabby; but the Gentlemen persisted in their Demand, and at length pulling her Riding-Hood and Apron aside, perceived a Kitten sucking at her Breast; whereupon they secured her, and carried her before a Magistrate, who discharged her, it not appearing that she had defrauded them, but only had ask'd Alms; but the Mobb being very great, they threw her into a Horse-pond, and there duck'd her so often, that she died last Tuesday.[156]

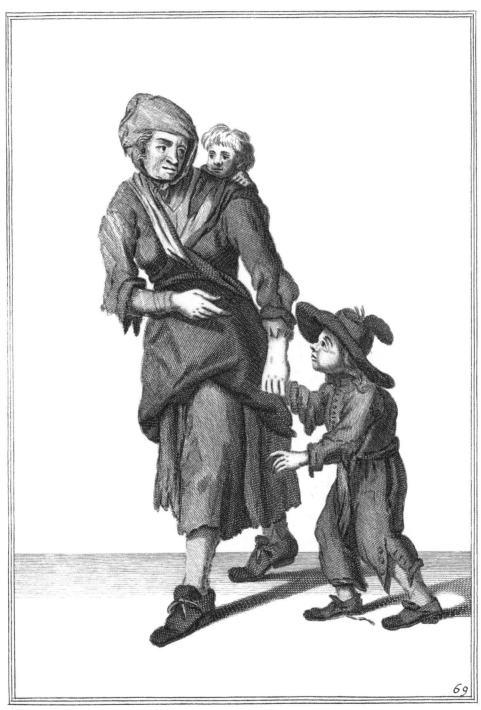

69

The London Begger

Le Gueux de Londres

La pouera di Londra

Mauron delin:

P. Tempest exc:
Cum Privilegio

JOHN THE QUAKER

This print of John the Quaker and the next four images offer portraits of religious figures and proselytizers, commonly called 'Divinity Pedlars'.[157] Quakerism was a new phenomenon in London when Laroon's *Cryes* appeared, having made its appearance in 1647 when it was founded by the English Dissenter George Fox (1624–1691). It aroused curiosity and suspicion, not least because Quakers regularly went to jail rather than pay war taxes.

Laroon's portrait of John reflects contemporary stereotypes of Quakers as quiet and pacific individuals whose religious practices paid little attention to the written word. His depiction is singularly positive and affirmative. John looks down, his head bowed and his arms folded in an expression of inwardness and modesty. His dress is simple, neat, in good order and conventional, a badge of his faith.

But Henri Mission's description, in his *Memoirs and Observations in his Travels over England* (1698), is typical of his time:

> The Quakers are great Fanaticks; there seems to be something laudable in them; to outward Appearance they are mild, simple in all respects, sober, modest, peaceable, nay, and they have the Reputation of being honest, and often they are so: But you must have a Care of being bit by this Appearance, which very often is only outward.[158]

As late as 1800, there was still animosity toward Quakers:

> The Quakers who are the principal dealers on the Corn Exchange, and who are esteemed of course the greatest monopolizers, were regularly attacked as they attempted to enter Market Lane … One person of that persuasion nearly lost his life. The crowd had a cord with a noose on it prepared for him, and, as he passed, threw it at his head, which he happily evaded, and took refuge in a respectable house in the neighbourhood, which was assaulted several times without effect, excepting the breaking of the windows.[159]

James Granger was familiar with the identification of John the Quaker as John Kelsey, who travelled to Constantinople to convert the sultan of Turkey. He was arrested there at the behest of Lord Winchelsea, ambassador to the Porte, who ordered that he be treated to 'a little of the Turkish discipline', whereby Kelsey was drubbed upon his feet and returned to England.[160]

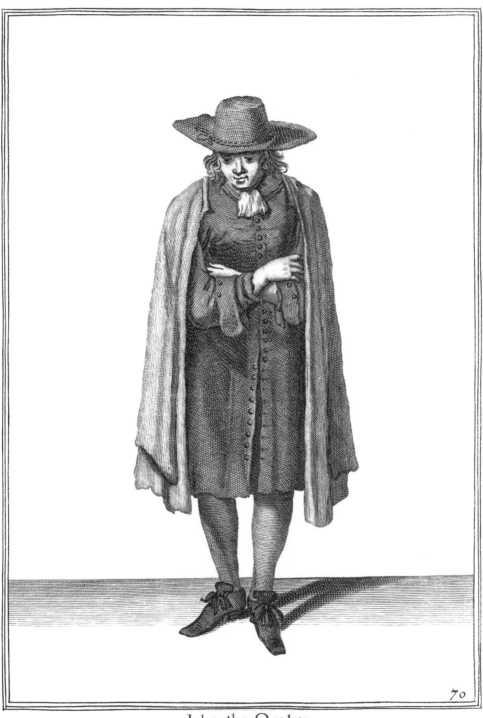

70

Iohn the Quaker
Le Trembleur de Londre
Bachetore di Londra

Mauron delin

P Tempest exc:
Cum Privilegio

THE LONDON QUAKER

The London Quaker, long identified as Rachel of Covent Garden, is in many respects the helpmeet of John the Quaker (p. 216). Like him, she casts her eyes downwards, turns away from the viewer and clasps her hands together in a gesture of penitence. Her face is melancholy and reflective. Her clothing, like John's, is simple, plain and in perfect repair. She modestly covers her head with a cap which frames her face and a large scarf tied under her chin.

James Caulfield, in his *Portraits, Memoirs and Characters*, proposes that Quakers are the opposite of what they seem:

> there can be no doubt, the appellation of Rachel of Covent Garden meant more than her dress warranted, although we do not find any particular history of her. Ward, in his London Spy, (vol. ii. p. 399) gives an anecdote of her by the appellation of demure Rachel of Covent Garden, who dressed in a plain lute-string hood and scarf, and a green apron.[161]

Caulfield, on slender evidence, also claims that this woman was a prostitute. He asserts that the Hogarth commentator George Steevens saw a copy of the *Cryes* in which a note alleges that Rachel died in St Martin's workhouse, which belonged to the same parish as Covent Garden and was a haunt of harlotry.

The power that Quakers granted to women made them the object of curiosity and hostility, as indicated by the following account of five English men and four women. Arriving in Boston, they carried 'many hereticall books full of Blasphemie, with intent to spread and skatter them through the plantations'; they were arrested and imprisoned and their books were reserved for the fire. But afterwards, as the governor walked home from religious service, Mary Prince, a woman captive, called out to him from behind her prison bars, 'Woe unto thee that art an Oppressor', denouncing him 'in a most impudent and bold maner', which she followed with 'a Letter stuft with opprobrious revilings'. Attempts to catechize Mary Prince failed; all nine were tried and banished to England.[162]

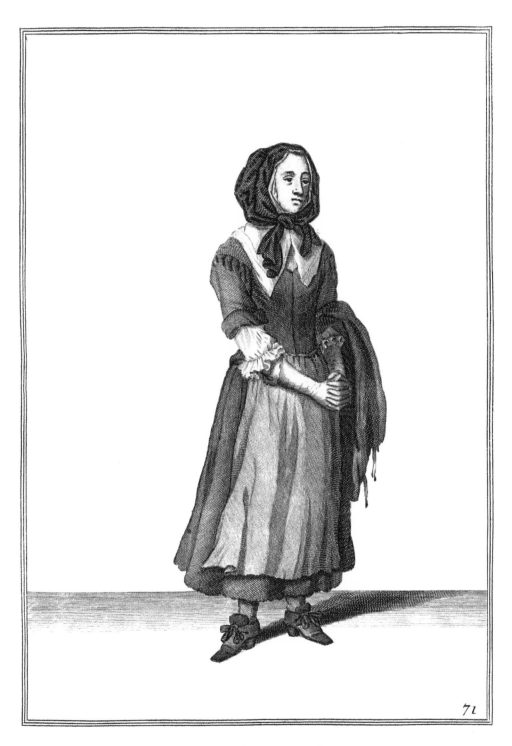

71

The London Quaker

P.Tempest. ex:
Cum privilegio

OLIVER C: PORTER

This plate shows the porter or doorkeeper of Oliver Cromwell. Named Daniel, he was a giant of a man at seven foot six inches (he may have had giantism). Cromwell's name was not spelled out in this caption because he was the object of violent hatred in the late seventeenth century, when his body was exhumed and hanged.
The French and Italian generic titles describe Oliver's porter as 'passionate for religion'. A Rasputin-like character, the porter was a prognosticator, proselytizer and preacher, who suffered spells of religious mania. Cromwell committed his porter to St Mary Bethlehem hospital, a psychiatric institution (from whence the term 'Bedlam' derived), where he ordered that he be supplied with a library and a secretary to record his prophecies.

Where the London Quaker and John the Quaker represent the church pacific, Oliver Cromwell's Porter represents the church militant, as emphasized by his closely cropped hair, with its military overtones. The two Quakers look down and bow their heads, but the Porter stares the viewer straight in the eye and thrusts out his Bible to his audience as if proposing a text. The Bible was said to have been given to him by Nell Gwynn. His outfit is neat and proper. Like John the Quaker he wears a double cloak, though his has a cowl. His tunic is belted high on his chest.

James Granger, in his *Biographical History*, links Daniel to George Fox, founder of the Quakers. The porter was, however, a celebrated prophet 'and was said to have foretold several remarkable events, particularly the fire of London'. According to Granger, people often went to hear him preach and would sit many hours under his window. Charles Leslie, a contemporary, asked a lady in his audience

"what she could profit by hearing that madman?" She, with a composed countenance, as pitying his ignorance, replied "That Festus thought Paul was mad."[163]

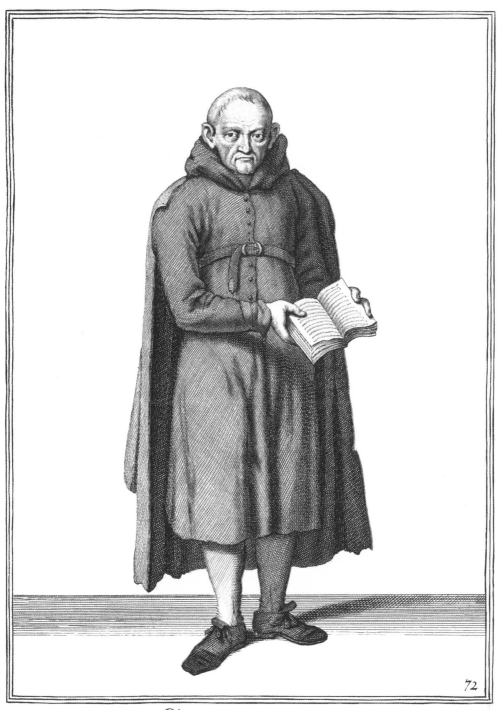

72

Oliver C: Porter

Un insense pour la Religion

Huomo impazzito per la Religione

Mauron delin:

P Tempest exc
Cum Privilegio

A Nonconformist Minister

The Nonconformist minister is the most richly dressed man in the *Cryes*. He shows off his own hair, elegantly coiffed and falling down to his shoulders. His fashionable hat is perfectly blocked, and his cloak is smartly cut and tailored. His tunic is distinguished by its shower of buttons and two low pockets, one of which displays a kerchief. He wears gauntlet gloves in a white or light-coloured material. His trouser legs are banded below the knees in two-sided bows, a rare statement. These match the bows that tie his shoes, which are so large that they trail on the ground.

His sacerdotal credentials are subdued. They appear in two bands with their tiny tassels and also in the ostentatious way he places his hand over his heart. This gesture is meant to suggest sincerity, although his sideways glance avoids the direct eye contact of Cromwell's Porter. The Italian legend describes him as a Calvinist.

This character has long been identified as Pierce Tempest (1653–1717), the publisher of the *Cryes*. Tempest was born into a landed Yorkshire gentry family, which would explain his assured pose and rich attire. In London he established himself at the Eagle and Child in the Strand, becoming one of the most distinguished print publishers of his age. He issued prints by Barlow and Place as well as erotica by Laroon. The entry for him on the British Museum website calls his *Cryes* 'the most interesting series of prints of this period'.[164] He is said to have trained under Hollar, but nothing from his hand survives, and he is known today for his remarkable business acumen. The British Museum calls this likeness 'a spoof portrait' of Tempest, but it is not clear just what that means. Was it a prank that both the artist and the publisher were in on? The portrait is flattering in some respects but not in others: he appears overdressed and grasps his rich cloak possessively. Nothing is known of the ties between Laroon and Tempest but relations between artists and their publishers were seldom simple.

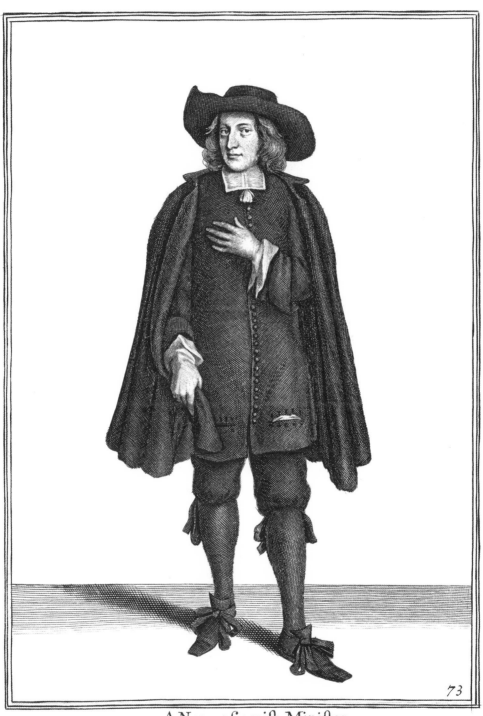

73

A Nonconformiſt Miniſter
Le Ministre Nonconformiste
Ministro ò Sacerdote Caluinista

M Lauron delin:

P Tempest exc:
Cum Privilegio.

FRATER MENDICANS

'Frater Mendicans' refers, in Latin, to a member of the Roman Catholic orders of monks called 'mendicants', that is, begging friars, the best known of whom were the Franciscans and the Dominicans. Such monks, tonsured as this figure is, travelled around selling religious favours, preaching, collecting alms and hawking indulgences, which are indicated by the paper he offers in solicitation. The figure's habit is generic religious garb, consisting of a tunic with a cowl and a rope for a cincture bearing rosary beads.

The print depicts an actor playing the part of a friar. The actor would have strolled about in the streets near to where he and his company were about to stage their play in order to drum up an audience. Laroon's plate for this Cry exists in two different states, the second of which is reproduced here. The first state shows the monk as 'The Spanish Fryar', a reference to John Dryden's tragicomedy *The Spanish Fryar* (c.1680).[165] It indicates that the Catholic friar here is the English actor Anthony Leigh, one of the most celebrated actors of his age, who played the lead role of Dominic, the Spanish Fryar. A full-length portrait of Leigh in the role of the Spanish Fryar was painted by Sir Godfrey Kneller, and mezzotinted by John Smith with the publication line 'G Kneller pinx: 1689', and along bottom 'I Smith fecit. Sold by I Smith and I Savage in the Old Baily'. Laroon's friar is clearly not a copy of Kneller's portrait of Leigh, since the religious habit of Frater Mendicans is quite different in Laroon, as are his shoes, but key elements link the two likenesses of Leigh: the crutched stick, the rosary beads (in the print) and the faces.

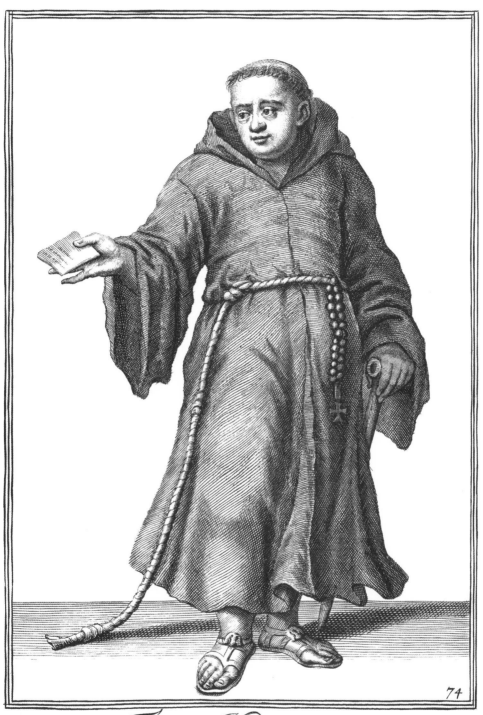

74

Frater Mendicans

Mauron delin

P.Tempest ex:

Notes

Introduction

1 Bainbrigg Buckeridge, 'An Essay towards an English School of Painters', in Roger de Piles, *The Art of Painting*, 3rd edn, London, [1754], p. 401.

2 *Mercurius Britanicus*, 23 December 1644.

3 Danielle van den Heuvel, 'Foods, Markets and People', in Melissa Calaresu and Danielle van den Heuvel (eds), *Food Hawkers: Selling in the Streets from Antiquity to the Present*, London: Routledge, 2016, p. 84.

4 Repertories of the Courts of Aldermen (MSS.), 24:68, quoted in Natasha Korda, *Labors Lost: Women's Work and the Early Modern English Stage*, University of Pennsylvania Press, Philadelphia, 2011, p. 149.

5 Antoine Truquet, *Cent et Sept Cris que l'on crie journellement à Paris*, N. Buffet, Paris, 1545, n.p.

6 Jonathan Swift, *Journal to Stella*, ed. Harold Williams, Oxford University Press, Oxford, 1963, vol. 2, p. 581.

7 *Read's Weekly Journal, or, British Gazetteer*, 20 March 1731.

8 This system is described at length, but from publishers' perspectives, in the commentary for 'Londons Gazette here' (see p. 188), where it is documented fully.

9 Paul Bairoch, Jean Batou and Pierre Chèvre, *La population des villes européennes, 800–1850*, Librairie Droz, Geneva, 1988, p. 198.

10 Eleanor Hubbard, *City Women: Money, Sex, and the Social Order in Early Modern London*, Oxford University Press, Oxford, 2012, p. 201.

11 *Hugh Alley's Caveat: The Markets of London in 1598*, ed. Ian Archer, Caroline Barron and Vanessa Harding, Topographical Society, London, 1988, p. 23.

12 Donald Lupton, *London and the Countrey Carbonadoed and Quartred into Severall Characters*, London, 1632, pp. 91–2.

13 John Gay, *Trivia, or, The Art of Walking the Streets of London*, London, [1716], bk 2, ll. 303–318.

14 M. Dorothy George, *London Life in the XVIIIth Century*, Knopf, New York, 1925, pp. 48–9.

15 Lupton, *London and the Countrey Carbonadoed*, pp. 92–4.

16 Ibid., p. 92.

17 John Denham, *Cooper's Hill*, 2nd edn, London, 1650, ll. 29–30.

18 Thomas Brown, *Amusements Serious and Comical, Calculated for the Meridian of London*, London, 1700, p. 18.

19 Henry Peacham, *The Worth of a Peny*, London, 1641, p. 21.

20 Bodleian Library, Gough Maps 46, fol. 169.

21 John Gay, *Trivia*, bk 2, ll. 365–6.

22 See Sheila O'Connell, *The Popular Print in England*, British Museum Press, London, 1999, pp. 181–2.

23 *A Catalogue of Plates, The Prints whereof are useful for Gentlemen, Artists, and Gentlewomen, and School-mistresses, Sold by* Arthur Tooker, *Stationer at the Globe over against* Salisbury House *in the Strand* …, included in Alexander Browne, *Arts Pictoria*, 2nd edn, printed for Arthur Tooker and William Battersby, London, 1675, p. [41].

24 Richard T. Godfrey, *Printmaking in Britain*, Phaidon, Oxford, 1978, pp. 9, 18.

25 Henry Peacham, *The Compleat Gentleman*, 1634, intro. G. S. Gordon, repr. Clarendon Press, Oxford, 1906, p. 129.

26 William M. Ivins, Jr., *Prints and Visual Communication*, Harvard University Press, Cambridge, MA, 1953, p. 47.

27 I am grateful to Nicholas Stogdon who provided me with a detailed analysis of the images in this *Cryes* and invaluable guidance in all matters of calcography.

28 Sheila McTighe, 'Perfect Deformity, Ideal Beauty, and the *Imaginaire* of Work: The Reception of Annibale Carracci's *Arti di Bologna* in 1646', *Oxford Art Journal*, vol. 16, 1993, p. 76.

29 *The Journal of Samuel Curwen, Loyalist*, ed. Andrew Oliver, 2 vols, Harvard University Press, Cambridge, MA, 1972, vol. 2, p. 586.

30 James Gandon, *The Life of James Gandon, Esq.*, Dublin, 1846, p. 208.

31 *Gentleman's Magazine*, Sept. 1801, p. 857; *The Diary of Joseph Farington*, ed. Kenneth Garlick and Angus Macintyre, 16 vols, Yale University Press, New Haven, CT, 1978–98, vol. 3, pp. 849–54.

32 Edward Edwards, *Anecdotes of Painters who Have Resided or Been Born in England*, London, 1808, p. 269.

33 Stephen Calloway, *English Prints for the Collector*, Lutterworth Press, London, 1980, p. 60.

34 Anthony Pasquin, *A Liberal Critique on the Present Exhibition of the Royal Academy*, Symonds, London, 1794, pp. 31–2.

35 Fynes Moryson, *An Itinerary Written by Fynes Moryson Gent.*, London, 1617, Part III pp. 152, 150.

36 Katie Scott, 'Edme Bouchardon's "Cris de Paris": Crying Food in Early Modern Paris', *Word & Image*, vol. 29, no. 1, 2013, pp. 59–91.

37 Ingrid D. Rowland, 'Roman Holidays', *New York Review of Books*, vol. 65, 28 June 2018, p. 57.

38 Zacharias Conrad von Uffenbach, *London in 1710*, trans. and ed. W.H. Quarrell and Margaret Mare, Faber and Faber, London, 1934, pp. 164–5.

39 George Virtue, *A Description of the Works of the Ingenious Delineator and Engraver Wenceslaus Hollar*, 2nd edn, London, 1759, p. 146; repr. in *The Eighteenth Volume of The Walpole Society, 1929–1930: Vertue Note Books, volume 1*, Oxford University Press, Oxford, 1930, p. 34.

40 I am indebted to the sleuthing of Nicholas Stogdon for this information.

41 Henry Peacham, *The Compleat Gentleman*, p. 129.

42 Richard Luckett, *The Cryes of London: The Collection in the Pepys Library at Magdalene College, Cambridge*, Old Hall Press, Leeds, 1994, p. xv.

43 *Diary of Samuel Pepys*, ed. Robert Latham and William Matthews, 11 vols, University of California Press, Berkeley, 2000, vol. 9, p. 293 (reading 'fallowed').

44 Luckett, *Cryes of London*, pp. vii–xxi and pl. 2.

45 Ibid., p. xviii.

46 Ibid., pl. 69.

47 James Granger, A *Biographical History of England, from Egbert the Great to the Revolution* (1769), 5th edn, 6 vols, London, 1824, title page.

48 Ibid., vol. 6, p. 10 n.

49 James Caulfield, *Portraits, Memoirs, and Characters, of Remarkable Persons, from the Reign of King Edward the Third, to the Revolution*, new edn, 3 vols, London, 1813, vol. 3, p. 249.

50 Granger, *Biographical History of England*, vol. 6, p. 179.

51 Ibid.

52 *Weekly Journal, or, British Gazetteer*, 27 December 1729.

53 'Lord' George Sanger, *Seventy Years a Showman*, Dent, London, 1926, pp. 190–91.

54 Hoh-Cheung Mui and Lorna H. Mui, *Shops and Shopkeeping in Eighteenth-Century England*, Routledge, London, 1989, p. 9.

55 Henry Mayhew, *London Labour and the London Poor*, 4 vols, London, 1861–2, vol. 1, preface.

56 Ibid., vol. 1, p. 5.

57 Ibid., vol. 1, p. 6.

58 *Daily Journal*, 15 October 1723.

59 Francis Boscawen, *Admiral's Wife: Being the Life and Letters of the Hon. Mrs. Edward Boscawen from 1719 to 1761*, ed. Cecil Aspinall-Oglander, Longmans, Green, London, 1940, p. 170.

60 Mayhew, *London Labour and the London Poor*, vol. 1, p. 5.

The Cries

1 *St. James's Chronicle, or, The British Evening Post*, 1–3 March 1768.

2 *Evening Post*, 25–27 June 1719.

3 *London Evening Post*, 1 December 1737.

4 Joseph Addison, *Spectator*, no. 251, 18 December 1711.

5 Jane Giscombe, 'The Use of Pins in Early Modern England (1450–1700)', *The Book & Paper Gathering* (blog), 31 May 2018, https://thebookandpapergathering.org/2018/05/31/the-use-of-pins-in-early-modern-england-1450-1700/#:~:text (accessed 5 June 2020).

6 Pepys, *Diary*, vol. 8, p. 389.

7 *The Case or Petition of the Corporation of Pin-Makers*, London, *c.*1690.

8 Pepys, *Diary*, vol. 4, p. 200; vol. 9, p. 226.

9 Ibid., vol. 7, p. 167.

10 *St. James's Chronicle, or, The British Evening Post*, 18–20 June 1761.

11 John T. Smith, *Cries of London*, London, 1839, p. 54.

12 Ibid.

13 *The Journeys of Celia Fiennes*, ed. Christopher Morris, London, 1949, p. 93.

14 *Flying Post, or, The Post-Master*, 31 December 1715–3 January 1716.

15 *Observator*, 5–8 February 1707.

16 Pepys, *Diary*, vol. 1, p. 318; vol. 7, p. 166.

17 Curwen, *Journal*, vol. 2, p. 641.

18 *Tatler*, 26–28 December 1710; see also 24–26 January 1710.

19 Pepys, *Diary*, vol. 7, p. 138.

20 Christopher Plumb, 'Exotic Animals in Eighteenth-Century Britain', PhD thesis, University of Manchester, 2010, www.rhinoresourcecenter.com/pdf_files/134/1345701669.pdf (accessed 5 June 2020).

21 Maria Grace, 'Of Quills and Ink: Regency Letter Writing', 10 July 2014, https://englishhistoryauthors.blogspot.com/2014/07/of-quills-and-ink-regency-letter-writing.html.

22 Ibid.

23 Ibid.

24 *Perfect Occurrences of Every Daie Journall in Parliament, and Other Moderate Intelligence*, 5–12 October 1649.

25 *Penny London Post, or, The Morning Advertiser*, 7–10 August 1747.

26 'Warden Pie', *The Foods of England Project* (blog), 2 September 2018, www.foodsofengland.co.uk/WardenPie.htm (accessed 5 June 2020).

27 Samuel Sorbière, *A Journey to London in the Year 1698*, London, 1698, pp. 29–30.

28 Judy Z. Stephenson, '"Real" Wages? Contractors, Workers, and Pay in London Building Trades, 1650–1800', *Economic History Review*, vol. 71, no. 1, Feb. 2018, pp. 106-32.

29 Pepys, *Diary*, vol. 7, p. 401 and n. 5.

30 Curwen, *Journal*, vol. 1, pp. 364–5.

31 *Post Boy*, 29 April–1 May 1697.

32 *London Evening Post*, 5–7 June 1739.

33 Thomas Dekker, *The Belman of London*, in *The Non-Dramatic Works of Thomas Dekker*, 5 vols, ed. Alexander B. Grosart, privately printed, vol. III, 1885, p. 109.

34 *Public Advertiser*, 13 July 1769.

35 Henri Mission, *Memoirs and Observations in his Travels over England*, London, 1719, p. 314.

36 *London Journal*, 4 August 1722.

37 Pepys, *Diary*, vol. 5, p. 277.

38 *Morning Post and Daily Advertiser*, 15 March 1776.

39 Jonathan Swift, 'A Description of the Morning', in *The Poems of Jonathan Swift*, ed. Harold Williams, 2nd edn, 3 vols, Oxford University Press, Oxford, vol. 1, 1966, p. 124.

40 Pepys, *Diary*, vol. 3, p. 41 and n. 2.

41 Anne J. Krush, 'A Cancer of Environmental and Occupational Etiology and a Thigh Tumor Described by Sir Percivall Pott in the Eighteenth Century', *Transactions of the Nebraska Academy of Sciences and Affiliated Societies*, vol. 5, 1978, pp. 63-5, http://digitalcommons.unl.edu/tnas/496 (accessed 5 June 2020).

42 *General Evening Post*, 19–21 July 1739.

43 Fiennes, *Journeys*, p. 87.

44 Deirdre Loughridge, *Haydn's Sunrise, Beethoven's Shadow*, University of Chicago Press, Chicago, 2016, pp. 69–70.

45 Mission, *Memoirs and Observations*, p. 307.

46 James Granger, *A Biographical History of England*, 5th edn, 6 vols, London, 1824, vol. 6, p. 173.

47 Bridget Hill, *Women, Work and Sexual Politics in Eighteenth-Century England*, McGill-Queen's University Press, Montreal, 1994, p. 32.

48 *Applebee's Original Weekly Journal*, 13 May 1732.

49 Curwen, *Journal*, vol. 1, p. 154.

50 Carl Moritz, *Journeys of a German in England in 1782*, trans. and ed. Reginald Nettel, Holt, Rinehart & Winston, New York, 1965, p. 24.

51 *Loyal Observator Revived, or, Gaylard's Journal*, 16 February 1723; *Daily Post Boy*, 18 April 1732.

52 Pepys, *Diary*, vol. 9, p. 443.

53 Ibid., vol. 6, p. 224; vol. 5, p. 90.

54 Daniel Lysons, 'Market gardens in London', in *The Environs of London*, vol. 4, London 1796, pp. 573–6, citing Castelvetro's treatise, titled 'Brieve Racconto di tutte le Radici, du tutte l'Herbe, & di tutti Frutti che crudi o cotti in Italia si mangiano', then in the library of Sir Joseph Banks.

55 T. Sarah Peterson, *Acquired Taste: The French Origins of Modern Cooking*, Cornell University Press, Ithaca, NY, 1994, p. 114.

56 Peterson, *Acquired Taste*, p. 114.

57 Pepys, *Diary*, vol. 8, p. 173.

58 C. Willett Cunnington and Phillis E. Cunnington, *Handbook of English Costume in the Seventeenth Century*, Plays, Boston, 1972, p. 67.

59 Ibid., vol. 4, p. 95.

60 *London Evening Post*, 25–28 September 1742.

61 *Weekly Packet*, 20–27 July 1717.

62 *British Journal*, 13 July 1723.

63 Curwen, *Journal*, vol. 2, p. 657.

64 Pepys, *Diary*, vol. 2, p. 29.

65 *Universal Spectator and Weekly Journal*, 9 June 1733.

66 *London Post*, 12–14 July 1703; similarly worded advertisement in the *Post Man and The Historical Account*, 17–20 July 1703.

67 'Mary Meggs', in Philip H. Highfill, Jr, Kalman A. Burnim and Edward A. Langhans, *A Biographical Dictionary of Actors, Actresses, Musicians, Dancers, Managers & Other Stage Personnel in London, 1660–1800*, 16 vols, Southern Illinois University Press, Carbondale, 1973–93, vol. 10, pp. 166-7.

68 Pepys, *Diary*, vol. 9, p. 195.

69 *London Evening Post*, 25–27 February 1735.

70 *Post Man and The Historical Account*, 12–14 October 1703.

71 *Loyal Protestant, and True Domestick Intelligence*, 7 September 1682.

72 Anne Buck, *Dress in Eighteenth-Century England*, Batsford Books, London, 1979, pp. 113–14.

73 *London Journal*, 30 November 1723.

74 Bernard Capp, *English Almanacs 1500–1800*, Cornell University Press, Ithaca, NY, 1979, p. 44; see also Eustace F. Bosanquet, *English Printed Almanacks and Prognostications*, The Bibliographical Society, London, 1917.

75 *Post Man and The Historical Account*, 8 November 1716.

76 Pepys, *Diary*, vol. 9, p. 457.

77 Curwen, *Journal*, vol. 2, p. 752.

78 Lel Gretton, 'Washing & Cleaning for a Duke', *Old & Interesting* (blog), 24 October 2007, www.oldandinteresting.com/17th-century-washing.aspx (accessed 5 June 2020).

79 *Post Boy*, 16–18 December 1712.

80 *Universal Spectator and Weekly Journal*, 2 February 1745.

81 *Penny London Post, or, The Morning Advertiser*, 1–3 March 1749.

82 Alice Clark, *Working Life of Women in the Seventeenth Century*, Routledge, London, 1919, pp. 32–3.

83 *Mist's Weekly Journal*, 17 May 1725; see also the *Stamford Mercury*, 28 September 1721 and 19 October 1721.

84 John Stow, 'The Temporal Government of London, The Haberdashers', in *A Survey of the Cities of London and Westminster*, London, 1755, vol. 2, p. 279.

85 Moritz, *Journeys*, p. 47.

86 *Weekly Journal, or, British Gazetteer*, 29 June 1717.

87 Granger, *Biographical History of England*, vol. 6, p. 173.

88 *Spectator*, no. 362, 25 April 1712; no. 251, 18 December 1711.

89 Fiennes, *Journeys*, p. 131.

90 *Stamford Mercury*, 29 August 1717.

91 *Grub Street Journal*, 16 July 1730.

92 One Wright, proprietor of 'a Cook's Shop near St. Giles's Church', sold a footguard tuppence worth of meat 'but a Dispute arising about a bad Half penny, Wright in his Rage struck the Soldier with his Carving Knife over the Head, and cut him in such a terrible Manner that … he died on Wednesday Morning' (*London and Country Journal*, 3 November 1741).

93 *Common Sense, or, The Englishman's Journal*, 7 May 1737.

94 W.J. Hardy, *Middlesex County Records. Calendar of the Sessions Books, 1689–1709*, Sir Richard Nicholson, London, 1905, p. 229, www.british-history.ac.uk/ middx-county-records/session-bks-1689-1709/pp223-235 (accessed 22 June 2020).

95 *British Journal, or, The Censor*, 6 September 1729.

96 *London Evening Post*, 13–16 January 1753.

97 *Stamford Mercury*, 11 January 1721/2.

98 *Country Journal, or, The Craftsman*, 4 January 1729.

99 *London Chronicle, or, Universal Evening Post*, 21–23 May 1761.

100 John Cordy Jeaffreson (ed.), *Middlesex County Records*, vol. 3, 1625–67, London, 1888, p. 101, www.british-history. ac.uk/middx-county-records/vol3/pp98-102 (accessed 22 June 2020).

101 The reconstruction is based on Ned Ward's *The London-Spy*, Casanova Society, London, 1924, p. 6: 'Did you take Notice (says he) of the Gentleman in a Blew coat, Red Stockins, Silver-hilted Sword, and Edg'd-Hat, who sat at the upper end of the Table?'

102 Ward, *London-Spy*, p. 6.

103 Granger, *Biographical History of England*, vol. 6, p. 168.

104 Daniel Defoe, *Every-Body's Business is No-Body's Business*, London, 1725, p. 7.

105 *Middlesex Journal and Evening Advertiser*, 24–26 May 1774.

106 *Severall Proceedings in Parliament*, 9–16 May 1650.

107 *Weekly Journal, or, Saturday's Post*, 8 March 1718.

108 *Weekly Journal, or, British Gazetteer*, 18 April 1730.

109 *British Journal*, 30 September 1727.

110 Pepys, *Journal*, vol. 9, pp. 301, 293; vol. 4, p. 301.

111 *Westminster Journal and London Political Miscellany*, 3 November 1764.

112 *Universal Spectator and Weekly Journal*, 5 March 1737.

113 '1758: England', quoted in Janet Clarkson, *Food History Almanac*, Rowman & Littlefield, Lanham, MD, 2014, p. 937.

114 *Daily Courant*, 21 December 1725. This long notice offers the fullest (but still incomplete) account of the legislation to which hawkers were subject.

115 *London Evening-Post*, 8–10 July 1729.

116 *Post Boy*, 6–9 November 1714.

117 *Daily Journal*, 17 February 1722.

118 *Brice's Weekly Journal*, 3 March 1727. The retail price index value of £44,000 in 2018 was £6.5 million.

119 *British Apollo*, 4–6 May 1709.

120 *Observator*, 16–19 April 1707.

121 Pepys, *Journal*, vol. 6, p. 305.

122 *Weekly Journal, or, British Gazetteer*, 16 March 1717.

123 *London Gazette*, 7 August 1679.

124 *Gazetteer and London Daily Advertiser*, 26 October 1762.

125 J.T. Smith, *Nollekens and his Times*, 2nd edn., 2 vols, London, 1829, vol. 1, p. 201.

126 Pepys, *Diary*, vol. 8, p. 249.

127 Daniel Defoe, *Review of the State of the British Nation*, 19 October 1708.

128 *Weekly Journal, or, Saturday's Post*, 9 September 1721.

129 Curwen, *Journal*, vol. 2, p. 651.

130 Pepys, *Journal*, vol. 4, p. 285.

131 *British Spy, or, New Universal London Weekly Journal*, 6 September 1755.

132 Geri Walton, 'Food and Drink Adulteration in the 1700 and 1800s', *Geri Walton: Unique Histories from the 18th and 19th Centuries* (blog), 20 August 2014, www.geriwalton.com/food-and-drink-adulteration-in-1700-and/2 (accessed 5 June 2020).

133 *Public Ledger, or, The Daily Register of Commerce and Intelligence*, 9 March 1761.

134 William Hone, *The Every-Day Book and Table Book*, 3 vols, London, [1827], vol. 3, p. 734.

135 Ibid.

136 Ted Flaxman and Ted Jackson, *Sweet & Wholesome Water: Five Centuries of History of Water-Bearers in the City of London*, E.W. Flaxman, Cottisford, 2004, pp. 90–91.

137 Leslie Tomory, *The History of the London Water Industry 1580–1820*, Johns Hopkins University Press, Baltimore, 2017, pp. 42–64.

138 *Post-Boy*, 3 May 1722.

139 Ibid., 8 September 1760.

140 Granger, *Biographical History of England*, vol. 6, pp. 169–70.

141 Pepys, *Diary*, vol. 9, p. 313.

142 'Advert for a quack doctor', *British Library: Timelines: Sources from History* (blog), 1650, www.bl.uk/learning/timeline/item104274.html (accessed 5 June 2020).

143 *Weekly Journal, or, Saturday's Post*, 29 April 1721.

144 Highfill et al., *Biographical Dictionary*, vol. 13, pp. 166-7.

145 Ibid.

146 Ward, *London-Spy*, p. 243.

147 W.J. Lawrence, *Old Theatre Days and Ways*, London, George G. Harrap, 1935, p. 65.

148 *Country Journal, or, The Craftsman*, 16 September 1732.

149 Tonya Howe, '"All Deformed Shapes": Figuring the Posture-Master as Popular Performer in Early Eighteenth-Century England', *Journal for Early Modern Cultural Studies*, vol. 12, no. 4, 2012, pp. 26–47, http://cerisia.cerosia.org/wp-content/uploads/2011/08/final.working.contortionist.pdf (accessed 5 June 2020).

150 John Evelyn, *Numismata: A Discourse of Medals, Antient and Modern*, London, 1697, p. 277.

151 Alexander Smith, *The History of the Lives of the Most Noted Highway-Men, Foot-Pads, House-Breakers, Shop-lifts and Cheats, of both Sexes, in and about London*, 2 vols, London, 1714, vol. 2, pp. 50-51.

152 Highfill et al., *Biographical Dictionary*, vol. 3, pp. 298–9.

153 *London Evening Post*, 16–18 March 1732.

154 Gregory King, 'Scheme of the Income and Expense of the several families of England calculated for the Year 1688', in *Natural and Political Observations and Conclusions upon the State and Condition of England, 1696*, ed. George Chalmers, London, 1810.

155 James Caulfield, *Portraits, Memoirs, and Characters, of Remarkable Persons, from the Reign of King Edward the Third, to the Revolution*, new edn, 3 vols, London, 1813, vol. 3, p. 279 (first printed 1794).

156 *Weekly Journal, or, British Gazetteer*, 27 December 1729.

157 *Pacquets of Advice from Rome*, 17 November 1682.

158 Mission, *Memoirs and Observations*, p. 226.

159 *Caledonian Mercury*, 18 September 1800.

160 Granger, *Biographical History of England*, vol. 6, pp. 10–11.

161 Caulfield, *Portraits, Memoirs, and Characters*, vol. 3, p. 249.

162 *Mercurius Politicus, Comprising the sum of Forein Intelligence*, 18–24 December 1656.

163 Granger, *Biographical History of England*, vol. 6, pp. 12–13.

164 'Pierce Tempest', The British Museum, www.britishmuseum.org/collection/term/BIOG48157 (accessed 22 June 2020).

165 As Nicholas Stogdon pointed out to me.

Further reading

General studies

K.F. Beall, *Kaufrufe und Strassenhändler. Cries and Itinerant Trades: Eine Bibliographie*, Hauswedell, Hamburg, 1975.
The modern study of Cries begins with this monumental account which records some 500 images and suites in many different formats depicting hawkers of all stripes. More than a bibliography, this important dual-language catalogue (in German and English) describes each listed work in detail, noting where it is preserved. Beautifully produced and lavishly illustrated, it is a treasury of Cries and a joy to peruse.

Melissa Calaresu and Danielle van den Heuvel (eds), *Food Hawkers: Selling in the Streets from Antiquity to the Present*, Routledge, London, 2016.
A collection of nine informative essays, global in focus, that pay attention to issues of representation, history, gender and urbanity.

H. Kaut, *Kaufrufe aus Wien: Volkstypen und Strassenszenen in der Wiener Graphik von 1775 bis 1914*, Jugend und Volk, Vienna, 1970.
This monograph is an extensive essay treating Vienna's trades, callings, styles of presentation, predecessors and models. It then gives a history of Cries through four chronological periods from the eighteenth century to 1914. Its images are satisfactorily reproduced, some in colour. It features photographs as well as prints, and has a bibliography.

C. Lacour-Veyranne, *Les petits métiers à Paris au XVIIe siècle*, Paris-Musées, Paris, 1997.
This title focuses on major French printmakers from the seventeenth century. It offers high-quality reproductions, which are accompanied by illuminating commentaries. Jean-Baptiste and Nicholas Bonnart's prints are reproduced in colour.

Richard Luckett (ed.), *The Cryes of London: The Collection in the Pepys Library, Magdalene College, Cambridge*, Old Hall Press, Leeds, 1994.
This important, fully illustrated book records and reproduces Samuel Pepys's various suites of London Cries. It details how Pepys organized his Cries and integrated them into his collection. Pepys is the first English bibliophile to collect Cries and his collection is preserved today in his original bookcase, exactly as he arranged it, in Magdalene College, Cambridge.

Massin, *Les Cris de la ville: commerces ambulants et petits métiers de la rue*, Gallimard, Paris, 1978.
This splendid volume offers over 170 pages of texts and images, many in colour and

some in full-page reproductions. It chiefly features prints, but includes photographs too. It is really an illustrated history of the Cris de Paris from the anonymous woodcuts of 1500 to the photographs of Eugène Atget in 1900. Unrivalled for the number and high quality of its illustrations.

C.P. Maurenbrecher, *Europäische Kaufrufe*, 2 vols, Harenberg, Dortmund, 1980.
These pocket volumes brim with reproductions in colour and black and white. Volume I covers cities in northern and eastern Europe including London, Danzig and Basel. Volume II covers western and southern European cities including Paris, Bologna and Istanbul. Each plate is accompanied by a commentary.

Dwight C. Miller, *Street Criers and Itinerant Tradesmen in European Prints*, Department of Art, Stanford University, Stanford, CA, 1970.
Miller's thirty-two-page pamphlet provides a small but important selection of Cries with a thoughtful commentary, a list of Cries and a bibliography.

Vincent Milliot, *Les* Cris de Paris *ou le peuple travesti*, Éditions de la Sorbonne, Paris, 1995.
A sophisticated theorist, Milliot reads the Cries of Paris as interventions that classify, tame and sanitize the underclasses to please elite audiences. Full of interesting images and provocative readings.

Bob Pullen, *London Street People: Past and Present*, Lennard, Oxford, 1989.
Inspired by Thomson's *Street Life in London*, some of whose plates it reproduces, Pullen juxtaposes street scenes from the past with views from his own photos. He also reproduces images of vanished occupations like the public disinfector, as well as of street people who were his contemporaries and walked the streets at the time the book was published.

Sean Shesgreen, *Images of the Outcast: The Urban Poor in the Cries of London*, Manchester University Press, Manchester, and Rutgers University Press, New Brunswick, NJ, 2002.
With 130 illustrations, some in colour, this is the first scholarly history of the London Cries from the seventeenth to the nineteenth centuries.

Individual artists
Annibale Carracci, *Le Arti di Bologna*, ed. Alessandro Marabottini, Edizioni dell' Elefante, Rome, 1966.
This volume consists of eighty prints with modern titles, and features two prefaces, a modern one by Alessandro Marabottini and the original to the first edition by Giovanni Atanasio Mosini.

David Hansen, *Dempsey's People: A Folio of British Street Portraits 1824–1844*. National Portrait Gallery, Canberra, 2017.

This book reproduces fifty-one watercolours, full-length portraits of street people and celebrities from a variety of British towns and cities. The subjects are equally various, ranging from hawkers of watercress and muffins to laces and sand to sprinkle on floors, to porters, doormen and beggars. A number of figures are blind, infirm or insane, or are amputees. Most of the watercolours record the date and place of composition and twenty-five name their sitters. The designs are executed with vivid realism and splendidly reproduced in full colour. Hansen provides a lively introduction that contextualizes the images and adds illuminating commentaries on the portraits.

William Laffan (ed.), *The Cries of Dublin: Drawn from the Life by Hugh Douglas Hamilton, 1760*, Churchill House Press, Dublin, 2003.

Features contributions from historical, economic, stylistic and iconographical perspectives by Toby Barnard, Sean Shesgreen and others. Reproduces sixty-six pen and ink sketches in an album by the Irish portrait artist Hugh Douglas Hamilton from *c.*1760. The vivid sketches and the artist's titles reflect a knowledge of Laroon's *Cryes*, but offers an authentic account of street celebrities (some of whom were notorious) and Dublin's poor as they followed their trades day by day. Its vividness appears to dramatic effect in 'Three Papist Criminals going to Execution' (fig. 26).

Goffredo Parise (ed.), *Le Arti che vanno per via nella città di Venezia inventate, ed incise da Gaetano Zompini*, Longanesi, Milan, 1980.

Sixty anecdotal prints by Zompini show street scenes (with little interaction or dramas) with several figures in each image. While it offers a short introduction, it provides no elucidation. It reproduces Zompini's four lines of verse to each image.

Sean Shesgreen (ed.), *The Criers and Hawkers of London: Engravings and Drawings by Marcellus Laroon*, Stanford University Press, Stanford, CA, and Scolar Press, Aldershot, 1990.

This scholarly volume reproduces the seventy-four engravings in Pierce Tempest's *Cryes of the City of London drawne after the Life*, together with a selection of Marcellus Laroon's original sketches. It also features an essay on London Cries and biographical information on its publisher, Tempest.

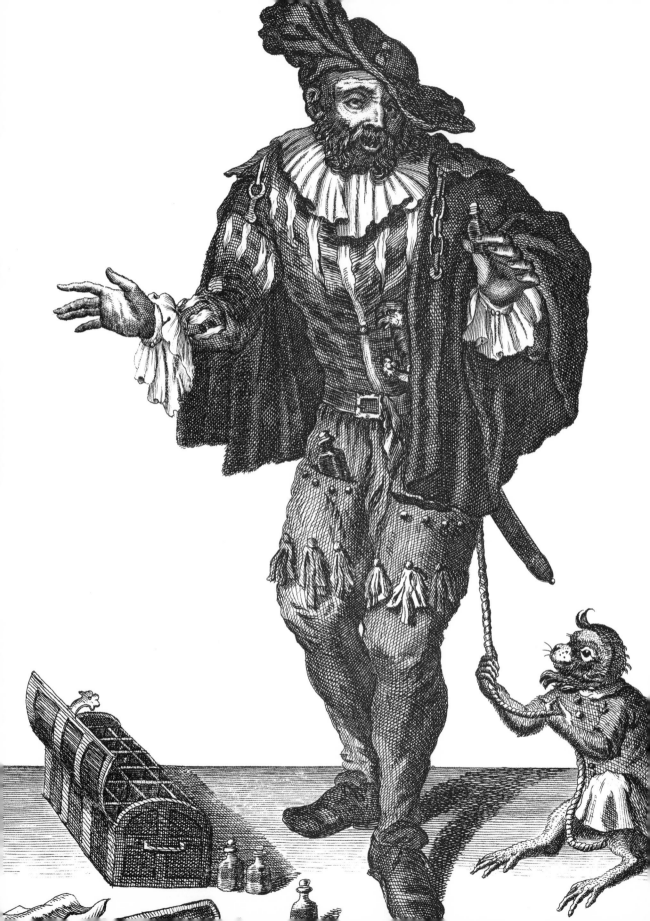

Acknowledgements

In 1990 I published Marcellus Laroon's *Cryes of the City of London Drawne after the Life* in a scholarly edition with an elaborate apparatus. That edition, titled *The Criers and Hawkers of London*, is now so long out of print that it has become the subject of exploitative pricing: a used copy was recently offered online for $99.99. So when the Bodleian Library's Samuel Fanous contacted me to express interest in publishing a new edition of the *Cryes* with sharper reproductions of the plates, I agreed to undertake the project. Today more than ever the need to understand the circumstances, past and present, in which the underprivileged spend their lives is a pressing enterprise.

Happily new technologies have made those lives more accessible today. The Burney and Nicholas collections of newspapers are now available online and are electronically searchable, allowing us to find out more England's marginal people. I have made extensive use of these databases thanks to Harriet Lightman, who taught me how to use them.

I take special pleasure in thanking Nicholas Stogdon who put me in contact with Samuel Fanous. Nicholas read an earlier draft of this book and made many valuable suggestions. My thanks to Ed Muir for guidance on social history and to Claudia Swan for direction on art history. Helen Walsh, Steven Kern and Johana Godfrey all read the manuscript with care. Elizabeth Murray helped me with questions of costume.

To those people whose support is so fundamental that it defies specification, I dedicate this book: Juliette Shesgreen; Deirdre Shesgreen; Jim, Gabriel and Serena LoScalzo; and Sarah Maza.

Paris, France

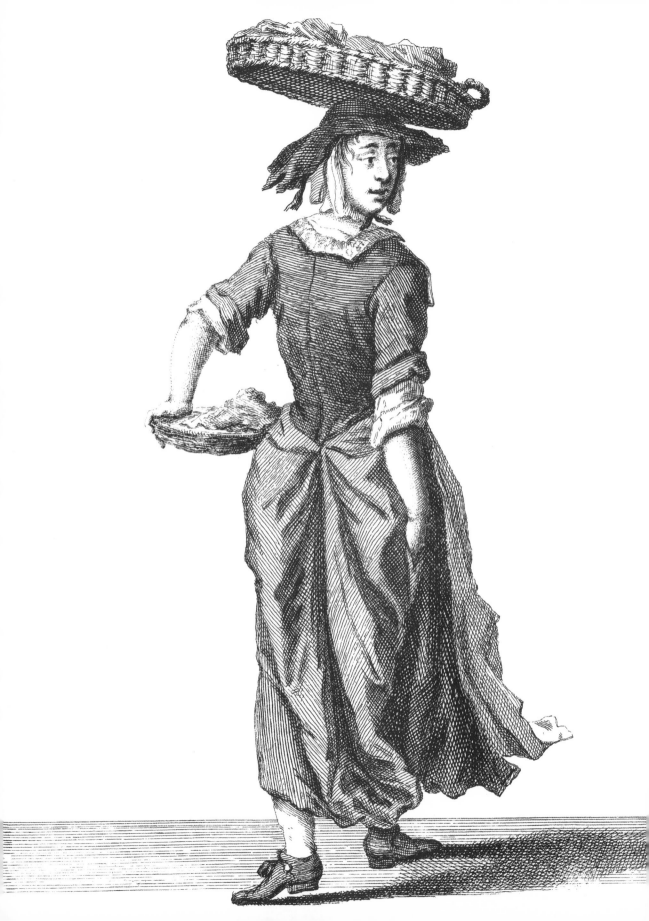

Picture credits

1 Bodleian Library, University of Oxford, G.A. Lond. 4° 16, frontispiece
2 Yale Center for British Art, New Haven
3 Bodleian Library, University of Oxford, Douce G subt. 61, plate 49
4 Paris, Bibliothèque nationale de France, département Arsenal, RESERVE EST-264
5 Paris, Bibliothèque nationale de France, département Arsenal, RESERVE EST-264
6 Rijksmuseum, Amsterdam, RP-P-2004-898/9
7 © British Museum, London, 1843.0311.279
8 Rijksmuseum, Amsterdam, 1951:664
9 Metropolitan Museum of Art, New York; Purchase, The Elisha Whittelsey Collection, The Elisha Whittelsey Fund, 1960, Acc. No. 60.634.53
10 From a facsimile held at London Metropolitan Archives
11 © British Museum, London, 1843.0311.28
12 Courtesy of The Lewis Walpole Library, Yale University
13 Courtesy of The Lewis Walpole Library, Yale University
14 Yale Center for British Art, New Haven
15 Yale Center for British Art, New Haven
16 Metropolitan Museum of Art, New York, The Elisha Whittelsey Collection, The Elisha Whittelsey Fund, 1959, Acc. No. 59.533.585
17 Royal Collection Trust / © Her Majesty Queen Elizabeth II 2020, RCIN 810507
18 Yale Center for British Art, New Haven
19 © Bodleian Library, University of Oxford, G.A. Lond. c.81
20 Courtesy of The Lewis Walpole Library, Yale University
21 © Museum of London
22 Private collection
23 Bodleian Library, University of Oxford, Opie P 213
24 The Lilly Library, Indiana University DRAFT
25 Bodleian Library, University of Oxford, 24763 d.46, vol 2 between 118 and 119 (p. 131 in pencil)
26 Private collection

pp. 80–225 © Bodleian Library, University of Oxford, G.A. Lond. c.81

Index

Illustrations are denoted by the use of *italic* page numbers.